Encouraging the Artist
in Yourself

Also by Sally Warner:

Encouraging the Artist in Your Child
(Even If You Can't Draw)

Encouraging the Artist in Yourself

(Even If It's Been a Long, Long Time)

Sally Warner

Illustrations by Sally Warner
Photographs by Claire Henze

St. Martin's Press • New York

For my friends

The bee stamp shown on pages 53 and 55 is copyright © 1985 by Hero Arts
Rubber Stamps.
The crayon sticker shown on page 23 is copyright © 1988 by Mrs. Grossman's
Paper Co.
The lizard sticker shown on page 23 is copyright © 1989 by Scott Silverman, Mrs.
Grossman's Paper Co.
The cat sticker shown on page 25 is copyright © 1987 by Susanna Gallisdorfer,
Mrs Grossman's Paper Co.
The pinwheel stamp shown on page 25 is copyright © 1989 by Melissa K. Carlson,
Mrs. Grossman's Paper Co.
The mouse sticker shown on page 25 is copyright © 1983 by Mrs. Grossman's
Paper Co.
The cat sticker shown on pages 23 and 29 is copyright © 1981 by Mrs. Grossman's
Paper Co.
The hat sticker shown on page 29 is copyright © 1989 by Julie Cohen, Mrs.
Grossman's Paper Co.
The drum sticker shown on page 29 is copyright © 1983 by Ellen Blonder, Mrs.
Grossman's Paper Co.
The house stamp shown on pages 52, 53 and 55 is copyright © 1987 by Personal
Stamp Exchange.

Library of Congress Cataloging-in-Publication Data
Warner, Sally.
 Encouraging the artist in yourself : even if it's been a long, long time / Sally
Warner.
 p. cm.
 ISBN 0-312-04467-7
 1. Art—Technique. I. Title.
 N7430.W37 1991
 702'.8—dc20 90-28802
 CIP

10 9 8 7 6 5 4 3 2

Acknowledgments

Once more, I first thank my family and "extended families" for their support—or at least for their tolerance. Specifically, I thank the Chambers family for their assistance, Jerry Barrish and Nancy Russell for their contributions, and Patti Ryan for her help on plaster casting day. Thanks also to Carol Thrun, Glenn Ehresmann, and Kit Davis.

Thanks again to Claire Henze for her photographs—and for her humor, flexibility, and patience during this project.

I also thank Graphic Products Corporation, Dover Publications, Personal Stamp Exchange, Hero Arts Rubber Stamps, Mrs. Grossman's Paper Company, Mel Schockner Photography of Fine Arts and Crafts, and Pasadena CopyMat, for their cooperation.

And again, I thank my former students at Pasadena City College. Almost all of the basic projects in this book were developed during our years together. They would bring in a project or an idea and the tinkering would begin. Of many age groups and from all over the world, they were not only good-natured art "guinea pigs" but also a personal and artistic inspiration to me.

Contents

Preface

Each semester for ten years I taught two courses called "Art Media for Early Childhood Education" at Pasadena City College in California. Each class had about twenty-five or thirty students, most of them teachers, virtually all of them devout lapsed artists.

Over a period of time I began to notice some things about these many students:

- Most of them had a profound longing toward some kind of creative expression.

- Many of them showed startling artistic abilities—often in areas they'd never had a chance to try before.

- Some of them decided to go on with their art after the course was over.

- All of them, I think, regained some measure of confidence in their own creativity and were able to apply the flexibility and problem-solving skills they'd rediscovered to other areas of their lives.

I gradually learned many things about art materials and methods that confuse or discourage reemerging artists. I learned how to explain these things simply to them.

This book is an attempt to bring together the teaching methods I learned with the things my students taught me about the creativity that is inherent in each of us. It is my hope that you, the reader, can use this information to encourage the artist in yourself.

Reintroducing Yourself to Art

Whatever happened to art? Most of us lost it somewhere along the way, probably during our elementary school years. And now art seems like a long-ago visit to a foreign land. It is remembered with nostalgia or a shudder, and a feeling that, even if we could somehow return, profound changes would have rendered the land unrecognizable.

But even though the face of art changes, one thing about art never changes: the joy we feel in making it. Many of us are lucky enough to carry this memory of creativity with us from childhood, when art was a natural part of our lives. That memory of creative joy is a resource that can stay in each of us for a lifetime.

How Do You Define "Real Art"?

Try to think of your art as an available resource, not just as a memory. The art is still there, waiting, and there are some things you can do to help it reemerge.

One thing you can do is to spend some time thinking about how you define art. In a general way, people seem to think about art as only "something artists do," which immediately throws a specialty fence up around the word. Don't concern yourself with the people who use this "fence" to keep you out, but ask yourself if you are using it to keep yourself from going back in to art—to keep yourself from doing something

you would enjoy.

Another way we often define "real art" to ourselves is by specific materials or skills, especially skills we lack. Oil painting sounds complicated, like open heart surgery sounds complicated. It's not something we're likely to just stumble into. And drawing, that elementary school litmus test of being "good at art," can seem even more arcane. Drawing skill seems like something the good fairies pass out (or, more likely, don't pass out) at birth.

"Now, this is something I could never do myself," said a woman admiringly as she looked at a drawing. It was true, but think of all the creative things she is perhaps uniquely capable of doing—things she has probably never had a chance to try. Just in the visual arts alone, perhaps she is a weaver, a sculptor, or has a genius for collage. She wouldn't have to quit her job and take to a garret for art to play a meaningful part in her life, either.

If we define "real art" as something we could never do ourselves, we are doing ourselves an injustice.

A last way many of us define art to ourselves is as a complete and separate way of life, one that involves sacrifice, being "misunderstood," and a degree of isolation. In many ways, this is true. It isn't easy being a full-time artist in our society, and one reason is that so many of us think of hardship as just the price artists have to pay for being artists. It's what they get.

Maybe some of this hostility comes from envy—from a sense that artists are getting away with something that the rest of us aren't able to. We should rethink this.

It would be wonderful if we were able to overhaul this entire attitude, but for now it's enough to think, "I can get away with something, with art, too!" Even if it's just for a couple of hours a week, even if we don't suffer, it still can be art—our own art.

Why Bother Making Art?

There isn't any one way to be an artist, and there are many ways to express ourselves in art. The projects in this book are intended to emphasize this. But some form of art can be a part of every life.

Why is this a desirable thing? Why do we yearn for it, even? Surely it's not just to accumulate more things, even things we've made ourselves.

No, it's more a yearning for the creative joy mentioned earlier—the joy we felt in our own "making" abilities when we were children. Did this joy come from a specific finished painting or a specific hole dug in the ground, or did the joy come more from being a creative part of the world? From being a person who makes things?

Creativity is one of our highest abilities, and it is never entirely lost to us. It's time to begin again.

A creative person is a person who makes something that hasn't been made before—something new. There's no getting around it: We can't merely "think art," make lists, or plan for a more artistic future. At some point we just have to begin.

If you have read this far, you already have the desire, the will to do this. All that's needed now is your action.

What About the Projects?

The projects in this book are intended to give reemerging artists a way to begin making art again. The book is divided into four parts: Part One has easy two-dimensional projects; Part Two has easy three-dimensional projects; Part Three has harder two-dimensional projects; and Part Four has harder three-dimensional projects. But instead of getting tense about "easy" and "hard," think instead about "two-dimensional" and "three-dimensional."

Projects that have height and width are two-dimensional. These are essentially flat: think of drawing, painting, and most collage work. Most art activities in school emphasize two-dimensional projects, probably because the supplies and projects are easiest to store, look the most in size and shape like "real work," and reflect the teacher's own art training or bias.

Think back on your own art history, to the two-dimensional projects you did in elementary school. Many of us really just did variations on the same two projects (drawing and painting) over and over, without really getting anywhere. But there are many two-dimensional art projects that are different, that will look good, be fun to do, and have some art in them. The two-dimensional projects in this book provide a start.

Projects that have height and width and depth are three-dimensional. These are not flat: think of sculpture. Many of us haven't had much opportunity to create three-dimensional art projects, so this is a good time to begin. And this may be the kind of art we feel most "at home" making.

There are many kinds of sculpture, by the way. Some of us hear that word and immediately picture huge blocks of marble or blow torches. But don't panic. The three-dimensional projects in this book are on a much smaller scale. Again, they provide a start.

The projects are not intended to be done sequentially but more according to interest, temperament, or whim. It might be a good idea to begin with Part One, especially if it has been a long time between creative bouts, but even that is not necessary.

Neither is it necessary to begin with two-dimensional projects and then "graduate" to three-dimensional projects. Just jump right in anywhere.

It's obvious that people, who are so different from one another, will work on art in different ways. For example, some people like a methodical approach; they feel more comfortable with detailed instruction and often like to work on a project over several sessions. They may be more apt to want to repeat the project, only this time with their own variations.

Others like more of a feeling of spontaneity—and why not? Our adult lives usually have so many demands that making art may provide one of the few opportunities to cut loose. Besides, there might not be time to work on your art over several sessions, and it is depressing to look at a shrouded, half-finished project gathering dust on the counter.

So there is variety in the projects, in all parts of the book. The projects are meant to appeal to different personalities and fit in with different schedules. One project might drive you crazy while another could suit you perfectly. Flip through the book and see for yourself.

Each art activity in the book begins with a list of materials and an estimate of the time needed to complete the project. After that, there is detailed instruction for each activity, not on how to make everything look "right" but on how to proceed, how to vary the project, how to work with the materials. This structure gives many reemerging artists the confidence they need to begin again.

But if detailed instruction makes you see red—if it seems to contradict your idea of making art, or if it reminds you too much of the bad old days in elementary school, then find your own most comfortable way of completing a chosen activity. **Safety information and crucial project information will always be emphasized.** Skim the instructions for **bold print.**

Who Are You Making Art For?

There is something that will surprise and perhaps dismay you as you begin to make art again: No one else will care. No matter how much they care about you they will not only not care about your art, they may even seem to work against your renewed creative efforts.

Don't let this stop you. In fact, turn it around, and let it work for you: anticipate it. And from the very beginning, instead of wasting energy trying to convince others of the value of what you're doing, use that same energy for yourself, for your own creativity. Creativity *is* energy. Conserve yours. And for heaven's sake, don't try to please others with your finished art, because that won't work either.

Why should anyone else care? Each of us has a life to lead, and one of the most central and personal issues in our lives is how we truly define ourselves. If you can see yourself as a creator—well, that's a personal triumph.

The people around you aren't failing you if they don't see you that way too; each of them is busy with his or her own central issues. Don't get caught in the trap of expecting other people to give you art.

And sometimes, let's face it, we expect credit for thinking or talking about something before we actually do anything. Just having the idea (or buying the book) seems like it ought to be enough.

Creativity doesn't work like that. Thinking about art, explaining theories, or buying art materials is not creativity. Making something is. Start.

Art is something you give yourself—it's a gift you give yourself. It can be fun, relaxing, and satisfying to make art. It feels good. And you may even like the finished "product."

So train yourself to ask, every so often, "Who am I making art for?" Then train yourself to answer, "Myself!" It's the best answer, and it will get easier with a little practice.

And when you complete a project, rather than trotting off even a little reward: a special magazine, an ice cream sandwich, a walk around the block at twilight. Something.

Why Is the Creative Process So Important?

There is an inherent contradiction in the projects in this book: On one hand, they can look really terrific; on the other

hand, they're almost beside the point. The art projects are just the outward signs of your creative process.

Have you ever heard an artist say, "All of my work is really autobiographical?" Even about work that doesn't seem to be about his or her personal life? One of the things this can mean is that the process of making the art is so tied in to everyday life that, forever after, that specific art work brings back the memory of his or her life at that time. Or, looking at it a different way, it can mean that the senses are so open when we are making art that our everyday lives become suddenly more important, more vivid to us, and that feeling comes back as we remember the specific art work.

Either way, that more intense connection with ourselves and the world around us is something that art gives back to us.

What Helps These Projects Look Good?

But it's only natural to want the art itself to look good—and it will. The knowledge of professional art materials and methods will make any art project look better.

You don't have to be a "professional artist" to use good materials. Don't worry; they don't ask for proof of capability at art stores.

But how many times have you spoiled a good project by using the wrong material?

- Do you remember feeling frustrated when your paint colors bled into one another, ruining a carefully thought-out color plan?

- Do you remember trying to brush a watercolor wash over drawn ink lines, only to have the ink run?

- Do you remember how your heart sank when the glue on your collage dried, leaving ripples and bulges?

- Or, almost worst of all, do you remember doing something that finally came out just right? Except that it was on newsprint and soon crumbled, or that the paper faded in a year, or that the glue didn't hold?

These early discouragements are enough to keep many of us away from art. When the gap between how we want something to look and how it looks gets too great, we draw back and search for some other form of expression—or we just give up.

And it's too bad, because it's really just a question of

knowing what materials (some of them brand new) are available, what each is best suited for, and what is the easiest way to purchase them.

Does "professional" always mean "expensive?" No. Often you will need to buy only one piece of good paper rather than a package of lesser-quality paper; sometimes you can choose one or two colors of paint for a project rather than purchase a set or kit you may not be able to use. The project instructions and appendices will tell you exactly what to ask for or send for.

"Expensive" is when you buy the wrong art materials or buy more materials than you really need.

And there will always be a range of materials you can choose from in any one activity. For example, you may wish to do a collage project on scrap cardboard you already have or on a piece of purchased illustration board. You will probably be happier with your finished art if you splurge on materials occasionally; the instructions will help you to splurge where it counts.

Think how long it has been since you made something you really liked and wanted to keep. Now think how much you spend when you go to a movie you may not like at all. It helps to put the cost of your art supplies in perspective.

Don't worry too much about wasting supplies if you make a "mistake." Do you remember the old saying "You can't make an omelette without breaking eggs?" You're going to break a few eggs along the way, but the instructions will help keep wastage to a minimum.

Knowing what is the best art material for a project and knowing where or how to get it will enable you to eventually proceed on your own with your art. This knowledge will give you the confidence you need to realize your own vision.

How Can Making Your Art Be Less Lonely?

Even though the people around you may not care much about your creative rebirth, there are little ways to sway them to your cause, and to help yourself feel less isolated as you work. One way is to briefly (and without build-up or warning) involve them in your art.

- A child could help choose leaves for your Leaf Tint.

- A teen-ager could gather tiny thrift store treasures for your Found Object work.

- A friend could help select a funny stamp for your Rubber Stamp project.

- A parent could save bizarre magazines for your Fantasy Cards.

- Any of them could pose for your Portrait Gallery folk art project. (Don't forget to reward the sitter, though.)

- All of them will probably volunteer for Drawing on Someone's Back!

Another way to involve others in your art is through bribery. Many of the book's projects make good small gifts. For example, suggested projects can be made into:

- Bookplates and bookmarks

- Post cards, note cards, and gift tags

- Decorated aprons and pillows

- Message holders and refrigerator magnets

These little presents will be better looking than things you would go out and buy, and they will also be really personal gifts.

Your other, bigger, projects will be ones you will most likely keep for yourself, either to display or not, as you choose. Here are a few things that might make you inclined to display your finished art work:

- There is enough "art" in each project to make it worth looking at over a period of time.

- There is enough "you" in the project to make you care about it.

- The materials in each project look good and will last.

- The two-dimensional projects will be in easy-to-frame sizes.

Suggestions on how to display your two-dimensional and three-dimensional art projects are included throughout the book.

If you complete a project and decide that you really don't like it at all, keep it for a while anyway, in a dark, secluded place. You may either change your mind about it later on or find you can cannibalize it for some other project. For instance:

- A torn-up drawing or Photocopy project can become an exciting collage element.

- A small rejected Stocking Face or Found Object sculpture can become a humorous part of a later assemblage.

- An unsatisfactory Landscape Collage can become the glowing backdrop to a subsequent Diorama.

But if for some reason a project just makes you feel bad whenever you look at it, get rid of it. You've already learned what it was you had to learn from it; your time wasn't wasted.

What Can You Learn from the Projects?

The three most important things you can learn from the projects in the book all have more to do with you than with the actual completed projects.

The first is the knowledge of materials and methods that you will gain. This knowledge will give you a new freedom of expression. You will no longer be limited by the lists and instructions teachers or writers provide when they suggest art activities; your own experience will tell you what works or could work.

The second thing you can learn is how it feels to play again. Even serious art can have a playful quality. Making art is fun!

There's something about messing around with bright paint, heavy paper, and jars of paste that causes the years to fall away. We putter and hum, mixing the paint, snipping the paper, and stirring the paste. We experiment, take chances, make mistakes. Mistakes! But so what?

You will have had fun—you will have played again.

The third thing you can learn from the projects is tied in with the first two, and has to do with rediscovering the creator in yourself. This discovery unfolds as you make the decision to begin again.

There is something—making art—that you want to try. And it's not for the first time, which would almost be easier. No, this is something you did a long time ago, and it may have ended badly.

The mystique and feared expense of art materials discourage you further, but you are brave enough to give it another try.

No one around you seems to notice or care about how brave you are—or else they notice the projects too much! You keep on making art anyway.

There is a good feeling—the feeling of making art, of participating in the creative process—that you want to recapture, and you're going after it.

You find and purchase the materials for the projects you select.

You find the time to make art; even a little time can be enough.

You find a place to make art; even the kitchen table can be your studio.

You work and play your way through the art activities that you've chosen—keeping this, changing that, improvising. Making each one yours.

There is a person—a creator, someone who makes things—that you want to be.

You don't just want to take, to use things up; you want to give.

In spite of its solitary nature, making art can give you a unique way of being involved with the world—of giving back to the world.

Give art another chance!

Part One

Easy Two-Dimensional Projects

Drawing

"**B**ut I can't draw," is the reemerging artist's anthem. You can with these first projects, though, because there is no wrong way to do them.

HANDS OUTLINE (1)

This is not just hands; it is a composition using hands in all their variety. The hands are the designs in this project.

Materials:
Choose one of the following for your base:

- Good white drawing paper (9" × 12" or bigger)
- White Bristol board (9" × 12" or bigger)
- White cold-press illustration board (Cut this or have it cut to an easy-to-frame size before you begin)

Ordinary poster board (also called railroad board) is very slick, and your lines may smear too easily. White construction paper is too absorbent, and your lines may bleed. ("Bleeding" is when the ink line blurs and spreads into the paper.) Here are some easy-to-find, ready-made frame sizes: 9" × 12"; 11" × 14"; 12" × 16".

Draw with any or all of the following:

- Water-based felt-tip markers (**Do not use solvent-based permanent markers.** Avoid wedge-tipped markers; they are hard to draw with. Look for pointed markers.)
- Skinny markers, such as Flair or Pilot, for variety
- Colored pencils for decorating the finished project

Time:

This project will take twenty to thirty minutes, depending on how hard it is to round up volunteers. Add another half hour for any further decoration you might want to add. Allow some time to do the project over again if you find another way you'd like to try.

Instructions:

1. Spread a sheet of newspaper on the kitchen table or the counter. Put your paper on it.

2. Outline your own hand first, using a favorite marker color. Don't do it in pencil first. Do this slowly—it feels good! Keep the marker as close to your fingers as you can. Bring the lines right off the edge of the paper; floating hands will distract from the strength of the project.

3. Outline any other hands you want. Shield the rest of the drawing with a paper towel as you work. Do this with one other person at a time in the room so you can take your time and enjoy being with each person. Remember that this is *your* work, and you get to choose the marker color and hand placement.

4. To make the project more interesting to look at and challenging to work on:

 - *Turn* the paper often. Unless you are after a "bouquet" look, there isn't a bottom to this project— until you decide on one.

 - *Overlap* the hands. You can create dramatic shapes this way.

 - *Vary* colors and use different marker widths if you want to.

- Unless you are doing a "family portrait" in hands, outline each hand as many different times as you'd like. This is art, not census taking.

- Extend the lines of each hand off the paper.

 And don't be afraid to outline only part of a hand against the edge of the paper, or to outline only the fingertips poking over the edge of the paper, or to include a long stretch of wrist every so often, or to just do a repeat outline of your own hand.

5. Wash your hands with soap or a mild abrasive cleanser.

Variations:

- Do the original outline with a wide marker, then decorate some or all of the drawn lines with doodles.

- Do the original outlines with marker, and then shade them in a little with colored pencils. (Remember "shading in" the borders of maps in elementary school?)

- Write in marker the names of the people whose hands you've outlined, along part of the outline. Cursive matches the beautiful curves of our hands, or you could print the names for contrast.

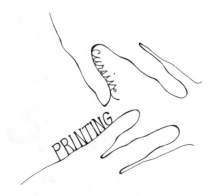

As a Hand Outline variation, write the names of the people whose hands you've outlined: (top) cursive; (bottom) printing.

Display:

If you did this project on paper or Bristol board, you can mount it on a larger piece of colored mat board. (Please see the instructions under Hands Outline (2), page 17, for a flawless way to cover a plain base with colored paper.)

Use spray adhesive or rubber cement to mount your art. **Always go outside to use spray adhesive, and read the label carefully.** Spray adhesive never dries, so you always spray the back of whatever smaller piece you're adhering to the base. You will not be able to see the adhesive on the back of your piece; touch the piece lightly to see if it feels sticky. Choose a colored mat board that picks up a color in your drawing and that fits in with your surroundings. Cut the mat board (or pay a little to have it cut at the art store—it's probably worth it, but save the scraps for later) to an easy-to-frame size such as 9" × 12", 11" × 14", or 12" × 16". Even if you never frame the project, it's nice to have the option. A lucite box frame would be a good frame for this project. **Do not display the project in the kitchen unless it is protected by glass or plastic. The marker**

This Hand Outline uses white drawing paper, Fadeless art paper, marker, and spray adhesive.

lines will bleed if they get splattered. If you did the project on illustration board, it can be displayed without framing; just prop it on a bookshelf or counter.

Hands Outline (2)

You don't need any hands other than your own for this project, which combines drawing with collage; the hands outline is just the beginning.

Materials:
Choose one of the following for drawing:

- Good white drawing paper (9" × 12" or bigger) **Do not use a heavier base; you will be cutting into the base later on in the project.**

Draw with any or all of the following:

- Water-based felt-tip markers (Since you will be using different paper colors to finish this project, you may want to use only one color marker, such as black. Use skinny markers to add variety.)
- Colored pencils for decorating the finished project.

Choose one of the following for your base:

- Bristol board
- Poster board
- Mat board
- Illustration board

Cut your base (or have it cut) to an easy-to-frame size such as 11" × 14" or 12" × 16". (If you don't like the color of your base, you can cover it with paper later on. Instructions follow.)
Other materials:

- Spray adhesive or rubber cement
- Fadeless art paper or other bright or small-patterned paper
- Good scissors
- Manicure scissors, utility knife, or X-acto knife

Time:
 The first part of this project, the *outlining,* will take about twenty minutes. The second part, the *cutting,* will take about one half hour. The third part, the *mounting,* will take another half hour.

Instructions:
 Outlining

1. Spread a sheet of newspaper on the kitchen table or the counter. Put your paper on it.

2. Slowly outline your hand with the marker. Don't do it in pencil first.

3. Repeat; change hand positions, and turn the paper as you work. Outline your hand 8 to 10 times. Extend all lines off the edges of the paper—no floating hands! Shield your composition with a paper towel as you work. Please read Instruction #4, page 14, for ways to make your composition more interesting.

4. Wash your hands with soap or a mild abrasive cleanser.

This is a good place to stop work if necessary.

Cutting

5. Look at the border of your drawing and the shapes created *between* the hands. Think of these shapes as puzzle pieces, and cut some of them out. Do not worry about "wasting" parts of your project; throwing something out *is* part of your project. Turn the paper as you work. You don't have to cut away from all four sides; the idea is to "open up" the boxy shape of the paper. Try cutting ¼" or more outside your marker line, thus leaving a narrow white paper margin. Since your composition will be mounted on colored paper, the white margin will add excitement to the finished piece. Experiment: Sometimes a thick/thin white margin looks good.

6. Look for other "created" shapes inside the composition. You may want to cut some of these out. This will make your finished piece look both lighter and more complex. Before you cut any more, though, place your piece on a piece of dark-colored paper. This will help you see everything more clearly.

Look at it for a while, turning the dark paper. Decide if there are any interior created shapes that you'd like to cut out. You may want to cut some shapes radiating away from the center. You may want to cut away puzzle-piece shapes in a "line" from one edge to another, or you may want to cut heavily away from one side, leaving it lacy and open while the other side is solid and closed. Whatever you decide, stop work every so often and put your composition down on the dark paper to see how it looks. Turn it around, look at it from different angles. To cut interior shapes: Use manicure scissors to poke a hole in the middle of the interior shape you want to cut out. Carefully snip the shape away, remembering to leave a white margin if you want one. You may also use a utility knife or an X-acto knife. With these sharp tools, put your composition face-up on a stack of old newspapers or a big discarded magazine. Carefully cut out the interior shape you wish to throw away, remembering to leave a white margin if you want one. **Be very careful when you use a utility knife or an X-acto knife. They are very sharp. Always put newspapers or a magazine under your work when you cut, or you will damage your table or counter.** When you are satisfied with the cutting, go on to the next step.

This is a good place to stop if you need to.

Mounting

You now have an oddly shaped, fragile composition that you will mount on a larger, sturdier base made of Bristol board, poster board, mat board, or illustration board. Select an easy-to-frame size for your base such as 11″ × 14″ or 12″ × 16″. You will want to cover your base with brilliant Fadeless art paper or some other paper that looks good under your drawing. It can even be patterned paper such as newspaper or gift wrap, but the project will look better if it is a very small pattern.

7. To cover your base, choose a piece of colored paper that is larger than the base. Take the base outside, and put it down on a big sheet of newspaper. Spray it lightly with spray adhesive. **Always go outside to use spray adhesive, and read the label carefully.**

8. Take the base inside, and place the colored paper on top. Smooth it down from the center out toward the edges.

9. Turn the base over, and cut the excess colored paper away from its edges.

10. *Before you glue your drawing onto the base,* experiment by placing a second colored paper (slightly smaller than the first) under your drawing. This second color could be one that is in your drawing, a color in the room you want to display it in, or just a color that looks wonderful with the first one. Try several ways of positioning your drawing on its background(s) before you mount it. If you decide to use a second background color, you will glue that down next.

11. *Before finally gluing down your drawing,* make tiny faint pencil marks on the base where the corners of the drawing will go.

12. To mount your drawing, take it outside and place it face down on a *clean* big sheet of newspaper. Spray the back lightly with spray adhesive, then take it inside and tape the two most solid corners against the faint pencil marks. Smooth it down.

Variations:

● Try the project once again. As you outline your hand, create more varied overlapped shapes with the rest of the project (*cutting* and *mounting*) more clearly in mind.

● Experiment further with background color combinations. They can be varied in color, shape, size, and even kinds of paper. For example, a smaller black rectangle could be mounted on a newspaper-covered base, a densely patterned gift-wrap rectangle could cover a vividly colored base, or small colored paper patches could be hidden behind the cut-out interior areas of your drawing.

Display:
Please see page 15 for display and framing ideas.

Fantasy Drawing: "Where I would Like to Live Someday"

Most people are so shy about their drawing skills that they probably will never display this next project, but they enjoy doing it anyway. It's relaxing, pressure-free, and fun to do.

This is more of a "how to dream" project than a "how to draw" project.

Materials:

Choose one of the following for drawing:

- White index or botany paper (8½" × 11"; comes hole-punched)

- Typing paper (8½ " × 11")

Draw with:

- Water-based felt-tip markers (especially skinny ones such as Flair or Pilot, which are good for details)

- Colored pencils to decorate the finished drawing (optional)

Time:

This project will take about twenty to thirty minutes; allow ten minutes extra for daydreaming.

Instructions:

1. *Stop worrying about not being able to draw it right.* Stick figures and lollipop trees are fine.

2. Take some time to really visualize this fantasy—and really fantasize! Don't just add another bathroom. Maybe you'd like to live in the city, in a penthouse apartment; or in the country, surrounded by dachshunds; or on the beach, where you can build boats.

3. Start to draw, shielding your hand with a paper towel to keep your lines from smearing. As you work, add as many details to your drawing as you can. Add (and name) as many people as you want. Do you want animals? trees? flowers? cars? major household appliances? What about color? What color is your house or your

penthouse screening room? You can use colored pencils to add color within the marker lines.

4. After you finish drawing: Since many people are more comfortable with words than with drawing, you may want to turn your drawing over and write something about it on the back. Just watch out that the writing doesn't accidentally take over; don't just dash off a five-minute sketch and then spend twenty minutes explaining it. Have your drawing explain itself.

Variations:

- This would be a good project to do once a year; it will be fun to go back and look at a series of them.

- Other drawings like this that you could do: Where I Would Like to Live Some Day (the floor plan), My Own Island (an aerial map), The Most Fabulous Me— In All My Glory, or How I See My Life in Five Years.

Storage:

These are playful but private drawings for most people. The best way to keep them unwrinkled and accessible is in a 9″ × 12″ loose-leaf notebook. Use a hole punch if necessary. Always date any work you store—it will make the drawings more interesting to look at later on. *If you found that you were more interested in the writing than the drawing,* maybe this is a good time to start a journal! Use the loose-leaf notebook for that, too.

As you work, add as many details to your drawing as you can.

Collage

Collage activities are projects in which something is glued to a base or, in these first projects, stuck to a base. Here are three projects that are fun to prepare for, easy to make, and result in welcome gifts.

STICKERS: BOOKPLATES

Bookplates are a decorative way of identifying who owns a book. They are put in the very front of the book. You can make just one Bookplate or a small set of them—they don't even have to match!

Materials:

- White self-adhesive labels—1½" × 4" or 2" × 4", depending upon the size of your stickers (**Self-adhesive labels may eventually slightly discolor the paper behind them.**)
- Stickers

Draw with:

- Skinny black permanent marker such as Pilot or Tombow. **Do not let children use permanent markers to draw with. Keep permanent markers separate for use**

in other art Projects. Skinny permanent markers come in other colors, but you will use black the most.

- You can use watercolor markers for this project, but your lines will smear much more easily on the labels as you work and may even smear onto the book if they ever get damp.

- Ruler; pencil; art-gum eraser or kneaded eraser

Time:

This project will take one half-hour to an hour.

Instructions:

1. First comes the best part: accumulating some stickers! There are several places you can find them. *Supermarkets* often carry packets of mixed or matching stickers (these are especially good if you want your Bookplates to match). These packets of stickers are the least expensive. Supermarkets also usually carry gummed or self-adhesive stars in the school supplies section. *Stationery stores* carry the self-adhesive labels you will need for this project. In the same section, look for self-adhesive colored dots, which you may be able to use in one of the Stickers projects. Stationery stores also carry packets of stickers, and sometimes the beautiful stickers you can buy one at a time off the roll. These are more expensive but are good for some projects. They look great, you get just what you want, and you won't need to buy too many. Stationery stores also carry gummed or self-adhesive stars. *Mail order catalogs* sometimes carry big assortments of fancy stickers. If you are a hoarder, you'll want to accumulate lots of stickers—and this is a good way to start.

2. Look at the white self-adhesive labels you have bought. Turn them—they can be used vertically (tall) or horizontally (wide). *You will keep the self-adhesive labels stuck to their backing paper throughout the entire project, until you are ready to use the bookplates.*

3. Keeping the stickers on their backing paper too, cut loosely around the ones you are thinking of using. Try the cut-out stickers on the self-adhesive labels. Do they fit? Are there two stickers that look good together?

Top: crayon sticker © 1988 by Mrs. Grossman's Paper Co. Center: cat sticker © 1981 by Mrs. Grossman's Paper Co. Bottom: lizard sticker © 1989 by Scott Silverman, Mrs. Grossman's Paper Co.

Draw very faint guidelines for your lettering.

Don't be afraid to overlap them. Set aside the stickers that you want to use—*but don't stick them down yet.*

4. First, you will do any lettering and/or decorating on the labels with your skinny permanent marker(s). Since the stickers will probably be the most expensive part of the project, it makes sense to stick them down only after you are satisfied with the other decoration. Before you do any lettering, draw *very faint* guidelines using a ruler and pencil. You will erase these later. For an adult, print or write the book owner's entire name. For a child, print something simple such as "Sophie's Book"; for a gift message, print something such as "Happy Birthday to Lucy from Aunt Nancy." Be sure to add the date, and remember to leave room for the sticker!

5. When the ink is dry, gently erase your faint pencil guidelines. An art-gum eraser or a kneaded eraser should not discolor or damage the paper. *If you used watercolor markers* for the lettering or decorating, it will take longer for the ink to dry. If you erase too soon, the marker will smear.

6. Attach the stickers onto the self-adhesive labels.

7. Finished Bookplates can go straight into waiting books, or a few sheets of them can be slipped into a gift envelope.

Variations:

● Look at the various available sizes of self-adhesive labels. With larger, 4" × 6", labels you can do a lot more decorating or write longer messages. You could cut into the larger labels, creating your own shapes such as hearts, clouds, or even a giant capital letter. *Just be sure to leave the labels stuck to their backing paper until you are ready to use them.* Try extending your drawn lines off the edges of the labels as you draw. **Do this only with the permanent markers;** watercolor marker lines may eventually smear onto the book. Work on a piece of newspaper or a paper towel to keep permanent marker lines off your work surface.

● Combine your marker decoration with the stickers. Draw a mustache on a sticker happy face—go ahead!

Give the stickers names. Have a sticker "say" something.

- Use these decorated labels for other purposes, such as decorating artwork, notebooks, or a mirror.

- Rather than create labels, use the same combination (stickers and drawing) to decorate blank post cards.

STICKERS: COUNTING BOOK

Here is a little present that you can make for a very young child. Even though there are beautiful counting books available in stores, a child will especially treasure something made just for him or her—by you.

You will letter a personalized cover for the Counting Book. Be sure to give yourself credit as the author!

This book counts from one to ten.

Materials:
Choose one of the following for your base:

- Bristol board

- Poster board

- Index paper

- Bright construction paper

Index paper and construction paper are lightweight. If you use these materials, have the finished pages laminated so that the book will last.

Other materials:

- Stickers (Packets of matching stickers are good for this project, as are stars and dots. Please see page 23 for where to buy stickers.) **Do not use stickers with little plastic eyes—they are not safe for young children.**

- Skinny markers (Use permanent markers unless you are planning to laminate the finished pages.)

- Ruler; pencil; art-gum eraser or kneaded eraser

- Single-hole punch and metal ring (for Bristol board or poster board book)

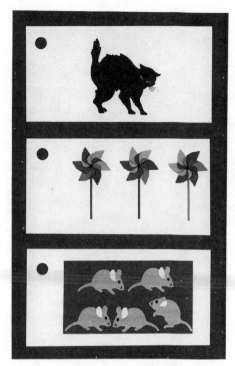

Here are three pages from a Counting Book. Top: cat sticker © 1987 by Susanna Gallisdorfer, Mrs. Grossman's Paper Co.
Center: pinwheel sticker © 1989 by Melissa K. Carlson, Mrs. Grossman's Paper Co.
Bottom: mouse sticker © 1983 by Mrs. Grossman's Paper Co.

● Stapler and brightly colored cloth tape (for lighter-weight paper)

A word about lamination:
Any of these bases can be laminated with plastic at the end of the project. This process will make your book last a lot longer—it can be manhandled, gnawed on, and wiped clean over and over. It's not very expensive and may well be worth the extra effort involved. Many stationery stores offer this service, or you can look in the phone book under "Laminations."

Time:
This project will take about one hour.

Instructions:

1. Cut twelve pieces of your base to the same size. The pieces can be different colors if you want. Ten pieces will be for numbers one through ten. Two pieces will be for the front and back covers. The book can be any shape; it can be long and skinny, for example. Each piece of hole-punched 8½″ × 11″ index paper can be trimmed and cut into two 4″ × 11″ pieces.

2. Choose the stickers you want to use for each number. One sticker will go on the first page, five stickers will go on the fifth page, etc. On any one page, try to have matching stickers. (The packets, stars, and dots are useful for the higher numbers.) It is harder for young children to get the idea of counting nonmatching stickers. *Use a separate page for each number,* and vary the way the stickers look on each page, i.e., group them in interesting ways. Each page is a little composition.

3. You may want to add some drawn decoration around the plainer stickers, but don't draw so much that it makes it hard for the child to count. Use a skinny permanent marker (such as Pilot or Tombow) unless you are planning to laminate the finished pages. Add little sparkle lines to stars, if you want. Dots can become flowers, balloons, or insects.

4. Now it is time for lettering. Don't worry about printing numbers and words on each page—let this just be a sticker book. You will want to letter the front of the

title page, though. Draw *very faint* guidelines for your lettering, using a ruler and pencil. You will erase these later. *Simple upper- and lower-case printing is best for very young children.* Print your words lightly in pencil, then go over the letters with marker. *Do not change marker color within any one word.* The title can say: "John's Book," "Molly's Counting Book," or "For Charlie." Add your name (but smaller!) at the bottom of the page.

5. Using the same method, print "The End" inside the back cover. There's something very satisfying to children in "reading" this at the end of a book.

6. When the ink is dry, gently erase your faint pencil guidelines. An art-gum eraser or a kneaded eraser should not discolor or damage the paper. Watercolor markers will take longer to dry.

7. *If you are going to have the pages laminated, do it now.*

Finishing the book:

8. If you used Bristol board or poster board, punch a hole in the upper left corner of each page. The metal ring will hold the pages together. **Do not punch the hole too close to the corner, or the ring will eventually tear the pages.** Make sure that the holes line up perfectly. Punch only one or two pages at a time. Thread the ring through the holes.

9. If you used index paper or construction paper, staple the pages together. (If you made a long skinny book, it should be bound at the short side.) Cut a piece of brightly colored cloth tape slightly longer than the stapled book. Place the stapled side face down over half of the tape, then carefully fold the tape onto the book's back. Trim the tape.

Variations:

● Buy some extra rings and make a few blank books for a child. You can decorate the covers with stickers, lettering, or drawing, or let the child decorate the covers.

● For slightly older children, combine pictures (stickers, drawings, or from magazines) with clearly printed identifying words. Select pictures of things that the child is interested in and cares about.

The metal ring will hold the pages together.

STICKERS: MATCHING

This is a domino-type matching activity for a child to play with alone.

Materials:
Choose one of the following for your base:

- Bristol board
- Poster board (Poster board comes in different colors. *Choose just one color board for this project;* otherwise, young children are more apt to try to match colors than stickers.)

Other materials:

- Stickers (three to four matching sets of six or eight each; packets, stars, and dots are good for this project. Please see page 23 for where to buy stickers.)
- Skinny permanent marker (such as Pilot or Tombow)
- Ruler

Time:
This project will take forty-five minutes to an hour.

Instructions:

1. Cut twenty-four (or more) pieces of Bristol board or poster board into 2″ × 4″ pieces. Cut larger pieces if you are using big stickers. Erase any pencil guidelines.

2. Divide your matching sticker sets among the pieces of board. Two stickers will go on each piece—one at each end. This will create a "domino" for the child to match to another "domino." If you don't have a big assortment of stickers, you can get a lot of use from stars or dots. For example: red stars can be matched with red stars, and blue with blue; yellow dots can become daisy centers with a little drawing added; blue dots can become eyes; or red dots can become ladybugs.

3. Attach the stickers.

4. Using a ruler and your skinny permanent marker, draw a line down the middle of each board between the two

re matching
—domino style.

stickers. Each rectangle is now "divided" into two 2" squares. *Do not cut the rectangles, though.*

5. Add any necessary drawn details to the stickers.

6. Keep the pieces together with a wide brightly colored rubber band.

Variations:

- Make a larger set so that you can play, too! Just be sure to limit the number of sets of matching stickers that you start out with.

- Think of other things that could be matched: colors; textures of fabric and/or paper; and, numbers. (Make your own dominos with the self-adhesive dots.)

- Some sticker sets have tiny "accessories" that can be added to a larger sticker character. Make a set of five or six same-sized boards, starting with only the sticker character. Duplicate the previous character exactly on each board, but add one "accessory" (such as a hat, purse, beard, or tie) each time. The last board will show the character all decked out! The child can sort the pieces according to how much the character is wearing.

Fabric Appliqué Gift Tags

We usually think of an "appliqué" as being sewn, but it can also be attached in other ways. In this activity, ribbons and trims are used to decorate a set of gift tags. This is a project that can combine both fabric and paper in the same collage—and why not?

Materials:
Choose one of the following for your base:

- Bristol board
- Poster board
- Index paper

Optional:

- Fadeless art paper or other decorative papers to cover your base (use spray adhesive for this)

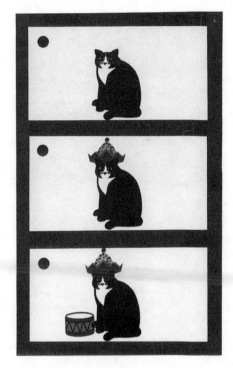

Add one accessory to each sticker.
Top: cat sticker © 1981 by Mrs. Grossman's Paper Co.
Center: hat sticker © 1989 by Julie Cohen, Mrs. Grossman's Paper Co.
Bottom: drum sticker © 1983 by Ellen Blonder, Mrs. Grossman's Paper Co.

Choose one or combine the following for your adhesive:

- "Stitch Witchery," "Wonder Web," or other fusible fabric (these are sold by the yard) and an iron
- "Yes" paste and a small brush ("Yes" paste is an excellent adhesive for collage, although it won't hold bulky or heavy collage materials well. The best thing about "Yes" paste is that it won't curl or wrinkle your collage materials.)
- Spray adhesive
- White vinyl glue (although vinyl glue is more likely to soak through very thin fabrics or cause your base to curve)

Other materials:

- Ribbons, trims, fabrics
- Scissors
- Ruler; pencil; art-gum eraser or kneaded eraser
- Skinny permanent marker such as Pilot or Tombow

To attach the Gift Tags to presents, choose one of these:

- Single-hole punch and yarn
- Double-sided tape and waxed paper

Time:

Allow an hour to an hour and a half to make several small sets of Gift Tags. More complex tags will take longer.

Instructions:

1. Decide what color you want your Gift Tags to be. If you want to leave them white or whatever color your poster board is, skip the next step.

2. To cover your base (optional): Fadeless art paper comes in brilliant colors. Cut 9″ × 12″ pieces in the colors you want. Take the base outside and put it down on a big sheet of newspaper. Spray it lightly with spray adhesive. **Always go outside to use spray adhesive, and read the label carefully.** Take the base inside, and

place the colored paper on top. Smooth it down from the center out toward the edges.

Do any necessary pencil drawing on the uncovered side of the base—eraser marks sometimes discolor the paper.

3. Plan what shapes you want your Gift Tags to be. They could be simple squares or rectangles. They could be circles or hearts. They could be in the shape of an ornament for a Christmas gift; a teddy bear or rattle for a baby gift; a simple house for a house-warming gift; or a flower for a shower gift. *If you want matching shapes,* cut a pattern from Bristol board or poster board. Lightly draw the shapes with pencil on the uncovered side of your base, then cut out the Gift Tags. Use your art-gum eraser or kneaded eraser to gently erase any pencil guidelines.

4. Assemble your ribbons, trims, and fabrics and plan a simple collage. Just one simple ribbon or trim "stripe" is usually enough to decorate a small tag. The decorations on the tags can be identical, but they don't have to be—just using the same trims within a set will make the tags look as though they belong together. *Cut your ribbons and trims a little longer* than you will need. You can snip off the extra later.

5. To attach the various trims:

 If you are using fusible fabric and an iron, cut skinny pieces of the fusible fabric to fit under your selected ribbons and trims. *The fusible fabric strip should be a little narrower than the ribbon or trim,* so that it will not be visible when it is sandwiched between the trim and the base. Set your iron on medium-low dry heat. Put a paper towel over the ribbon or trim as you iron. The heat from your iron will fuse the trim to the base.

 Fusible fabric can be cut to any shape and is good to use under irregular appliqué shapes. *Just remember to cut your fusible fabric slightly smaller than the appliqué shape.* If the heat from your iron curls the Gift Tags, press them flat under some books.

 If you are using "Yes" paste and a small brush, put a dab of paste on a piece of aluminum foil. Using a small brush and some water, thin the paste a little bit. Place your ribbon, trim, or fabric scrap face down on

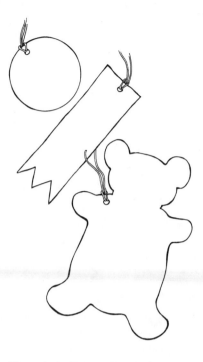

Plan what shapes you want your Gift Tags to be.

a piece of newspaper, and carefully brush the "Yes" paste onto the back. Position the appliqué piece on the base and press. Change the newspaper often as you work to keep paste spots off the front of your appliqué pieces.

If you are using spray adhesive (only for your lightest-weight trims), follow the instructions for using spray adhesive given earlier in this project. *Remember to spray the backs of the trim pieces you use rather than the Gift Tags themselves.*

If you are using white vinyl glue, follow the instructions for "Yes" paste.

You may combine adhesives on one tag. For example, you could use fusible fabric or spray adhesive to attach a ribbon strip and then use "Yes" paste to attach a heavier lace appliqué.

6. Snip off the extra trim lengths that poke over the edges of your Gift Tags.

7. Using your skinny permanent marker, do any lettering you want. Use a ruler and pencil first if you want to draw faint pencil guidelines—you will erase them later with your art-gum eraser or kneaded eraser.

8. To finish your Gift Tags:

If you will tie the Gift Tag to a present, use your single-hole punch to punch a hole in the corner of each tag. Don't punch the hole too close to the edge or it will tear the tag. Cut a 6″ length of yarn for each tag. Loop the yarn over your finger. Poke the loop through the hole, then pull the loose yarn ends through the loop.

If you will use double-sided tape to attach the tags, put two strips of tape on the back of each tag. Cover the sticky tape with waxed paper until you are ready to use the tag, or just wait until you are ready to attach the tag to the present, and then use your tape.

9. Keep your finished Gift Tag sets in sturdy small plastic bags; otherwise, you may forget what you've made!

Variations:

● Try more collage on your Gift Tag bases. Spray adhesive will hold lightweight decorative papers flawlessly. Work in layers.

- Experiment with various fabric appliqué shapes. For example, a simple house-shaped Gift Tag could have calico windows. An ornament shape could have polka-dot stripes. A teddy bear Gift Tag could have a plaid bow tie.

- Work assembly-line style and make lots of sets at the same time. These make good small gifts or fund-raiser offerings.

- Work slightly larger (and longer), and turn this into a one-of-a-kind collage piece.

THE CIRCLE IN THE SQUARE

Here is another appliqué project, one that is slightly more challenging. Like Gift Tags, it can combine paper and fabric in one finished piece. Unlike the previous project, however, it starts with only one shape—the beautiful square.

When you work on this project, think in terms of stacking the layers rather than piecing them together.

Materials:
Choose one of the following for your base:

- Foam board
- Corrugated board (6″ or 8″ square)

If you work on a thinner base such as illustration board, mat board, or poster board, be prepared for it to curve as the glue dries.

Choose one or combine the following for your adhesive:

- "Stitch Witchery," "Wonder Web," or other fusible fabric (these are sold by the yard) and an iron

- "Yes" paste and a brush

- Spray adhesive

- White vinyl glue (although this may soak through very thin fabrics)

Please see Gift Tags (page 29) for more information on working with each of these adhesives.

This appliqué project combines burlap, gingham, paper, and pompons, and is made with spray adhesive and a hot-glue gun.

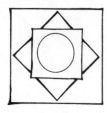

Begin to plan your design by
visualizing a circle in the square.

Other materials:

- Fabric pieces and trims (look for variety in color, pattern, texture, and value—light and dark)
- Decorative papers
- Good scissors

Time:
 This project will take one and a half to two hours.

Instructions:

1. Look at your square base and picture a big circle floating on it. Begin to plan a design using the circle in the square. You don't have to make a "picture." For example, your design could be variously patterned target circles shrinking on the square. You could make the circle *be* the "picture"; for instance, it could become a round beetle, a face, the moon, or a flower. Additional collage pieces will be attached to your circle later. You could have another appliquéd image "framed" by the circle: A checkered heart could be inside the circle; fabric initials could form a monogram within the circle; a glittering foil star could hang inside the circle.

2. Look at the fabrics and papers you have, and plan which ones you want to use. You can use just about anything—it's just a matter of using the correct adhesive for each fabric or paper you select. *Remember that you can combine adhesives on one collage.*

3. Decide what you want to cover your square base with. Cut a fabric or paper square slightly larger than the size of the base. You will trim the excess later. Attach a *fabric* square to the base with fusible fabric, "Yes" paste, or thick white vinyl glue. Attach a *paper* square to the base with "Yes" paste or spray adhesive. Trim away the extra fabric or paper. *Sometimes fabric will shrink slightly as it dries,* so wait until the glue or paste is dry before you trim it.

4. Before you glue anything else down, please read the following.

A word about the art:

This is a very small collage. *Simplify* your design; take out what isn't needed. If you decide to include a complex shape such as a tree or a hand, consider assembling it in pieces. It's easier, and it will look a lot better. Don't try to hide the places where the pieces join—you can even exaggerate those places. Look at the edges of your collage pieces. Are they all the same—all cut? Remember that they can also be torn, frayed, or pinked. *Double-check* that you have enough variety in your surfaces—that's what will make the collage interesting.

Color: Do your color choices work well together, or are there too many colors for this one small piece?

Value: Squint your eyes. Can you see light and dark differences, or does everything just blend together?

Pattern: Do your patterned collage pieces work together, or are they fighting? Try repeating just one pattern in different parts of the collage. Vary how you use that pattern—fray the edges, turn it around, turn it over.

Texture: Is everything too much the same texture—felt or woven?

Add visual excitement to the composition with foil, a doily, slick magazine paper, sandpaper, burlap, fake fur, corduroy, or velour. After you have thought about these things, you are ready to go on to the next step.

If you decide to include a complex shape, assemble it in pieces.

5. You will be working in layers. This requires a little advance planning. The first layer you will glue down will be the circle in the square. You will build up your appliqué layers from there. *Do not get excited and glue down the "fun" part first,* then spend extra time trying to piece in the background. Work slowly. Use the correct adhesive for each collage piece. Keep the newspaper under your gluing area clean.

6. There is no requirement that this has to be a flat collage. There are lots of things you can attach: Yarn braids or hair bows can decorate a round face; buttons or a bow tie can formalize a teddy bear; paper flowers, curled fabric leaves, or a fuzzy bee can embellish a branch or a flower. *If you are attaching something bulky,* use thick white vinyl glue. You could also use a hot-glue gun to attach these final three-dimensional pieces. The hot-glue gun is a useful tool for craft work. You insert a solid glue cylinder at one end of the gun

and squeeze the hot clear glue out the other end by pressing on the trigger. The glue dries almost instantly and so immediately attaches and holds otherwise awkward collage materials onto bases. **Be very careful when you use the hot-glue gun.** Don't touch the wet glue or the nozzle. Always rest the hot-glue gun with the nozzle well away from your table or counter. Put a piece of aluminum foil underneath the resting glue gun to catch any drips. **Always squeeze the hot glue onto the base rather than onto any small collage piece you are holding.** If necessary, use a toothpick to move very small collage pieces onto the hot glue. Just a little glue will usually hold a collage piece.

Variations:

- Do this project in an easy-to-frame size such as 5" × 7" or 8" × 10". Now it's the Circle in the Rectangle— just remember to keep the circle big. Select a frame with a narrow space between the glass or plastic and the collage surface.

- Keep the project square but do several, perhaps using the same fabric and paper selections on each. The finished squares look good together—they can be displayed next to one another like tiles. Make each family member's monogram. Do a series of pet portraits. Try a more ambitious series—try the four seasons!

- Adapt the project. Use your compositions to plan a larger craft piece such as quilt squares or square appliquéd pillows.

Display:

Prop your finished collage on a counter, or nestle it in a bookshelf. Its base is sturdy, and the project will last a long time even without framing.

BEAN MOSAIC

The success of this activity definitely depends upon your personality type. Some people love to fiddle with tiny collage materials while others find it maddening.

Don't try to "improve" yourself by doing this project if you know in advance that you won't like it. Go on to another project, or go outside and chop some wood.

But if you take pleasure in tiny things, in detail work, give the Bean Mosaic a try.

Materials:
Choose one of the following for your base:

- Masonite (comes precut in various small sizes)
- Foam board
- Corrugated board

Work small (6″ or under). It takes time to cover even a very small base. If you use a thinner base, it will curve as the glue dries.
Other materials:

- Dried beans and peas (Choose two or three varieties from among black beans, white beans, black-eyed peas, kidney beans, pinto beans, and green or yellow split peas.)
- Pencil, or white Stabilo pencil (good for use on Masonite)

Use for adhesive:

- Thick white vinyl glue

Use one of the following for a shiny finish:

- Thin white vinyl glue
- Glossy acrylic medium
- Glossy plastic spray

Time:
This project will take one and a half to two hours, depending upon the size of your base.

Instructions:

1. It is easiest to work from the center of the base out to the edges. So first, you have to find the center of your base. Draw two diagonal lines to intersect the base. These lines will cross at the center of your base. White Stabilo pencil shows up best on a Masonite base.

Plan a simple design.

Work from the center out.

2. Plan a very simple design—the simpler the better. Remember that this is going to be done in beans, not in needlepoint. Remember also that much of how the finished project looks will depend upon how carefully you work with the beans—pattern, direction, etc.—and not on how clever the original drawing is. Your design could be a heart, stripes, a curved band, or even just the triangles created by the diagonal lines you've already drawn. Draw your design on the base with pencil or white Stabilo pencil.

3. Begin to glue down your beans or peas. *Remember to work from the center of the base out to the edges* as much as you can. Work in one very small area at a time. Pay attention to *pattern:* Even if you work with just one color, the bean lines can be curved or varied in a number of ways.

 Pay attention to *direction:* What are you doing with the beans? They can be placed on their sides or their "edges" (especially the black-eyed peas). Take advantage of all the different ways each one can look. Squeeze the thick white vinyl glue onto each small area as you work. The glue should form a "cushion" that will hold the beans and peas. The glue will dry clear. You may find it helpful to use a toothpick to prod the beans and peas into place as you work.

4. After you have worked for a while, review your original design. Is it too fussy? Is there some way to simplify your design even more? A way that will let you do more design work with the beans and peas? That *is* the project, after all! If you find yourself just heaping split peas onto a glued area to cover it quickly, perhaps it's time to take a break . . . or time to make some soup.

5. As you get close to the end of your Bean Mosaic, consider finishing it with a narrow border design in beans. This will serve visually as a "frame" for the project. After you have finished, let the project dry for a day or two.

6. *If you want your mosaic to look shiny,* there are two ways to go about it: 1) Thin white vinyl glue: Mix white vinyl glue with a little water until it looks like milk or thin cream. Gently brush it onto the mosaic with a small watercolor brush. It will look cloudy, but it will dry clear. Rinse the brush carefully, or the dried glue

will ruin it. (Glossy acrylic medium will give the same effect.)

2) Glossy plastic spray: **Always go outside to use any spray, following the label directions carefully.** Put newspaper under your work area before you spray.

Variations:

● Work a little bigger. Foam board has a finished look to it, and you can use your utility knife to cut it to any shape or proportion that you want. Plan several designs for a same-sized series of Bean Mosaics, but keep them simple. Here are some ideas: striped patterns; fruit (whole or sliced open); leaves; or designs inspired by The Circle in the Square. Whatever you do, keep the beautiful natural colors of the beans and peas in mind as you plan your mosaics.

● Use dried pasta in your mosaic work. Take advantage of the varied shapes available.

● For the ultimate mosaic challenge, do an entire Bean Mosaic in only one kind of bean! This will really test your mastery of pattern and direction.

Display:

Be warned: Whoever sees this project will say, "Oh, we did this in elementary school, too!" People won't be so impressed with it as you might want them to be—no matter how well it comes out. Still, it's yours. This small mosaic is good to display in the kitchen. Prop it in the kitchen window, and admire it yourself.

TORN-PAPER COLLAGE

Have you ever noticed how often we use old "sayings" in our conversation, even when we are trying to express our deepest feelings? This isn't as unoriginal as it may seem. These expressions can instantly communicate a situation or feeling, and in a very visual way.

The "sayings" we so often use can bring snapshotlike pictures to our minds. For instance, if you say that someone is a "butterfingers," can't you just "see" it? Or if someone else is "green with envy?"

This collage project starts with that cartoonlike mental image of a "saying." Your task, should you choose to accept it,

Fadeless art paper creates a beautiful effect in torn-edge collage work.

will be to find the simplest way to communicate a chosen "saying"—nonverbally. No words allowed.

You will be communicating the actual wording of the saying and not the spirit of it. For example, if you select "kick the bucket," you won't show a tombstone or a tasteful wreath. There will be a bucket there somewhere. This is not a subtle project.

And don't get lured into trying to "spell it out" charades-style. Just go with your first mental image, simplify it as much as you can, then think of the most beautiful way to "say" it—with torn-paper collage.

Why use torn paper? There are two reasons. First, torn paper will force you to be bold and clear in your design. If you decide to illustrate "egghead," you won't be as apt to put in every separate eyelash and strand of hair with torn paper. You'll work instead on the "big picture."

The other reason for using torn paper is the best one: The torn edge can be very beautiful in collage work, and most of us don't think to use it enough. We think of it as inferior to a cut edge—cruder, more babyish.

But the opposite is often true. It's not crude, it's expressive. And as you'll discover, it takes great skill to tear a specific shape.

And it's not babyish. The torn edge comes closest to many natural "edges" we see as we look around us—such as clouds, trees, shadows, and mountains. Furthermore, some papers such as Fadeless art paper give us a "bonus" when we tear them: a ragged white edge emerges that looks terrific when placed against another color.

There are hundreds of "sayings" to choose from. Think about some of them, and select one that appeals to you—for whatever reason.

Many "sayings" refer to our bodies. Here are a few to consider:

Pea brain	Get cold feet
All ears	At one's fingertips
Two faced	Foot in one's mouth
Hand in hand	Heart of gold
Apple of one's eye	In the palm of one's hand
Win hands down	Cold shoulder

Other "sayings" are inspired by animals or other living creatures:

Free as a bird	Happy as a lark (or a clam)
Smell a rat	Bookworm
Raining cats and dogs	Horse sense
Blind as a bat	Crocodile tears
Birds of a feather	Eat crow
Snake in the grass	Road hog

Some of our "sayings" come from the world around us:

Up the creek	Out on a limb
Cool as a cucumber	Break the ice
Stick in the mud	Straw in the wind
On cloud nine	Like pie in the sky
Beat around the bush	Down-to-earth
Up a tree	On top of the world

Many sayings (such as "He was all ears") refer to our bodies. This collage uses Fadeless art paper and spray adhesive.

And then there are "sayings" that just sound funny—or sound like they could *look* funny:

On pins and needles	Fat chance
Son of a gun	Trial balloon
Small fry	Bottom dollar
Hem and haw	Make ends meet

Materials:
Choose one of the following for your base:

- White cold-press illustration board (cut or have cut to an easy-to-frame size before you begin)
- Bristol board
- Poster board
- Good white drawing paper

- Construction paper (black is a good choice for this project)

Choose an easy-to-frame size for your base: 9″ × 12″; 11″ × 14″; 12″ × 16″.

Use any or all of the following on your collage:

- Fadeless art paper
- Construction paper
- Tissue paper (won't show up well on dark backgrounds, though)
- Foil
- Slick magazine paper
- Newspaper

Choose one of the following for your adhesive:

- Spray adhesive (You will not be able to see the adhesive on the back of your piece; touch the piece lightly to see if it feels sticky.)
- "Yes" paste and a small brush
- Rubber cement (use with adequate ventilation)
- White vinyl glue (White vinyl glue will be more apt to cause your collage papers to wrinkle and your base to curve.)

For cutting:

- Scissors or utility knife (for trimming only)

Time:

This project takes about one hour.

Instructions:

1. Choose the "saying" to illustrate using only torn-paper collage. The saying that you select will be one that brings a vivid picture to your mind. Remember that one simple picture.

2. Prepare your base: Begin with an easy-to-frame size in case you end up loving this project. Black makes an

excellent background for this activity. If you want to cover a sturdy base such as foam board or illustration board with black paper before you begin, use spray adhesive. It's fast, and there won't be any lumps or wrinkles on your base. Here are some black papers you can use: Fadeless art paper; construction paper; or Canson Mi Teintes pastel paper. Cut a bigger piece than your base, adhere it, then trim it before continuing.

3. Begin to plan your collage. *Do not glue anything down yet.*

 Keeping everything simple and clear is the hardest part of the project. For example: If you choose "green thumb," do you really need flowers and seeds in your collage? If you select "up a tree," do you need clouds and the sun? If you decide to illustrate "road hog," do you need to include trucks and a billboard? Probably not. Focus on the main point of each "saying" and not the other things that pop into your head when you hear it.

4. Before you glue anything down, please read the following:

A word about the art:

- Work in layers, not in puzzle pieces. Think before you glue.

- Avoid the tendency to start with the flashiest part; you will need to adhere the background or larger torn shapes first.

- Do not draw the shape you want to tear and then try to tear along your pencil lines. If you need a pattern, sketch the shape on a piece of scrap paper and then follow its contours with your eyes as you tear. You can control the torn edge to a large extent, but it won't look like a cut edge. It shouldn't.

- *Tear very slowly;* use your fingertips.

- If you decide to include a complex shape such as an animal, assemble it in pieces. It will be easier to tell what it is, and it will be more interesting to look at. If you are making a hand, begin with the basic palm shape and then add the fingers, perhaps joint by joint. If you are making a tree, start with the trunk. Then add the

large boughs; finish with a few smaller branches. If you are making an animal, begin with the basic body shape and then "grow" out from the larger shapes (the neck, the haunches) to the smaller ones.

- The only perfectly straight lines on your collage will be the edges of your base; extend the torn collage pieces off them as you work. You will trim them later. Those straight edges are an important part of your design— the contrast between the straight lines and the torn edges will add to the beauty of your collage. If, instead, you "float" the torn edges right next to the straight edges, the viewer's attention will waste itself in wondering what is going on there.

- Take advantage of the torn edges. You may want to exaggerate or highlight them with an additional lighter, darker, or brighter torn border.

5. *As you work;* remember that *contrast* will make your collage more interesting to look at. In this Torn-Paper Collage you can show contrast with color, value (light and dark), pattern, texture, and torn/straight edges.

 If you use magazine paper in your collage, use it only as a collage material. Do not tear out a picture of a tree from a magazine; create your own tree using torn papers.

 Keep the newspaper under your gluing area clean—that way you won't get glue spots on your collage surface.

 If you are using spray adhesive, work outside, and remember to spray only the backs of your small collage pieces. Do not spray the base—spray adhesive does not dry. (You will not be able to see the adhesive on the back of your piece; touch the piece lightly to see if it feels sticky.)

 Do not just dab your glue onto the collage pieces. Do a thorough and careful job of gluing down each piece.

 Turn your collage as you work. Look at it from different angles. Put it upright, and look at it from across the room. Stop work every so often and consider: Is your collage pleasing to you? Is the "saying" still clear, or have you gotten sidetracked with unnecessary details?

6. When you have finished gluing, turn your collage over and trim away the excess paper from the straight edges of the base. There should be plenty to trim. **If you are using a utility knife for this, place the collage face down on a thick pad of newspaper before you cut, otherwise you will damage your table or counter. Be very careful when you use a utility knife.**

7. Write the "saying" on the back of your collage, then try it out on your family!

Variations:

- Combine glued fabric appliqué with torn paper for your next "sayings" collage. Cut the fabric, but consciously use those cut edges as visual contrast to your torn paper edges.

- Experiment with different collage papers. How many papers can you use in this project? Can you find papers that you never before thought of using in an art project? How about sandpaper, paper towels, doilies, or aluminum foil? Look for special papers you can buy in art stores one sheet at a time: rice paper; marbled paper; metallic paper; Canson Mi Teintes pastel paper; and velour paper.

- Experiment more with the torn edge. Refine it. Exaggerate it. "Outline" it with another torn edge.

- Create several Torn-Paper Collages to hang together. The series could have a unifying "sayings" theme.

- Make a set of small "sayings" collages, and use them as post cards or notecards. Print the "saying" in small letters on the back of each post card or notecard. If you decide to make a set of notecards, scrounge or buy the envelopes first, then cut the notecards to fit them before beginning your collage work. Spray adhesive will work best on post cards or notecards. Bristol board is a good base for post cards. Good white drawing paper or light Canson Mi Teintes pastel paper is a good base for notecards.

Display:

This collage is both colorful and funny, so you may want to display it for a while. If you hang it in the kitchen, it should

You can create a composite Collage Portrait from magazine pictures or photographs.

be covered with glass or plastic. A lucite box frame is good for this project. If you did the project on a stiff base such as foam board or illustration board, you can just prop the finished collage on a shelf.

COLLAGE PORTRAIT

One of the hardest things for a reemerging artist to do is to make a composition look just "like" something, especially if the artist is drawing or painting a person. We scan the attempted image, looking for the "likeness." We say, "I think I got the mouth right, but not the eyes. . . ."

A portrait doesn't have to be exactly "like" its subject. In fact, if you think about it, how could it be? How could marks on paper or dabs on canvas be "like" a human being, a tree, a landscape? If you want an exact image, buy a camera. Or a mirror.

Still, it's a challenge to try to "capture" something of another person—or yourself—with art. Not a mirror image, but something else. Something more.

This next activity provides an amusing way of doing this. The project is a type of collage known as "montage," which in this case means that it uses magazine pictures to create the composition. The result is a surreal portrait that may well be a closer "likeness" to your subject than you could otherwise create. You may want to start with a self-portrait, though, so that there will be no hard feelings!

Materials:
 Choose one of the following for your base:

- Foam board

- Illustration board

- Poster board

Work in a small, easy-to-frame size such as 5" × 7" or 8" × 10"
Use any or all of the following in your collage:

- Magazines (Use whatever you have saved. Start looking for good collage magazines at yard sales and library sales. *Arizona Highways* is the best magazine for big landscape backgrounds. *Life* is a good choice for big bodies and head shapes. Many other magazines, ads

included, are a good source for individual facial features and assorted other body parts.)

- Fadeless art paper, bright construction paper, other paper (for background)

Other materials:

- Spray adhesive; (best for this project) or "Yes" paste and a small brush

- Utility knife or X-acto knife; good scissors; manicure scissors

Time:

Allow an hour and a half to two hours for this project. Finding the ideal magazine pictures to cannibalize for your portrait may take longer than you think.

Instructions:

1. Prepare your 5" × 7" or 8" × 10" base. It can be larger, of course, but these sizes are closer to the sizes of most of the magazines you will be using. In addition, working small will encourage you to combine and overlap more montage pieces.

 If you want a big landscape background for your portrait, select an uncomplicated picture that is slightly larger than your base and has no lettering on it. Mount the landscape background onto your base with spray adhesive. **Always go outdoors to use spray adhesive, and read the label carefully.** Then turn the base face down on a pad of newspaper and use your utility knife to trim away the excess paper from the edges of the base. (You can also use scissors for this.)

 If you want a colored background for your portrait, choose one or two colors of Fadeless art paper or construction paper. Cut or tear them to cover your base, remembering that they should be slightly larger than the base. Trim off the excess paper later. Keep your background design very simple.

2. *This step is an important one,* and it will determine how easily the rest of the project goes. You will select the main and biggest collage piece for your portrait. This could be a large head, a head-and-shoulders collage piece, or an entire body. *It will probably not look*

at all like the subject, and you will glue lots of other things onto it before you are done, but take some time to select this piece. Your collage will look stronger if you have this biggest collage piece extend past the edge of your base. If the shape teeters right next to the edge, the viewer's eye will be drawn there needlessly.

Cut out your largest shape in as much detail as you can, using manicure scissors if necessary. *Detail is what makes this project work.* Spray adhesive will flawlessly adhere even the laciest cut pieces.

Cut out detailed interior shapes using a utility knife or an X-acto knife and working on a thick pad of newspaper or an old magazine.

3. Select the smaller photos for your collage portrait. Thumb through your magazine pile, and rip out big or small pictures that catch your eye; you will do your careful trimming later.

Try to keep lettering out of this project. Commercial lettering can be a wonderful collage element, but save it for another activity. Keep the following in mind as you search:

- Don't start searching with a preconceived idea of how you want the finished collage to look.

- Don't worry too much about scale (relative size); you can use big eyes, tiny ears, and a huge mouth together.

- Don't search with a specific feature in mind. This is a fast instinctive hunt, not a logical one.

- Don't get too caught up in hairstyles and eyelashes; concentrate instead on basic features.

- Don't be afraid to combine color pictures with black and white pictures.

- Don't glue anything down yet; wait until you have an assortment to choose from.

4. *When you have a pile of rough pictures to choose from,* go through the pictures one at a time. Select the ones that you want for your collage. If you don't know where to begin, start with the eyes. (They don't even need to match!) Carefully cut out the features one at a time, and arrange them on your base. Don't glue anything down until you have experimented with several ar-

rangements and compositions. Do this part instinctively, too. Maybe your portrait will have "eyes in the back of its head" or be "all thumbs!" Don't be afraid to overlap the different collage pieces.

You can include various clothes, accessories, and props as part of your portrait. Don't try to be too realistic, though. Keep a strong element of fantasy going in your composition. Decide on the final arrangement of features, body parts, clothes, accessories, and props that will somehow make this a portrait.

If it isn't "like" anyone you know but you love it anyway, change the name of the project!

5. Carefully cut out the collage pieces.

If you are using spray adhesive, take the pieces outside and put them face down and close together on a clean sheet of newspaper. Spray the collage pieces lightly with the adhesive; you will not be able to see the adhesive. Touch the pieces lightly to see if they are sticky, then take them inside to position them on the base. Spray adhesive is easiest to use for this project.

If you are using "Yes" paste, put some of the "Yes" paste on a piece of aluminum foil. Using your small brush, thin the paste slightly with water. Place one collage piece at a time face down on a clean sheet of newspaper and brush the paste on evenly. Do not just dab the paste on—you want each collage piece to lie perfectly flat and smooth. Keep the newspaper clean under your gluing area.

6. Take a few minutes to look at your nearly finished Collage Portrait. Is there anything more that it needs? You may want to add a final three-dimensional flourish such as an artificial flower, some buttons, or a small piece of costume jewelry. You may want to add a narrow border of colored paper, ribbon, or other fabric trim. If you are adding something heavy or bulky, you will need to change adhesives. Use thick white vinyl glue or a hot-glue gun to attach these final collage items. **Always be careful when you use your hot-glue gun.**

Variations:

- Create your own mythological creature—bird or animal—from various magazine pictures. Try combining these with pictures of people. *Ranger Rick, My Big*

Combine magazine pictures to make your own mythological collage creature.

Backyard, and *National Geographic* all are good sources for nature pictures.

- Fashion your own fantasy landscape. Why not have icebergs gliding across the desert? Why not have orchids blooming underwater? Why not have tropical fish cruising in outer space? Just make it look as "real" as you can by means of your careful cutting and clever overlapping. *Arizona Highways* has the best big landscape pictures for you to begin with.

- Try making a small portrait using only black-and-white magazine pictures. You could mount them on a black or brightly colored background. You might add just one piece of color to the collage: glistening red lips, a big pink nose, or a giant green eye.

- Consider adding some printed lettering to a collage. Look at the lettering (or at individual letters) as design. Use them as carefully and cut them out as carefully as you would any other collage piece. *Don't let the message of the lettering take over* your art—you are the boss.

- Think about cutting your original primary human shape from a pattern placed on a nonhuman background. For example, a head could be cut from a cloudy sky, a head-and-shoulders piece could be cut from an ocean, or an entire body could be cut from a field of wildflowers. Then add the rest of the features to this base.

Use varied magazine pictures or photographs to create surreal landscape Post Cards.

- Do one self-portrait every year. Date them, and keep them in your journal or portfolio.

Display:

This small collage is easy to frame and display. If you have added any final three-dimensional pieces to the collage, you will need a frame with a space between the glass or plastic and the collage surface.

Printmaking and Painting

Rubber Stamps: One-of-a-Kind Picture or Post Cards

Even if you buy the most wonderful rubber stamp in the world, how many times do you actually use it? There it sits in your desk drawer, making you feel guilty.

But there are several ways to get a lot of art use from your rubber stamps, as the following projects show. They also give you a good excuse to add to your collection.

Materials:
Choose one of the following for your base:

- Bristol board
- Poster board

Other materials:

- Spray adhesive
- Fadeless art paper; tissue paper; construction paper (bright or light colors)
- Utility knife or good scissors

This One-of-a-Kind Picture was created from a house stamp (© 1987 by Personal Stamp Exchange), and moon, tree, and star stamps carved from an art-gum eraser.

- Rubber stamps
- Black ink stamp pad

Time:

A small One-of-a-Kind Picture will take about one half hour. A set of Post Cards will take an hour or more to complete.

Instructions:

1. You will probably wish to cover your base with colored paper. Use bright or light colors, or your stamped image won't show up on the base. Spray adhesive will quickly and flawlessly attach the colored papers to the base. **Always use spray adhesive outside, and read the label carefully.**

 If you are covering just one small base, cut the colored paper slightly larger than the base, adhere it, then trim away the excess paper from the edges.

 If you are going to make a set of post cards, cover a big piece of Bristol board or poster board with the colored papers, and *then* cut the base into post cards (standard post cards are 3½″ × 5½″). *Don't be afraid to mount different colors or combine different papers on your base.*

2. Practice stamping the image on a piece of scrap paper. Experiment: Even using only a black ink stamp pad and one rubber stamp, the stamped image can look very different. It can be dark. It can be very faint. The images can overlap. The image can be stamped going off the edges of your base. *The main point of the Rubber Stamp project is that the image can be repeated.* Take advantage of this; consider planning a design that

will repeat the image. It might be a school of fish, a herd of sheep, a bouquet of flowers, or a cluster of trees.

As you practice stamping your image, consider symmetry and asymmetry. Many reemerging artists tend to polka-dot their images evenly and symmetrically as they work; this isn't always the most interesting kind of composition to look at. Even if you like your work to look this way, don't do it without thinking. If you decide to print a *symmetrical* composition (one that is the same on either side), do it consciously and carefully. Experiment with asymmetry, though. An *asymmetrical* composition is not the same on each side—the balance is uneven. Asymmetry is often unexpected and can be a source of drama in a composition. If you have difficulty creating asymmetrical composi-

Top: This bee stamp (© 1985 by Hero Arts Rubber Stamps) is used to create a repeat, asymmetrical design for a Post Card.
Bottom: This house stamp (© 1987 by PSX Rubber Stamps) is used to create a symmetrical border design for a Post Card.

tions, try exaggerating the asymmetry; for example, use empty space to balance the weight of your stamped images.

As you practice your stamping, concentrate on what is called the "figure/ground" relationship of the design and the base itself. This means that you will pay attention not only to the stamped images but to the entire base—to the spaces between the images and around them, too, all the way out to the edges. *Spend some time now learning to see your base this way;* developing a sense for figure/ground relationships will help you with every two-dimensional project you'll do.

Your base is *not* like a sheet of notebook paper—it is not just something to fill up, with the margins and the spaces between the lines serving only to make the message clearer. In art, the *whole paper* is the message—the empty spots ("negative space"), too. Every scrap of space is important to your composition; pay special attention to the empty spaces as you proceed. Make them work for you.

Remember that repetition can work for you, too. Repetition doesn't have to be boring—it can be a very strong design element. Repetition can also provide an element of humor or surprise. For example: The school of fish you stamped earlier could include a solitary fish swimming upside down or in the wrong direction; the herd of sheep could be stamped gray, and one black sheep could stand out; one flower could float away from the bouquet; or a single tree could remain standing in an otherwise devastated forest.

3. Stamp-print your Picture or Post Cards. Keep a piece of scrap paper nearby. Use it for test stamping or for getting your stamped image just faded enough.

Variations:

- Stamp borders for your Post Cards, leaving the centers blank for a written message or a small trimmed and mounted photograph. Mount the photograph with spray adhesive or "Yes" paste.

- Select two rubber stamps that you haven't used together before. Think of a composition. They could be used together in a formal pattern. They could be overlapped faint over dark. They could be combined in

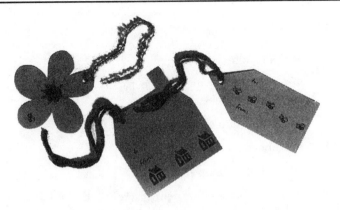

These Gift Tags are made with rubber stamps, marker, and (for the interior of the flower) Fadeless art paper on Bristol board. (Bee stamp © 1985 by Hero Arts Rubber Stamps; house stamp © 1987 by Personal Stamp Exchange.)

some startling way: a bunch of cats and one bird; a housing development with a heart popping up from one chimney; a solitary tortoise with a dozen musical notes rising above her.

● Go back to one favorite stamp, and print it in different ways in your composition. For instance, you could design a pattern where you print the image sideways or upside down.

Display:

If you have made a One-of-a-Kind Picture in an odd size, it can still be easily framed and displayed. Cut a second base in a small, easy-to-frame size such as 5" × 7". Cover it with black or brightly colored paper. Use spray adhesive (outdoors) for this. Mount the stamped picture onto the second base with spray adhesive or "Yes" paste.

Rubber Stamps: Gift Tags

This next activity is essentially the same as the previous rubber stamp project. There are two differences, though: The base is less likely to be the traditional pictorial rectangle; and the stamped image is more likely to be a simple, formal stamped design. So in some ways it's a harder project, and in some ways it's easier. Sets of these stamped Gift Tags make good small gifts or fund-raiser offerings.

Materials:

Choose one of the following for your base:

● Bristol board
● Poster board

Other materials:

- Spray adhesive
- Fadeless art paper; tissue paper; construction paper (bright or light colors)
- Utility knife or good scissors
- Rubber stamps
- Black ink stamp pad
- Skinny black permanent marker such as Pilot or Tombow
- Pencil
- Art-gum eraser or kneaded eraser
- Yarn

Time:

This project will take an hour or longer, depending upon how complicated your base is—its size, shape, and initial covering.

If you work assembly-line style, you can make lots of Gift Tags in the same session.

Instructions:

1. You will probably want to cover your base with colored paper. Use bright or light colors, or your stamped image won't show up on the base. Spray adhesive will quickly and flawlessly attach the colored papers to the base. **Always go outside to use spray adhesive, and read the label carefully.** Cover a large section of your base material and *then* cut it into smaller pieces. Don't be afraid to mount different colors or combine different papers on your base. These can even be combined randomly; they don't have be in any "logical" arrangement under your stamped images.

2. Cut your base material into the desired Gift Tag shapes. You could cut small, same-sized sets of tags that are round, or whose ends are notched banner-style, or that are cut in unusual shapes or proportions. They needn't look just like store-bought tags.

You could cut larger, one-of-a-kind shapes such as a cottage shape for a housewarming gift, a wine bottle shape for a dinner party, a suitcase or airplane shape for a bon voyage gift, an umbrella shape for a shower gift, or a huge flower shape for a birthday present. These big tags can be stamped with a "logical" image (bees on the flower, for instance) or any image stamped as a pattern (hearts on the suitcase).

If you have covered your base with colored paper, draw faint pencil guidelines for your Gift Tag shapes on the back of the base and not on the colored paper. Erase the pencil guidelines with an art-gum eraser or a kneaded eraser.

3. Practice stamping the image on a piece of scrap paper. Experiment.

4. Stamp-print your Gift Tags. Remember to look at the entire shape of each tag—even the empty spaces—as you work.

5. Use your skinny black permanent marker to write any words or message on your Gift Tags. If you draw faint pencil guidelines first, make sure that you let the marker ink dry thoroughly before you try to erase the guidelines. Gently erase them with your art-gum eraser or kneaded eraser.

6. To finish your Gift Tags, use your single-hole punch to punch a hole in the corner of each tag. Don't punch the hole too close to the edge, or it will tear the tag. Cut a 6″ length or yarn for each tag. Loop the yarn over your finger. Poke the loop through the hole, then pull the loose yarn ends through the loop.

Here are some Gift Tag shapes for a rubber-stamp project.
Top: banner shape
Center: heart shape
Bottom: bookworm shape

Variations:

● Combine your stamped images with the materials and methods you have learned about in previous projects. These could include: Stickers (page 22); Fabric Appliqué (page 29); and Torn-Paper Collage (page 39).

Storage:

Keep your Gift Tag sets in clear small plastic bags. That way you'll remember what you've made!

Fruit and Vegetable Prints

Here is another stamp printing project—but this one uses fruits and vegetables to create the stamped image. You will use these beautiful natural designs to decorate a plain T-shirt, apron, or tea towel; the finished project will be brightly colored.

This is a good activity to do with a friend. The finished projects make good gifts or fund-raiser offerings.

Materials:

- Heat-set fabric dyes (Choose a brand such as Peintex Fabric Dyes from Sennelier, available at an art supply store or through a catalog.) *Be sure to get dyes that can be heat-set by ironing.* You will need only a small quantity of one or two colors.

- Plain white T-shirt, apron, or tea towel (These can also be any light solid color if your dye color is dark. Remember that the dyes are transparent and won't show up against a dark background. If your T-shirt, apron, or tea towel is brand-new and stiff with sizing, wash and dry it once before you print.)

- Plain light fabric scrap (such as muslin) for test printing

- Paper towels or old washcloth for stamp pad

- Iron

- Small watercolor brush for painted details (optional)

Choose any of the following for printing:

- Fruits: apples (including tiny crab apples); citrus (all sizes: squeeze slightly and let dry out before printing)

- Vegetables: artichokes; carrots; celery; green peppers; mushrooms; potatoes (may be cut into varied shapes)

Experiment with other fruits and vegetables; print whatever works.

Time:

This activity takes about one hour. It will take longer if you decide to print several projects in the same session or if your stamped pattern is especially complex.

Instructions:

1. Decide what fruits or vegetables you'd like to use for this activity. You will need only one or two of any that you select; you'll get lots of prints from each one.

2. Decide what you want to print the fruits or vegetables on—a T-shirt, apron, or tea towel. Select any plain white or light fabric. Wash and dry it if necessary.

3. *Take time now to experiment* with printing your fruits and vegetables. Do this on a plain light fabric scrap.

 You will need to slice the fruit or vegetable flat to print it, but you will discover that there is more than just one way to slice and print each fruit or vegetable. It can be cut vertically—from top to bottom. It can be sliced horizontally—across the middle. Some, apples for example, can be cut into sections.

 To make your own dye stamp pad for this project, fold and slightly dampen several paper towels with water. Put the pad on a plate or a piece of aluminum foil. You can also use an old washcloth for this. Dampen the towels or cloth slightly with water. Brush the dye onto the surface of your stamp pad.

A word about the dyes:

You might not be able to distinguish one color from another until the dyes have been heat-set. If you use more than one color, you will need to label each pad so you won't mix them up. When you use the dye full strength, the dye color will be at its strongest. If you dilute the dye with water, you will get a tint of the dye. For example:

Red + water = pink
Blue + water = baby blue

Experiment to get the intensity or tint that you want. The water you use to dampen your dye stamp pad is intended to help the dye spread evenly onto the pad. If it dilutes the dye color too much, brush the dye directly onto a dry pad of paper towels instead or directly onto the fruit or vegetable. Experiment, too, with brush-painting the dye directly onto the fabric. Use a watercolor brush for this.

4. Now heat-set your practice stamped images with an iron. To do this, follow the instructions that come with the dyes. Put a paper towel over your stamped images as you iron.

Always take time to experiment before printing the actual item. These cauliflower prints are made with Peintex Fabric Dye (from Sennelier), printed on muslin, then heat-set with an iron.

Now that you have a better idea of the process, you are ready to stamp your design on the T-shirt, apron, or tea towel.

5. If you are printing on a T-shirt or other article of clothing, put paper towels or a piece of newspaper between the layers of clothing before you begin; otherwise, the dye may seep through the layers as you work.

A word about the art:

Restrain yourself! You don't need to pattern the entire surface. You needn't print every single fruit or vegetable on each project, either; you don't want it to look like an all-you-can-eat buffet. You could print linked green pepper rings across the back of a T-shirt. It's the veggie Olympics! You could stamp three mushrooms along the top of an apron. You could print an apple in one corner of a tea towel.

On the other hand, let yourself go! The T-shirt has two sides, two sleeves, a neckline, and shirttails. Any or all of these areas can be stamp-printed. *Remember that the T-shirt is a three-dimensional object* when someone is wearing it! Plan accordingly. The apron has a narrow top and wide bottom. Sometimes there is a pocket that can be printed, too. The tea towel has a center, a border, and four corners that can be printed. Whatever you print on, consider its shape your base and use all the space well—whether you print it or leave it blank.

When you've thought through your design, stamp-print your images onto the fabric.

6. Add some hand-painted details to the stamped images if you want to. Use a watercolor brush for this.

7. Heat-set the dye with an iron. To do this, follow the instructions that come with the dyes. Put a paper towel over your stamped images as you iron.

8. If you think it's necessary, add to your heat-set composition: Go back and stamp or hand-paint additional designs onto the fabric, and then heat-set them with your iron.

Variations:

● Brush two colors next to each other on the damp dye stamp pad, or swirl them together. Moistening the pad

with water first will help the colors blend together softly. The trick is to choose colors that will look good when blended together. Select colors that are close to each other on the color wheel (related colors). Here are some suggestions:

Red + blue
Blue + yellow
Yellow + red
Orange + yellow
Violet + blue
Green + yellow

Do not try to "paint" a specific design or picture onto the pad; just stamp-print the blended or swirled colors.

● Colors across from each other on the color wheel look good together, too. These complementary colors are best to stamp separately or hand-paint, however. Here are some complementary colors:

Red + green
Blue + orange
Yellow + violet

● Remember that the point of stamp printing is to take advantage of the repeat image. You can repeat the image in different ways, however, to add to the complexity of your composition. If you are printing with an apple, for instance, you could slice it vertically and print it that way. You could then stamp-print tiny seed shapes in the sliced apple image: use a pencil eraser for this if you like round seeds. You could also hand-paint the apple seeds or paint in leaves. You could combine the vertical image with a horizontal one—the pattern looks different when the apple is sliced this way. You could also print a small vertical section of the apple, or try alternating it with one of the bigger images. You could print a tiny crab apple image with a larger apple. You could turn any of these apple shapes as you work;

● Don't be afraid to "crop" the stamped image. Try stamping it going off the edge of your fabric or poking up from underneath a pocket. Just put paper towels or newspaper over the area you don't want the dye to touch, then stamp the image. For example, green pepper rings could encircle a collar or shirttails. A trail of

The "apple" of this stamp-print image is created from a sliced apple; the leaf from a carved potato; and the seeds from a carved art-gum eraser. The stem is hand-drawn.

These frilly rings are created from a sliced green pepper, and are printed with Peintex Fabric Dye (from Sennelier) on muslin, then heat-set with an iron.

mushrooms could creep down and off a sleeve. An artichoke could peek out from behind an apron pocket.

- Try printing with a *simple* rubber stamp, using this heat-set dye method. You may need to paint the dye directly onto the rubber stamp to get the clearest stamped image. Use a watercolor brush for this, but don't load it too full. Stamp it on scrap paper to get rid of any excess dye, then stamp-print the rubber stamp. Experiment.

- Try printing with soft leaves. When you are printing with something that isn't flat enough to provide an easy-to-print surface, the following steps will make it easier:

 1. Brush the dye directly onto the leaf or other surface you want to print.

 2. Press the fabric down onto the damp printing surface. That way you will pick up the surface details better.

 3. Experiment with scrap fabric to familiarize yourself with this way of printing.

 Neither of the following two variations is a heat-set dye project, but each uses materials and methods you are familiar with by now. The final variation is trickier but can create an intriguing image.

- Stamp-print fruit or vegetable images onto unwaxed white or colored tissue paper. (Squeezed and dried citrus prints make especially beautiful lacy images.)

 You will use food coloring for this activity. Squeeze the food coloring onto a damp paper towel pad. Keep clean newspaper underneath each sheet of tissue as you work. Practice-stamp the image onto newspaper *before* each tissue stamp; otherwise, the stamped image will probably look blurred. You want to print a clear and detailed image each time.

 You can use the printed tissue plain, or you can mount it onto aluminum foil for a sturdier gift wrap. Use spray adhesive for this, but **always go outside to use spray adhesive, and read the label carefully.**

- Stamp-print the images onto colored unwaxed tissue paper using a bleach stamp pad.

You will use bleach for this activity. Pour a little liquid bleach onto a damp fabric scrap to make your pad. **Be careful when you use bleach.** Do not do this around children, do not inhale the bleach fumes, and keep the bleach away from your fingers. Keep clean newspaper underneath each sheet of tissue as you work. Practice-stamp each image to remove excess bleach; this way you will keep your stamped image crisp. The bleach will remove the color from *most* colors of good-quality tissue. It will also remove the color from your clothes, though, so be careful not to splash as you work.

PULLED-STRING PAINTING

Here is a failure-proof way to recapture the fun of "messing around" with paint. This project can be as simple or as complex as you want to make it. Start simple!

Materials:
Decide whether you want a symmetrical or asymmetrical painting. "Symmetrical" means that it will look the same on both sides. You could use a flexible base for either a symmetrical or an asymmetric composition. You can mount a flexible painting onto a stiff base when you are done.

For a symmetrical painting:
You will need a *flexible* (foldable) base of one of the following materials in an easy-to-frame size such as 9″ × 12″, 11″ × 14″, or 12″ × 16″:

- Good white drawing paper
- Fadeless art paper
- Bright or dark construction paper
- Canson Mi Teintes pastel paper

For an asymmetrical painting:
You will need a *stiff* base of one of the following materials in an easy-to-frame size:

- Foam board
- Illustration board
- Mat board (comes in many colors)

Try printing with soft leaves. Peintex Fabric Dye (from Sennelier) is brushed onto the ribbed side of a fig leaf (top) and a rosemary sprig (bottom). Then prints are made on muslin and heat-set with an iron.

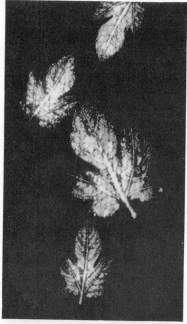

Bleach can be used as a dye for stamp printing. An old brush is used to apply bleach to the ribbed side of a fig leaf (top) and a rosemary sprig (bottom). The prints are made on colored, unwaxed tissue paper and then heat-set with an iron.

For flexible or stiff paintings:

- Newspaper or newsprint

- Optional: Fadeless art paper or black construction paper for contrast backing to paintings on paper (backing must be larger than painting)

- Tempera paint (You will need only a small amount of whatever color or colors you choose.) Don't forget black or white as "color" choices. If you mix your paint from dry tempera, mix it thick. Liquid tempera colors usually look more vivid.

- Cake pan, pie plate, or other shallow container.

- An assortment of string, yarn, sturdy thread

- *NOTE: If you want to use acrylic paints for this project,* thin the acrylics slightly with water. Work on a light-colored base or mix the more transparent acrylic colors with an opaque color so the paint will cover a darker base. Cover your paint, when not using, with aluminum foil to keep a "skin" from forming on top.

Time:

Allow an hour to an hour and a half for this project.

Instructions:

1. Cover your work surface with newspaper. For a symmetrical composition, fold your flexible base crisply in half, then unfold it. You will work on one side of the fold. For an asymmetrical composition, you will work on the entire base. Since that base will remain unfolded, it can be stiff.

2. Pour a little medium-thick tempera paint into your shallow container. Choose a paint color or colors that will look good with your base color. Tempera paint is opaque, so you can use light paint colors on a dark base and they will still show up. Select 18"–24" pieces of string, yarn, or sturdy thread to use in this activity.

3. *Experiment with the following technique* before you try it on your final base. Use newspaper or newsprint while you are practicing. Experiment both with a folded and

unfolded practice base. No matter how many layers you build up, you will dip, press, and pull the strings one at a time.

Holding onto one end of the string, dip the rest of the string thoroughly into the medium-thick paint. *Squeeze out much of the paint from the string.* This will give you a much more interesting look when you pull the string. Quickly rinse the paint from your fingers. Arrange the damp string in a serpentine pattern on your base, leaving the clean "tail" of the string poking over the edge of the base.

If you are using a folded base, arrange the string close to the center fold. Place a big piece of newspaper or newsprint over the top of the damp yarn, or bend the folded base over the damp yarn. *Press firmly* on the covering newspaper or newsprint with one hand. Grasp the clean string "tail" with your other hand, and pull out the string. *Move your pulling hand around* as the string comes out; this will create a more interesting pattern.

Uncover or unfold your experimental Pulled-String Painting and see what you have.

This symmetrical Pulled-String Painting is made with tempera on folded paper.

- Did you press down hard enough on the covering paper?

- Did you move your pulling hand around enough?

- Does the paint need to be thicker? If it is too thin, it can look meager and weak.

- Will there be enough contrast between the paint color and the final base color?

- Is the pulled design too blurry? You may still have too much paint on the yarn. You should be able to see something of the fiber quality of whatever it was that you pulled.

4. Now you are ready to do the Pulled-String Painting on your final base.

Build up your paint layers one string, yarn, or thread at a time. *Look at the pulled design after each "pull,"* and plan your next paint layer. Since you are using so little paint, you won't have long to wait for the paint to dry between "pulls." Build up the layers; they

Always pay attention to the empty areas on your base; these are part of your painting, too. This symmetrical pulled-string painting is done with white tempera on folded Fadeless art paper.

can be the same color or different colors. Here are some ways to vary the different layers:

- Use different paint colors.
- Use fibers of different widths and textures.
- Pull them in different patterns.
- Pull them in different directions.

Always pay attention to the empty areas on your base; these are part of your painting too.

5. If you did your Pulled-String-Painting on paper and you want to mount it onto a stiffer base such as foam board, do it now. Use spray adhesive for this. **Always go outside to use spray adhesive, and read the label carefully.**

Have your stiff base cut to an easy-to-frame size, just in case you want to mount it. You can mount a contrasting color behind your painting if you want. A vivid color of Fadeless art paper or black construction paper is a good choice for this contrast backing. Use spray adhesive (be sure to work outdoors) to mount the backing to the base.

Variations:

- Save your best newspaper or newsprint covering papers for possible collage use in future projects.
- Build up even more layers on a painting; deliberately overlap your pulled-string designs. Keep the strings well squeezed so that the paint layers look delicate and detailed rather than messy.
- Combine symmetry and asymmetry in one composition.
- Make a set of tiny Pulled-String Paintings. Cut them out and mount them onto post cards or note cards. Use spray adhesive (outdoors) for this; spray the back of each cut-out design and not the post card or note card.
- Make several separate symmetrical Pulled-String Paintings in varied sizes. Cut them out and layer them in a collage. Use spray adhesive (outdoors) for this; spray the back of each collage piece as you work.

- Make one large symmetrical Pulled-String Painting. Work closely against the fold. When you are done, unfold it and look at it until you see a *mask* design. (It won't be any recognizable creature.) If you can see one, cut out the mask design. Mount it onto a stiffer base if you want, using spray adhesive (outdoors).

 Bristol board or *poster board* will provide a stiffer base but can be cut easily to any shape with scissors. A mask mounted on Bristol board or poster board can be curved against your face.

 Foam board or *illustration board* will provide a stiff, nonflexible base. Keep this base rectangular, or cut it to another shape with your utility knife. **Be very careful when you use the utility knife, and keep a thick pad of newspaper underneath your base as you cut.**

This asymmetrical Pulled-String Painting is done with white tempera on black Fadeless art paper, then cut out, then mounted onto a stiffer base.

 A mask mounted on foam board or illustration board can be propped on a counter or framed and hung on a wall.

 Additional details can now be added to your mask. They can be drawn on with watercolor markers, they can be painted on with tempera or acrylic paint, or they can be glued on. If you are attaching anything bulky or heavy to the mask, use a hot-glue gun; otherwise, white vinyl glue will probably work.

 If you look and look but can't see a mask in your Pulled-String Painting, skip this variation!

Display:

 A Pulled-String Painting done on a flexible base will be easy to frame. If you want your painting to have a contrasting color around it, you can either have a mat board "window" cut for it, cut the mat yourself, or mount the painting onto a colored background.

 If you have a mat cut, have the outside dimensions of the new base cut to an easy-to-frame size. Make your new base big enough so that the mat doesn't look skimpy, and back the mat with foam board.

 If you cut the mat yourself (many people find this difficult), follow the previous guidelines and **use your utility knife carefully, always cutting on a thick pad of newspaper to protect your table or counter.**

 Hint: Cut your "window" with the mat board face up on the newspaper pad. People often turn the mat board face down

before they cut, thinking that this is a neater way to work. But mat board is covered with colored paper, and this thin layer often tears when the cut-out "window" is pulled away. Draw your very faint pencil guidelines, cut the "window," then gently erase any leftover pencil marks with an art-gum eraser or a kneaded eraser. Back the mat with foam board.

If you mount the painting onto a colored background (this is the easiest way to get a matted look, and it is much less trouble than cutting "windows"), use a piece of colored mat board or cover your own new foam board or illustration board base with Fadeless art paper, construction paper, aluminum foil, newspaper, or whatever looks good under your painting. Use spray adhesive for this. **Always go outside to use spray adhesive, and read the label carefully.**

Cut the base paper larger than the new base, mount it, then trim off the excess paper. Make sure that your new base is an easy-to-frame size. You can mount any painting shape onto your new base, but make sure that your painting is carefully trimmed before you mount it. Spray the back of your painting with spray adhesive (**outdoors**), carry the painting inside, and position it on the new base.

To display a lightweight three-dimensional Pulled-String Mask, glue (with a hot-glue gun or thick white vinyl glue) two flat-backed picture-hanging hooks onto the back of your mask.

LEAF TINT

This activity might sound unpromising, but often ends up being a surprise favorite. It looks good.

The project uses tempera paint on a black or other dark-colored base. Tempera is an opaque paint—you can't see through it. For this reason it can be used on a dark base. (If you tried to paint on a dark base with transparent paint such as watercolor, the transparent colors just wouldn't show up.)

Any tempera color that you select will be mixed with white tempera to create a tint—what many people call a "pastel." This new color shows up beautifully against a dark base and is a form of stamp printing that creates a dramatic painting.

This Leaf Tint is done in tempera on black Canson Mi Teintes pastel paper, cut out, and mounted with spray adhesive on white drawing paper.

Materials:

Choose one of the following for your base:

● Black or dark Fadeless art paper

● Black or dark construction paper

- Black or dark Canson Mi Teintes pastel paper
- Black or dark mat board

Work in an easy-to-frame size. If your painting is done on paper, it can be mounted onto foam board, illustration board, or any color mat board to make it sturdier. You will need to use spray adhesive (**outside**) for this.
Other materials:

- Tempera paint in white; plus other colors to mix tints
 White + red = pink
 White + blue = baby blue
 White + yellow = pale yellow
 White + brown = tan

- Brush

- Paper towels

- Newspaper or newsprint

- An assortment of soft leaves

Time:
Allow an hour and a half for this project. This doesn't count the time that it will take you to gather the leaves.

Instructions:

1. On the day that you plan to do the project, go for a walk and gather a varied assortment of soft flexible leaves. Select varied shapes and sizes. Wash them off if they are grimy.

2. Prepare your dark base. Work in an easy-to-frame size such as 9″ × 12″, 11″ × 14″, or 12″ × 16″.

3. Mix your tempera tints.
 Keep the paint thick for this project. *Always start with white,* then add only a little color at a time to create your tint. *Limit the number of tints you use on any one painting;* the interest will come from your composition and the leaves themselves and not from color.

4. Practice printing for a while on a dark piece of scrap paper. Brush the thick tempera tint onto a leaf, then

press the leaf onto the dark paper. Press newspaper or newsprint on top of the leaf, and smooth it down hard.

Experiment: Do you like the printed image best if the front of the leaf is stamped, or the back of the leaf? Is the tempera thick enough? Is the tint light enough to show up well on your dark background? Is there too much paint on the leaf? (To remedy this, prestamp the leaf on a piece of scrap paper to remove the excess paint, or apply the paint to the leaf with a drier brush, or wipe some of the thick paint from the brush with a paper towel. Rinse your leaves with water, and pat them dry with paper towels.)

5. Take some time to plan your Leaf Tint composition.

A word about the art:
The leaves that you print will be the primary shapes in your painting. The other important shapes will be the "negative space"—the empty spaces between and around the leaves. Each shape "counts" in your composition.

Vary the shapes and sizes of the leaves; this will make your composition more interesting to look at. Your composition can be symmetrical (the same on both sides) or asymmetrical. Don't forget that you can overlap your stamped images. Don't forget that you can print the leaves going off the edges of your base.

Variations:

- Since leaves are basically symmetrical, it can be visually interesting to use them in an asymmetrical composition.

 If you did a symmetrical Leaf Tint painting—one that was balanced equally on each side—try something different: Deliberately print your leaves in an asymmetric composition.

 Make the empty spaces work to visually balance the printed images—those spaces have "weight," too. Exaggerate, and don't be afraid to overlap the stamped images or print the leaves going off the edges of your base.

- Experiment. Look for other things that you can use for interesting stamp-printed images. They should all have a fairly flat surface for printing. *If the printing surface*

isn't perfectly flat, carefully press the *flexible* base onto the printing surface rather than stamp the surface on the base. Remember to prestamp the image onto scrap paper to remove excess paint. You want the stamped image to be delicate and detailed.

- Try printing with dark paint on a light-colored base.

- Use some of your extra stamped images—dark or light—in collage work. Carefully cut out the shapes, possibly leaving a narrow border around each leaf, then mount the collage pieces against a different-colored base.

- Print small dark leaves on light-colored paper to create note cards. Use good white drawing paper or light-colored Canson Mi Teintes pastel paper for this.

 You could also print small Leaf Tints on dark paper. Carefully cut them out, then mount them on the folded light-colored note paper. Use spray adhesive (**outside**) for this.

 HINT: Whenever you make note cards, buy or scrounge the envelopes first, then cut the note cards to fit them before you begin any further work.

- Print a symmetrical pattern on an asymmetric background. Select dark colors of tissue paper or Fadeless art paper. *Working big and fast,* tear the paper into large irregular pieces, and mount them onto your base. Use spray adhesive (**outside**) for this, and work in an easy-to-frame size. Trim away the excess paper from the edges of the base. Print your symmetrical Leaf Tint pattern on this informal background. You could also print a dark pattern on a light-colored torn-paper background.

- If you purchased heat-set fabric dyes for the Fruit and Vegetable Prints (page 58), you can use them to print a leaf image onto a T-shirt or sweat shirt. You will use an iron to heat-set the dye; the print will then be completely permanent and machine washable. The dyes are transparent and will show up only against a light-colored background—you won't be able to print a "tint" against a dark background using these dyes. Experiment on a piece of light-colored scrap fabric. Be sure to prestamp your image to remove excess dye and ensure a crisp, clear image.

This copyright-free image from *Floral Ornaments* catalog (Graphic Products Corporation) is a good beginning for photocopy art.

Display:

If the Leaf Tint painting was done on a stiff base, it can simply be propped on a counter or shelf. If it was done on paper, you will need to either frame it or mount it onto a stiffer base before displaying it. Please see Pulled-String Painting (**Display**), page 67, for suggestions on having a mat cut, cutting a mat yourself, or mounting the painting onto a colored background. Select a background color that picks up a color in your composition and that contrasts dramatically with your painting.

PHOTOCOPY ART

The photocopy machine is an inexpensive and easily overlooked art resource, but you can have a lot of fun discovering what it can do. Here are a few tips to get you started with Photocopy Art:

• Look for a self-service copy center, which allows you more flexibility as you work. If there is no self-service copy center near you, you can still do these projects—you'll just pay a little more per copy and be a little less free to pursue ideas that come up as you work.

• Try to do your Photocopy Art during nonpeak business hours; you'll be able to concentrate better if you're not rushed.

• Look for a copy center with more than one machine. Surprisingly, different machines have different "personalities." Some print darker, take heavy paper better, etc. Ask.

• Look for a copy center with a wide range of paper stock to choose from. You should be able to find varied sizes, colors, and weights. You will also be able to bring in your own special paper. The *thinnest* paper you can use will be the weight of notebook paper. Tissue paper is too thin. The *thickest* paper you can use will be Canson Mi Teintes pastel paper. Watercolor paper is too thick.

• Look for a copy center with a laser copier, especially if you want to try printing on textured paper. Laser copiers are getting more common, but you can do these projects on an ordinary photocopy machine if a laser copier isn't available.

This copyright-free image from *Floral Ornaments* catalog (Graphic Products Corporation) is photocopied onto white Canson Mi Teintes pastel paper. It can be colored with watercolors or colored pencils.

- Look for a copy center with a full range of copy sizes available: 8½″ × 11″ (standard), 8½″ × 14″ (legal), and 11″ × 17″ (ledger). A machine that prints this largest size will give you a chance to break away from the sizes we associate more with school and business. You can do these projects in "standard" or "legal" sizes, however.

- Look for a machine with a manual feed tray—also called a paper bypass tray. With a manual feed tray, you "feed" each individual piece of paper into the machine to print. This makes it unnecessary to open the machine and stack your special paper on the ordinary stock. It will make your work much easier.

 If the machine you use doesn't have a manual feed tray, check whether to place your special paper face up or face down on the ordinary stock—it varies from machine to machine.

- Look for a copy center with a color copier if you want to try some color printing. A color photocopy means that you are copying a color picture, not that you are printing a black-and-white picture with colored ink. A

color photocopy is a lot more expensive than a black-and-white one, but it will still be well under five dollars for even the largest color copy. You can do the following projects without a color copier.

● Come prepared—prepared to do what you've planned, and prepared to improvise. Cut your special papers to the correct size at home. Bring a stack of copyright-free photocopies to work with—bring more than you'll need. If you plan ahead and work during nonpeak times, you will be able to ask questions, change paper size, color, and weight, and even change machines if you want to.

Photocopy Art: Overlapped Image

For this project you will select flexible leaves or a photocopied copyright-free image to print. Look for an open single image rather than a boxy or pictorial image.

Catalog sources for copyright-free images are listed in the Appendix.

Materials:

Choose either of the following to photocopy:

● Flexible flat leaves

● Photocopied **copyright-free** images (Do not try to print projects directly from books or catalogs. Make a photocopy on plain paper and work from that.)

Other materials:

● Liquid Paper for photocopies

● Photocopy machine or laser copier

Choose from the following for your paper:

● Paper stock available at copy center

● Fadeless art paper

● Medium-weight white drawing paper

● Canson Mi Teintes pastel paper

Cut these special papers to the correct size before you go to the copy center.
Optional:

- Watercolors and/or colored pencils

Time:
This project will take about half an hour.

Instructions:

1. If you are printing from a book or catalog, make your first black-and-white photocopy on plain paper. Your final composition will be overlays of this image or similar images. *You can run your final paper through the machine up to three or four times* during one session; it's best to do this fairly quickly.

 If there are any unwanted spots or lines on your initial plain paper photocopy, touch them up with Liquid Paper for photocopies. (Photocopy ink will smear when you use ordinary Liquid Paper on it.)

2. Select the paper you want to use. If you think you will want to add color to your final composition with watercolor or colored pencils, print on white paper. Use the copy center's stock that has the highest cotton content, or bring precut white drawing paper or white Canson Mi Teintes pastel paper from home.

 Put a large piece of white paper over the back of the leaves or your original photocopy before you print.

3. Copy the image onto your final paper.

4. Quickly move the leaves or your original photocopy to a different position. Don't be afraid to have part of the image go past the edges that will be printed. Refeed your final paper into the machine and print the repositioned image on top of the first one.

5. Reposition, and print a third or even a fourth time if you want to.

6. Now that you are familiar with the process, try another composition. You can change the size you are working on. You can change the color or weight of your final

If you are printing from a book or catalog, make your first black-and-white photocopy on plain paper (leaf image by Karl Blossfeldt).

Quickly move the leaves of your original photocopy to a different position.

paper. Pay attention this time to creating interesting empty spaces on the paper—these spaces are part of your composition, too.

There will always be some element of chance in this Overlapped Image project; you won't be able to totally predict just where the repositioned images will print on the final page or how they will look. Don't let this bother you. It's a good thing about the project, not a bad thing!

7. Take your prints home. Now, if you want to, add color to your white paper with watercolor or colored pencils.

Watercolor: Photocopy ink is permanent and won't "bleed" into the watercolors. Since the paper is relatively thin, however, avoid heavy washes, which will make the paper buckle. Use your watercolor sparingly, as an accent. Watercolors are transparent; if you plan to layer colors, start with the lightest colors.

Colored pencils: Like watercolor, colored pencils provide transparent color. You can blend colors beautifully by overlapping them. Colored pencils have two advantages over watercolor: You can control your color application more easily simply by varying pencil pressure, and your paper won't be as apt to wrinkle with colored pencils as it will with watercolor. Of course, you can use watercolor and colored pencils together on the same print.

Variations:

- Create a series of three or four compositions using the same single image. Vary only the way you overlap the image. Display them together.

- Overlap two color photocopies on good white paper, or combine a color photocopy with a black-and-white one on good white paper. A color photocopy is one that copies a colored picture, not one that copies a black-and-white picture using colored ink.

- Create an original design for your preliminary photocopy. You could do this using projects described earlier in this section. These include: Hands Outline (pages 13 and 16), Rubber Stamps (page 51), and Fruit and Vegetable Prints (page 58).

Display:

Trim your composition if you want. Mount it onto a stiffer base before displaying it. You could use colored poster board, colored mat board, or illustration board for this. You could also cut a piece of Fadeless art paper to serve as a contrasting border for your print. Cut the Fadeless art paper slightly larger than your print, and mount it onto the stiff base. Then mount your trimmed composition onto the contrasting Fadeless art paper. Use spray adhesive for this. **Always go outside to use spray adhesive, and read the label carefully.** Spray adhesive never dries; always spray the back of the smaller pieces you are adhering—do not spray the base.

If you think you would like to frame your print, trim it to an easy-to-frame size, or mount it onto a base cut to an easy-to-frame size.

PHOTOCOPY ART: COLLAGE BACKGROUND

In this project, you will photocopy a black-and-white image onto a simple collaged background you have prepared at home.

Materials:

Choose either of the following to photocopy:

- Flexible flat leaves
- Photocopied **copyright-free** images (Do not try to print directly from books or catalogs. Make a photocopy on plain paper and work from that.)

Other materials:

- Liquid Paper for photocopies
- Photocopy machine or laser copier
- Spray adhesive

Choose from the following for your paper:

- Typing paper and colored tissue paper
- Fadeless art paper collaged with more Fadeless art paper or colored tissue paper.

- Metallic paper collaged with white and colored tissue paper

Select light or bright colors so that the photocopy will show up well.

Time:

This project will take about an hour at home and half an hour at the copy center.

Instructions:

1. Make your preliminary black-and-white photocopy on plain paper from leaves, a book, or a catalog. Combine images in subsequent photocopies if you want. You will end up with the photocopy you want to print onto your collage. Select bold images that will show up vividly against the collage background. If your photocopy is too delicate, the image will get lost against the collage. An image with lots of black looks good in this project. The image can be a lot smaller than your collaged base; the collage will be so interesting that you will want it to show. If there are any unwanted spots or lines on your initial plain paper photocopy, touch them up with Liquid Paper for photocopies. (Photocopy ink will smear when you use ordinary Liquid Paper on it.)

2. At home, prepare several collaged backgrounds. When you take them to the copy center, you want to be able both to tolerate mistakes and experiment with new ideas. If you have several collaged backgrounds to select from, you will have this freedom and flexibility. When you make your collages, work in the correct final printing sizes: 8½" × 11" (standard), 8½" × 14" (legal), or 11" × 17" (ledger, if available).

 If you make a big 11" × 17" collage and then discover that your copy center doesn't print that size, just cut it in half—you'll have two 8½" × 11" collages!

 Keep your collages as lightweight as possible—the photocopy machines won't accept paper that is too thick. You can always mount the final print onto a thicker base when you are finished. Use spray adhesive to flawlessly mount the collage papers onto the thin

base. Use the least spray adhesive possible for this collage and for any photocopy work. **Always go outside to use spray adhesive and read the label carefully.**

A word about the art:

Don't get too finicky when you are making your collages—the black-and-white photocopy will be the main point of the project. The collage will just be the background. Torn paper is good to use for this project. Whether you use torn or cut collage pieces, however, work big and fast, and trim away the excess paper from the edges of the base later.

Select background colors that "make sense" with your photocopied image. For example: Leaves could be photocopied onto a collage of greens; fish could be photocopied onto a collage of blues; a scene from Dante's *Inferno* could be photocopied onto a collage of reds.

Keep your background colors light or bright; if you print a black image over a dark brown, navy blue, or forest green collage, it just won't show up. Avoid getting overly pictorial in your collage background. Remember that much of the collage will be covered up when you photocopy over it.

If you are using tissue paper for your collage, the colors will blend somewhat as you overlap them. For this reason, you will probably want to create your tissue collage using related colors or monochromatic colors. Here are some examples of related colors:

> Yellow + gold + pale orange
> Lavender + light blue + pink
> Pale green + turquoise + light blue

Here are some examples of monochromatic colors:

> White + pink + rose
> Grass green + pale green + white
> Metallic paper + any light color + white.

If you are using Fadeless art paper for your collage, you can print the photocopied image directly onto the collaged Fadeless art paper. You should not mount the paper onto a stiffer base until you have finished printing—the photocopy machine will not accept a base that is too thick.

You can adhere any thin paper to the Fadeless art paper

for your collage. Tissue paper or another color of Fadeless art paper can be used (even together) for the collage.

3. Bring your black-and-white photocopies, collaged backgrounds, and Liquid Paper for photocopies to the copy center. Print the photocopies onto plain white paper in your final printing sizes. Cover the back of each photocopy with a big piece of plain white paper before you print. Touch up any unwanted spots or lines with Liquid Paper for photocopies. Then make the final print from the touched-up photocopy onto your final collaged base. Feed the collaged base face up into the manual feed tray.

 Even though you have tried to keep the base fairly thin, sometimes it will take several attempts before the machine will accept the paper. You could even try switching machines if one won't accept your base. It's worth a try!

4. If you want to overlap a different image onto your collaged base, do it right away. Please see Overlapped Image (page 74) for ideas and instructions.

5. Repeat this process on your various collaged bases. *On at least one of the bases, create a composition—a single photocopy or overlapped images—that you didn't plan in advance.*

6. Take the prints home and trim them if you want. You can always remount odd-sized prints onto a new background cut to an easy-to-frame size. You might trim away any unwanted lines that have unexpectedly printed around the edges of your composition. You might want to "fix" the final proportions of the composition either to correct its symmetry or to exaggerate its asymmetry.

Variations:

● Create a series of three or four Collage Background photocopies. Photocopy the same strong image onto same-sized collages done in different colors. Trim the final prints to an identical size, and mount them together on black mat board. Use spray adhesive (**outside**) for this, and remember to spray the back of the smaller pieces you are mounting, not the base. If spray

adhesive won't hold the prints securely, use "Yes" paste instead.

- Make a series of three or four different prints. Photocopy them onto same-sized collages done in the same colors. Trim the final prints to an identical size, and mount them together on black mat board.

 NOTE: When you are working big, as you would be in either of these two variations, it will be cheaper and easier to frame your final piece if you carefully cut the mat board (or have it cut) to an easy-to-frame size before you adhere the prints. Keep your measurements simple—18″ × 28″, for instance, rather than 18½″ × 28¼″. You will then be able to assemble your own frame from two ready-made frame pairs. Even if you decide not to frame your composition, it's nice to have the option.

Display:

Mount your composition onto a stiffer base if you want. Please see Overlapped Image (**Display**), page 77, for mounting ideas, and **Variations** for framing suggestions.

PHOTOCOPY ART: COLLAGE

Here is another project that uses your collage skills, but this time you will do the black-and-white collage work on the initial photocopy, not on the background. This kind of collage work offers you a good opportunity to bring varied images together for the first time in a new composition.

Here are two copyright-free images that can serve as "frames" for collage work.
Top: from *Floral Ornaments* catalog (Graphic Products Corporation)
Bottom: from *Good Olde Days* catalog (Graphic Products Corporation)

Materials:

For photocopying, you will need the following:

- Various printed images that have caught your eye; images that reproduce well in black and white (pictures or lettering) selected from: magazines, newspapers, photographs, correspondence, and other two-dimensional souvenirs.

- You will do your 8½″ × 11″ collage work on typing paper.

- Do 8½″ × 14″ or 11″ × 17″ collage work on lightweight white paper cut to the correct size.

- Liquid Paper for photocopies

- Photocopy machine or laser copier

Choose any of the following for paper:

- Good white drawing paper

- Fadeless art paper (including metallics)

- Canson Mi Teintes pastel paper
 You will work in the following sizes:
 8½″ × 11″ (standard)
 8½″ × 14″ (legal)
 11″ × 17″ (ledger, if available)

 Select light or bright colors so that the photocopies will
 show up well.

Other materials:

- Spray adhesive

- Good scissors

- Manicure scissors, utility knife, or X-acto knife

Time:
 This project will take about an hour at home and half an
hour at the copy center.

Instructions:

1. Create two or three black-and-white collages at home
 on plain white paper. Work only in your three possible
 final printing sizes.

 A word about the art:
 It may seem like too much work to make more than one
collage, but give it a try. When you work on several composi-
tions at once, you will probably be more flexible as you work—
the "pressure is off" any one composition, and you'll have more
fun as you work! It is important not to plan your final collage
too much in advance. Keep it loose—literally! Don't glue any-
thing down until the very end.
 Move your collage pieces around. Try them in different
combinations against different backgrounds. Try them upside

down or going off the edges of your collage bases; trim any excess only after you finally glue the pieces down.

Turn your collage bases as you work. As in the Portrait Gallery activity using collage (page 194), detailed cutting can make this project look more interesting. Use manicure scissors, a utility knife, or an X-acto knife to cut detailed shapes. **Work on a thick pad of newspaper when using a utility knife or an X-acto knife and, as always, be careful.**

Your final collage might be made up of just two or three different images, or it might be a rich and complicated mixture of many images. Remember that the final collage must still be fairly thin for the machine to accept it for printing. You can, however, "build up" a more layered photocopy:

- Make an initial collage.

- Photocopy it, and touch up any unwanted spots or lines with Liquid Paper for photocopies.

- Do more collage work on top of this initial photocopy.

- Then photocopy the new collage.

- Repeat the process if necessary.

This collage is created from copyright-free images from *Good Olde Days* catalog (Graphic Products Corporation) photocopied onto white Canson Mi Teintes pastel paper.

2. After you have decided on your final compositions, attach the collage pieces to the bases. Use spray adhesive for this. **Always go outside to use spray adhesive, and read the label carefully.**

 Working on newspaper, lightly spray the backs of your collage pieces. Do not spray the bases. Always use the least spray adhesive possible in photocopy projects. You could use "Yes" paste instead of the spray adhesive if you want.

3. Trim the excess collage pieces away from the edges of your bases.

4. Still at home, cut your final printing paper to the correct sizes. Bring your collages, Liquid Paper for photocopies, and good printing paper with you to the copy center.

5. Photocopy your final collages onto plain white paper in your final printing sizes. Cover the back of each photocopy with a big sheet of plain white paper before you

print. Touch up any unwanted spots or lines with Liquid Paper for photocopies. (Photocopy ink will smear when you use ordinary Liquid Paper on it.)

6. Using these touched-up photocopies of your collages, make your final prints on the good printing paper.

Variations:

- Photocopy the same collage onto different paper colors, and display them together. For example: You could print the same collage on sky blue, canary, and poppy red Canson Mi Teintes pastel paper. You could print the same collage on lime green, turquoise, and gold Fadeless art paper.

- Photocopy different collages onto the same color paper, and display them together.

- Create a collage on a black Fadeless art paper background. Make the exposed black areas important parts of your final composition.

- Photocopy your collage onto a simple collaged background. Please see Photocopy Art: Collage Background (*A word about the art*), page 79, for collage suggestions.

- Experiment with using different basically flat collage materials such as flexible leaves, lace trims, or threads as parts of your initial collage. If something doesn't work, it doesn't work. But as long as the collage piece lies flat and doesn't scratch the photocopy machine, there's no harm in trying! Then "build up" your layered photocopy:

- Make an initial collage using these varied materials.

- Photocopy it, and touch up any unwanted spots or lines with Liquid Paper for photocopies.

- Do more collage work on top of this initial photocopy, then photocopy the new collage.

- Repeat the process if necessary.

You can attach additional three-dimensional collage pieces to the top of your final Photocopy Art: Collage. These collage pieces might include: fabric trims, photographs, and miscella-

neous collage items. Just use the correct adhesive for this final collage work. Spray adhesive will hold the lightest-weight collage pieces. "Yes" paste will hold medium-weight collage pieces. White vinyl glue will hold heavy or bulky collage pieces but is more apt to wrinkle them as it dries.

Display:

You can mount your Photocopy Art: Collage onto sturdy foam board. Use spray adhesive (**outside**) for this. If you want to frame your print, cut foam board or mat board to an easy-to-frame size before you mount your print on it. An 8½″ × 11″ print can be mounted onto a 12″ × 16″ backing. An 8½″ × 14″ print can be mounted onto a 12″ × 18″ backing. An 11″ × 17″ print can be mounted onto a 16″ × 22″ backing.

Please see Photocopy Art: Collage Background (**Variations**), page 80, for suggestions on framing larger pieces. If you want to frame a print that has additional collage pieces glued to its surface, you will need to buy a frame with a space between the glass and the collage surface.

Drawing on Someone's Back

Most of us have played at spelling out words on someone's back. But drawing is a little more challenging—and it's potentially a lot funnier, too. This is probably the most relaxing project in the whole book, even if no one ever guesses correctly.

Materials:

- Backs
- Fingers

Time:

This project can last as long as you want!

Instructions:

1. Establish at the start which direction is "up." It's harder to guess this with drawings than it is with letters of the alphabet.

2. Keep the drawings simple—make them single images rather than scenes.

3. Trade places every few drawings—take turns drawing.

You get to be the draw-ee sometimes, too.

I have to admit I'm good at this game. My greatest guessing feat happened years ago. It awed my youngest son and established my domestic reputation as a psychic—or at least as a pretty good guesser!

My son was drawing on my back and was ready to finally confound me. He thought hard, stretched, flexed his drawing finger, and began.

He traced a large curve and a line.

"Elephant seal!" I said crisply.

He gaped.

I've been clinging to that triumph ever since, although my son recently pointed out that perhaps the real story here is not how well I can guess but how well he can draw!

Part Two

Easy Three-Dimensional Projects

Learning to Think
and Create in
Three Dimensions

Isn't it strange that we human beings, three-dimensional creatures inhabiting a three-dimensional world, so often primarily think of art as being flat? And then, even stranger, we go on to praise illusionistic two-dimensional art by saying, "It looks so *real*. . . ."

A lot of wonderful two-dimensional art does "look real," but not all of it. And a lot of wonderful art is two-dimensional, but not all of it. I hope that this section will encourage you to try some easy three-dimensional art projects.

We take up space from the very second we're born—well, even earlier than that. Ask any pregnant woman. And we masterfully weave our way through space each day—gesturing, walking, driving. We expertly judge distance in one way or another every waking moment, and each of us is beautifully aware of where he or she "fits" into the physical world at that moment. It's amazing.

And then it's time to make art, and we haul out the same small rectangles of paper or prepare a flat, familiarly proportioned canvas, as if the potential for easy stacking, storing, or hauling away were the most we could expect from our art . . . or the best we could hope for it. It's a shame.

I'm sure that many artistically gifted people go through life thinking that they're bad at art. They're not. They may have histories of being bad at staying "inside the lines" when they color, of drawing lopsided Mickey Mouses or unlikely bowls of fruit, or of getting tangled in the potholder instructions, but "bad at art"?

What about sculpture? Many of us never even got to try the kind of art we would have felt most "at home" with—three-dimensional art. Sculpture.

Sculpture isn't just for "serious" artists making large public pieces or imposing monuments. It can be monumental or intimate, serious or whimsical, imposing or humble. It can be something *you* make. Give it a try. You may find that you're good at it, or, even better, that you enjoy making it!

Three-dimensional art gives us the opportunity to look at something from many different angles. We hardly ever do this with anything, unfortunately, even with sculpture. We usually look at a sculpture—or at a person or situation—as if it were a painting hanging on the wall. We look at things from one angle and see pretty much what we expect to see. How much we miss!

But making three-dimensional art is like an exercise; it accustoms us to looking at things in a different way. We stretch. It must be good for us.

Even if you are a person who feels perfectly comfortable making two-dimensional art, make three-dimensional art from time to time. You'll develop new skills, and it may even help your other work.

And if you are a person with psychological art scars caused by a botched paint-by-numbers experience, try these easy three-dimensional projects. Give yourself another chance at art.

Most of the activities in this section are small, semipractical, and easy to display. For example, the soft-sculpture project Stocking Faces will result in a set of refrigerator magnets or Christmas ornaments. The assemblage project called Clothespin Creature will yield a small message holder. Even a larger project such as Fantasy Flowers can be stuck in a vase or used as a final gift wrap flourish.

But sometimes art should be big and awkward, with no earthly purpose whatsoever except to please the eye—or to please you, its creator, while you are making it. A couple of the projects in this section fit these specifications.

Sometimes you should trip over your art, stub your toe on it, and wonder what in the world you're going to do with it. Sometimes you should hear people say, "What's *that* supposed

to be?" or "Did you do that on purpose?" instead of "Isn't that cute!" or even "It looks so *real. . . .*"

Don't be afraid of uncomfortable or awkward art. That can be good for us, too.

CLOTHESPIN CREATURE

Assemblage is a word that means three-dimensional collage. Like other collage work, it provides the opportunity to combine unrelated objects in unexpected ways.

This project is much easier to do if you have a hot-glue gun. Make several Clothespin Creatures in the same session; it's not that much more work, and you may discover that each comes out better than it would have if you worked on it alone.

Materials:

- Unvarnished wood spring clothespins

- Hot-glue gun or white vinyl glue (use white glue for all glitter work)

- Varied collage materials: fabric scraps, felt scraps, paper scraps, feathers, ribbons, trims, sequins, glitter, old costume jewelry, yarn, small pompons, buttons

- Skinny markers

These Clothespin Creatures are created from clothespins (dyed), pompons, feathers, toys, and glitter, and are assembled with a hot-glue gun and white vinyl glue (for the glitter).

Optional: Bath to dye the clothespins

- Rubbing alcohol or white vinegar
- Food coloring

Time:
Allow about an hour for this project.

Instructions:

1. If you want to color your unvarnished wood spring clothespins, dye them. This can be done easily and quickly, and they will dry almost immediately.

 How to prepare the dye bath: Pour some rubbing alcohol or white vinegar into a shallow dish or bowl. If you use rubbing alcohol, you may want to work outside. If the dish or bowl is glass, you will be able to see the color you add better. Add some food coloring to the rubbing alcohol or white vineger. A little bit of color will create a tint, and more of the same color will give you a more intense hue. For instance: A few drops of red food coloring added to half a cup of rubbing alcohol or white vinegar will dye the wooden clothespins a pale pink. A teaspoon of red food coloring added to the same half cup of rubbing alcohol or white vinegar will dye your clothespins a more vibrant red. Remember that this is a transparent dye, and the natural wood color of the clothespins will show through it.

 Food coloring is sold in only a few colors. You can mix some colors on your own, but you can't mix blue. If you want blue and have trouble finding it, go to a cake-decorating supply house—they have it. Here are some color mixing instructions:

 > Yellow + red = orange
 > Orange + yellow = yellow-orange
 > Red + blue = violet
 > Blue + yellow = green
 > Green + yellow = yellow-green
 > Green + red = brown

 To dye your various clothespins several different colors without changing the dye bath, start with a light

color and slowly change it by adding another color. Dye a couple of clothespins with each change. For example: By adding red to yellow food coloring, you can go from yellow to yellow-orange to orange to red-orange. By starting out with only a very little green in the dye bath and then adding more green and then blue, you can go from palest green to intense green to blue-green.

Lift the dyed clothespins from the dye bath with a slotted spoon, and drain them on newspaper. Carefully pour the dye bath down the drain, and wash the dish or bowl. The wood grain of the clothespins will show through the transparent dye.

2. Gather your collage supplies, and begin to plan the Clothespin Creatures.

A word about the art:

● Don't plan every single detail in advance—leave room for improvisation.

● Don't try to make these too realistic or specific; these are only clothespins, after all! Rather than "robin," for instance, assemble a fantasy bird. Rather than "beagle," work toward a more general dogginess.

● Work *with* the basic clothespin shape, don't try to fight it or disguise it too much. You are not going to fool anyone. . . .

Turn the clothespins, and look at them from different angles. You may well come up with a completely unexpected design when you do this. Remember that the clothespins don't each have to represent a creature's entire body, although they can. One clothespin could be an alligator's head. Another might not be a creature at all, but a decorative jeweled or feathered assemblage.

Look for contrasts in color and texture when you select your collage materials. Think of how the materials will look against the wood.

Don't glue things down too soon: Move the collage pieces around as you plan your designs. Don't be afraid to use fantasy and whimsy in this project. When your neighbor says, "What on earth is that?" say, "Art!"

If you have planned any drawn decoration (polka dots, stripes, etc.) to go under the collage work, do it now, before you glue anything down.

After you have planned your designs, plug in the hot-glue gun. If necessary, use a toothpick to move very small collage pieces onto the hot glue.

3. Finish with any final drawn details or glitter work.

Notes on using glitter:

- Be careful not to get glitter near your eyes.
- Use white vinyl glue rather than the hot-glue gun in your glitter work. The glue dries clear.
- You can use a small watercolor brush to "paint" on the white vinyl glue in very detailed patterns if you want; work on one small section at a time.
- Always wash your glue brush thoroughly right after using it, or it will be ruined.
- Work over a piece of aluminum foil; when you finish, tap the excess glitter onto the foil, then funnel it back into the glitter jar.

Variations:

If you did this project in the right spirit, you already have plenty of variety in composition and materials. But, in addition to creating message holders:

Here are Stocking Faces made with stockings, polyester fiber, thread, pompons, and fabric scraps; they are assembled with a hot-glue gun.

- You could clip these creatures to a Christmas tree or wreath. They can look a *little* like reindeer—if you squint.

- Clip some creatures to a curtain in a child's room. He or she can play with them. **CAUTION: Do not let very young children play with these.** They might eat the little collage pieces that will inevitably fall from your Clothespin Creatures.

- Chase someone around the room while you snap the clothespin. (Art can add dignity to our lives. . . .)

STOCKING FACES

I'm sure that you have seen these endearing little creations in varied forms at shops and craft fairs—but now you can make your own. They can be fashioned into many things: lapel pins, finger puppets, ornaments, and funny centers for big false flowers. In this project, they will be made into refrigerator magnets.

A word about the art:

If you try to plan your faces—especially the noses—too much in advance, you will be disappointed. Think instead of a humorous personality already lurking inside each lump of fiber; you will help guide each one out. If you try to fashion exact miniature Mt. Rushmore heads or flattering family portraits, you'll probably end up feeling as though you've failed.

Top: finger puppet (baby)
Center: ornament (elf)
Bottom: flower center

Materials:

- Stockings (Old clean stockings are fine.) You will need only a small un-run patch (about 3" or 4" square) for each Stocking Face. Opaque stockings work very well for this project; don't neglect such colors as white or black. If you don't have access to old stockings, buy a pair of inexpensive opaque "knee high" stockings. You will be able to make several Stocking Faces from one pair.

- Thread (same color as stocking); needle

- Polyester fiber (available at fabric store)

- Hot-glue gun or white vinyl glue

- Varied collage materials: yarn or twine (unravel for

Where this tied-off part of the stocking ends up depends on your design.
Top: For a bald character, tie stocking at the back.
Bottom: A character with hair, a kerchief, or a hat can be tied off at the top.

hair), fabric scraps, felt scraps, paper scraps, feathers, ribbons, trims

- Magnetic tape (available at craft store)

Optional:

- Small dark beads for eyes
- Blusher for cheeks or noses

Time:

Allow about an hour and a half for this project.

Instructions:

1. Cut out un-run 3″ or 4″ squares from your clean stockings. Tear off a small wad of polyester fiber, and experiment with pulling a stocking square around it. The fiber should be tightly compressed within the stocking square. Decide how big you want your faces to be—this will determine how much fiber you will need for each Stocking Face. You will tie the stocking square around the fiber with thread.

 Where this tied-off part of the stocking ends up depends upon your design. If you want your creation to be bald, tie the stocking tightly at the *back* of the Stocking Face. If you are going to glue on hair, a kerchief, or hat and want the back to look clear and uncluttered, tie the stocking tightly at the *top.*

 To tie the stocking around the fiber: Wrap the middle of a 12″ length of thread tightly around and around the clasped stocking ends. Bind the stocking as tight as you can, and knot the thread several times. If there is a lot of excess stocking after you've made your knot, clip the stocking ends a little closer to the knot. Don't clip too close, though, or the stocking face may eventually come apart.

2. Squash the stocking faces between your fingers for a while; play with them. Squeeze them into different shapes, and imagine various personalities. Take a few minutes for this.

3. Thread your needle with an 18″ length of thread. Knot the end several times. You will use this thread to "sculpt" the features of your Stocking Face. The

sculpting is the most important part of the project; this is not an embroidery activity, one that is done just on the surface. You will actually model the features with thread. There are three ways to do the modeling. You will probably use all three ways on any one stocking face.

Sunken Dot: This single pulled stitch quickly creates eyes or dimples. Starting from the tied-off top or back of the head, poke the needle through to where you want an eye to be. If you are using small dark beads for eyes, thread a bead onto the needle at this point. You don't need beads for eyes, though; this stitch alone will do. Poke the needle back in very close to the first hole you made, and guide it back to your starting place. *All of your stitches will begin and end at this starting place; there is no need to clip and reknot the thread during the project.* Gently pull on the thread to "sink" the eye stitch as deep as you want. Knot the thread several times for a more prominent eye. Repeat this for the other eye, if your face has two eyes. It is a good idea to begin with the eyes on each head you make.

Raised Bump: This is the trickiest modeling method. You might want to practice it a few times on a lump of stocking-covered fiber. This method is mentioned second because if you decide to use it, it should probably be the next step; it can take up a lot of stocking and batting and will distort your design if you do it later. The *raised bump* creates wonderful noses and ears. The nose can be so important that it will determine the rest of the project.

Pull up a little lump of stockinged fiber in the nose area. Knead it into roughly the size and shape you want. Poke the threaded needle up next to the little lump. Wrap the pulled thread tightly *around* the lump a couple of times so that it will stay raised. Guide the needle back to your starting place. Repeat this process for raised ears if you want to.

Take some time at this point to reevaluate the Stocking Face. The face may have a new shape. There will be unexpected wrinkles in it. Plan the mouth design only after reevaluating what you now have. You may just want to repeat the *sunken dot* stitch for a surprised mouth.

Sunken Line: This third stitch is good for a wider mouth. You can do it with a single long stitch for a

straight line (a determined or irritated face) or with two or more joined stitches for a longer or curved *sunken line* (a smiling or frowning face).

Single stitch: Poke the needle from the back through to one side of where you want the mouth to be. Stick it back in where you want the other side of the mouth to be. Guide the needle back to your starting place, and gently pull the thread until the line "sinks" into the face.

Joined stitch: Poke the needle through to either the middle or one side of where you want the mouth to be. Take one stitch and guide the needle back to your starting place. Pull gently on the thread to "sink" this first line. Poke the needle back very close to the first stitch, and repeat the procedure with another small joined stitch. You will "sink" each stitch from your starting point.

When you have finished sculpting each face, take several tiny finishing stitches at your starting place, and clip the thread. This is a good place to stop work on the project if you need to.

4. Drawing on these faces doesn't work well at all, but you could add a little color with blusher if you want. Gently dab the blusher onto cheeks, noses, or ears with your finger, a cotton swab, or a dry watercolor brush.

5. Gather your varied collage materials, and plan the final collage work for each of your Stocking Faces. One might have wisps of polyester fiber hair, a yarn mustache, and tiny wire glasses.

Another could have yarn bangs peeking out from under a calico kerchief. A third might wear a miniature jeweled turban and a mysterious expression.

You can stitch or glue the collage materials onto each face. A hot-glue gun will instantly attach them; white vinyl glue will take longer to dry and may not hold the materials as well. **Please see page 35 for safety information on using the hot-glue gun.**

6. If the tied-off stocking ends are still showing, some people like to cover them with a little patch of felt. Stitch or glue the felt over the flattened stocking ends.

7. Unroll the magnetic tape and cut off a piece to go on the back of each Stocking Face. The magnet will stick to your refrigerator. Magnetic tape is sticky on one side,

but you will want to use a stronger adhesive. Attach the magnetic tape to your sculptures with a hot-glue gun or with white vinyl glue.

Variations:

- Make bigger faces.

- Try a self-portrait.

- Use the Stocking Faces in different ways—art doesn't always have to end up on the refrigerator.

FANTASY FLOWERS

When I was growing up, we used to labor over facial tissue flowers that looked "almost like" carnations. Maybe you made these, too.

The following activity is a lot more fun, and there's a lot more art in it. You get to invent your own flowers—no pesky old reality in *this* project.

You can create Fantasy Flowers over a period of time by doing parts of the project in different sessions, or you can do it all at once.

Materials:

Choose one or combine the following for the flowers:

- Round Rockline flat white coffee filter papers (not crimped or shaped)

- Good quality colored tissue paper or white tissue paper (If you want to add color or remove color from tissue paper, used unwaxed tissue. To *add* color to the paper you will need: food coloring, water, optional spray bottle filled with water or eye dropper. To *remove* color from the paper you will need liquid bleach.)

Optional:

- Glitter

- White vinyl glue

Choose one of the following for the stems:

- Skein of green chenille wire

These are Fantasy Flowers made from dyed tissue and round coffee filter papers.

- Pipe cleaners (for smaller flowers)
- Green florist's wire

Time:

Allow one and a half to two hours for this project. It can also be done in two sessions: one to color the papers and another to assemble the flowers.

Instructions:

1. Round flat white coffee filter papers are excellent for this project. They are sturdy and dye well, and they can be combined with tissue paper to create the flowers. The filter papers can be hard to find, though; you may just end up using tissue paper for this project.

 Crisply and carefully fold each filter paper in half, then in quarters, sixths, or eights. Or fold the *light-colored* tissue paper into squares, cut out 6", 8", or 10" circles, and fold same-sized tissue circles into quarters, sixths, or eighths. You will dye the folded filter papers one at a time, but you can fold and dye two same-sized tissue circles at one time. It is easier and quicker if you cut several layers of tissue at the same time. You will cut into the circles later to create petals. Since food coloring is transparent, it will show up only on the white filter paper or on white or light-colored tissue. You can add color to darker tissues if you carefully remove the dark tissue dye with bleach first. Please see instruction #2 for how to do this.

 Put newspaper on your work surface, and remember that food coloring stains. Pour a little dye into a shallow dish. For this project, it is best to keep the dye very shallow; refill the dish when necessary. Write the name of each color on the newspaper—sometimes it is hard to distinguish color differences. If you want blue and have trouble finding it, go to a cake-decorating supply house. *For this project, you can thin the food coloring with water* if you want to. Adding water to a color will create a tint of that color. For instance:

 Blue + water = light blue
 Orange + water = pale orange

Another way to lighten a color is to spray a little water onto the paper before dyeing it. This also creates a

Top: Dyeing the center point yields a starburst design.
Bottom: Dyeing the folded sides yields a radiating pattern.

softer, more watercolorlike look; the colors will blur and blend more. Dip the center point into the dye; this will create a circle or starburst. Press a folded side into the shallow dye; this will make a stripe. *These papers are very absorbent, so you need only to dip them very briefly when you dye.* If you want to layer the colors of dye, start with the lightest ones. For example, you could dip folded white paper into yellow to create the first broad area of color. Then dip the paper very quickly into orange and even more quickly into red. All three colors will be visible.

Blot the dyed filter papers between old sections of newspaper. Wait to unfold them until the papers have dried a little. If you have dyed tissue paper circles, remember that they are much more fragile than the filter papers. They can easily tear when wet. Resist temptation: wait to unfold your dyed and blotted tissue circles until they are dry.

2. You can also remove color from parts of the tissue paper. You can then use the paper, or you can add a different dye color to the new white area. Use liquid bleach to remove color. **Work outside or near an open window when you use bleach.** Don't get the bleach on your fingers or clothes. Crisply and carefully fold the tissue circles in half, then into quarters, sixths, or eighths. You can fold two same-sized tissue circles together. Dip parts of your folded tissue into the bleach, and quickly blot it with old newspaper. You will see the color start to fade from the bleached areas. It will take a couple of minutes for all of the color to fade from the blotted tissue.

NOTE: Occasionally, bleach will not remove color from the tissue. Sometimes this is because the tissue is waxed. Sometimes the process won't work with just one color from your assortment. Try other tissue colors; if you can't remove the color, you can always use that tissue as a solid color.

Carefully pour the bleach down the drain, and wash up. You can either use the tissue circles as they are or you can add some color to the bleached areas. Please see instruction #1 for suggestions on dipping variations and how to layer colors. When you have finished dyeing the papers, you can stop work if necessary.

Dip parts of your folded tissue into the bleach.
Top: center dipped
Center: center dipped; outside edge dipped
Bottom: folded sides dipped

3. You could just make flowers from the round papers, but you will probably want to cut into them. The cutting will be easier and your flowers will look more symmetrical if you keep the dyed circles at least partially folded as you cut them.

A word about the art:

It's not likely that these flowers will look realistic; it's not even necessarily desirable. There can be a "logic" to each flower, however, that will help it look its best.

- The circles that make up each flower will probably be stacked big to small.

- If you are combining filter paper with tissue, the sturdy filter paper will probably look best on the outside of the flower.

- The colors within each flower might be related colors.

- Although the cut circles will be different sizes, there will probably be some consistency in the way the petals are cut within any one flower.

- Add variety with spiky or fringed flower centers in black or another contrasting color.

- Try dipping the very ends of these flower centers in white vinyl glue, then in glitter or tiny bits of shredded tissue.

- Play with cutting and stacking your dyed circles. *Ideally, you will have prepared enough circles so that you can experiment this way.* Don't be stingy!

4. To assemble the flowers: Cut 14"–16" lengths of the green chenille wire or the florist's wire. You will need to allow 2"–3" extra to twist around the base of each flower. If you are using regular pipe cleaners for stems, they do not need to be green—remember, these are *Fantasy Flowers!* Most craft pipe cleaners are only 12" long. You will need to make smaller flowers to fit these shorter stems, otherwise your flowers will look top-heavy.

Pick up the stacked paper circles and tightly twist the centers together. Fashion a wrappable narrow "knob" of twisted paper centers. Tightly wind the end of the green chenille wire, pipe cleaner, or florist's wire

several times around the twisted paper centers. Do this with each flower; use different lengths of green chenille wire or florist's wire to give the flowers more variety.

Variations:

- Experiment with different folding patterns when you dye the papers.

- Try crumpling and dyeing the paper for a more random design. You can iron the dry dyed paper circles before fashioning them into flowers.

- Try splattering the paper circles with food coloring or bleach for a speckled look. Use an old toothbrush for this. Wear rubber gloves; wash them right away when you're done. **Work outside when you do this, and protect your clothing.** If you splatter the papers inside a big old cardboard box, you will protect yourself and your surroundings.

- Don't avoid using black paper in this project. Some black tissues bleach beautifully, and black can provide a dramatic contrast to other colors.

- Combine other papers with your dyed circles to create the flowers. Doilies, Fadeless art paper, and aluminum foil can all be used.

- You could also use lightweight fabrics. Spray-starch and iron small-patterned gingham or calico shapes to use in making the flowers.

- Use the extra dyed papers for other small projects.

- You could make bookmarks: Use spray adhesive (**outside**) on Bristol board. Cover the lightly sprayed board with the dyed paper. Cut the board into various shapes for bookmarks.

- You could cover small notebooks: Again, use spray adhesive (**outside**). This time, lightly spray the back of the dyed paper. Attach it to the cover of the small notebook. If the uncovered notebook is dark or has bold printing on it, precover it with white paper or aluminum foil. Next, attach the dyed paper. Trim away any excess paper. If you want, you can adhere a final trim

Top: flower shapes stacked large to small
Bottom: stacked shapes twisted into "knob," ready to wrap with pipe cleaner or chenille

You could make bookmarks. This Fantasy Flower variation uses feathers and yarn on dyed tissue paper attached to Bristol board with spray adhesive.

along the top of the covered notebook: You could use rickrack or some other fabric trim for this. You might also use fancy gold or silver paper trim.

Display:

As mentioned, these flowers can be displayed in a vase or used to decorate wrapped gifts. The flowers can also serve as informal napkin rings for a party—just wrap the wire stems around the napkins. Guests can take the flowers home as favors.

ANTIQUED RELIEF SCULPTURE

Sculpture has three dimensions—it has depth, but not all sculpture is intended to stand in the middle of the room. A three-dimensional wall piece is a sculpture, too. This kind of sculpture is called "relief." It has a flat back.

The following activity is a lightweight relief sculpture that can be displayed on the wall or on a table. It is a design project—it is nonobjective. This means that you will not be attempting to model a three-dimensional object such as a pony or a dragon. Instead, you will be working with the repetition of simple shapes. (Your chosen shape can be the outline of a simple recognizable object, though, if you wish.)

Even different sizes of one shape such as a square or a triangle can result in a successful Antiqued Relief Sculpture.

Materials:

- Foam board
- Aluminum foil
- Construction paper
- Utility knife or X-acto knife; old newspapers

Choose one of the following to attach foil to foam board:

- Spray adhesive
- White vinyl glue

Choose one of the following to attach foam board pieces to one another:

- Hot-glue gun
- White vinyl glue

To "antique" the foil:

- Black tempera or black watercolor (*Do not use acrylic paint for this project.*)
- Liquid detergent
- Watercolor brush
- Sponge or paper towels

Optional:

- Clear plastic spray

Time:

Allow about two hours to complete this activity. The project can be done in two sessions if you want. In the first session you will cut, wrap, and assemble the foam board shapes. In the second session you will "antique" your finished relief sculpture.

Instructions:

1. Plan your design and the shape of your base. Visualize flat stacked shapes, with the bigger ones on the bottom. Avoid sharply angled shapes such as stars—these will be hard to wrap with the wrinkled foil. There is no requirement that this project be mounted on a "traditional" rectangular base, although it can be. The foam board base for the project can be any shape; this is a chance to break away from the expected. Cut your shape patterns from a piece of construction paper.

 If you want your relief sculpture to be formed from different sizes of one shape, cut your first pattern the biggest size. Trace around it with a pencil on the white foam board. *If you want thicker shapes,* trace another foam board shape in the same size. You will glue the two (or more) pieces of foam board together before wrapping them with foil. Varying the depths of the stacked shapes is one way to make the project interesting to look at. Then cut away an even border from the big construction paper pattern to create the same evenly proportioned pattern in a smaller size. Trace around this smaller size. Repeat as often as necessary. If your base is about 12″ long, you will want to trace at least four shapes in different sizes—probably more.

This Antiqued Relief Sculpture incorporates foam board and aluminum foil (joined by spray adhesive), black watercolor, and liquid detergent. The layers are assembled with a hot-glue gun.

Visualize flat stacked shapes, with bigger ones on the bottom.

If you have trouble coming up with a design, here are a few ideas to get you started:

- Cut only different-sized squares. Add variety to your composition by stacking them in different thicknesses or by slightly turning each stacked square.

- Alternate squares and circles. You can start with a circular base if you want.

- Use only triangles. They can be cut in several different proportions and sizes. Parts of the stacked triangles could protrude past the edges of the base to form a spiky relief sculpture.

2. Next, you will cut out all of the foam board shapes. You will use a utility knife or an X-acto knife for this. **Always cut on a thick pad or newspaper or a big old magazine, or you will damage your table or counter.** Shapes with straight edges are easiest to cut; you can use a ruler to guide your blade. But the foam board edges don't have to be perfectly smooth. The wrapped foil will cover them.

3. If you have cut same-sized pieces of the same shape to stack for thicker shapes, glue them together. The hot-glue gun will adhere them instantly. **Be very careful when you use the hot-glue gun, and protect your table or counter from the nozzle and from glue drips.**

4. You can make and attach wire picture-hanging loops at this point if you want. The twisted wire ends will be covered by foil. You will probably want two wire loops for the back of your base; the sculpture will hang more evenly that way. On the *back* of your uncovered foam board base, measure and pencil-mark the spots for the two loops. They should be a couple of inches from the top of your sculpture and be several inches apart. Poke two holes for each loop—the holes will be only about ½" apart. Use a yarn needle or an ice pick to punch the four tiny holes through the foam board. Cut two 3" lengths of pipe cleaner or wire, and form each piece into a little hoop. Working from back to front, poke the wire ends into the two holes on each side of the sculpture, and twist the wire ends securely together on the front. Flatten the twisted ends. You want to end up with two same-sized loops on the *back* of the base; the twisted wire ends will lie flat on the *front*.

5. Now, it is time to cover the base and the various shapes with aluminum foil. You will do this before you attach the foil-covered pieces to the base or to one another. *The foil will cover both the surface and the sides of each piece* and will tuck under the bottom of each piece.

 You could wrap the foam board pieces with smooth, unwrinkled foil, but the wrinkles are what will enhance the "antique" look later in the project. Tear off enough pieces of aluminum foil to cover your foam board shapes. Each foil piece should be slightly larger than the foam board shape it is to cover. Gently crumple each piece of foil, then carefully smooth and flatten each piece. Creases and slight ridges will still be apparent on the foil—these are what will catch the paint when you finally "antique" the project. You can use either spray adhesive or white vinyl glue to adhere the foil to the foam board.

 To use spray adhesive: **Always go outdoors to use spray adhesive, and read the label carefully.** Working on a big sheet of newspaper, lightly spray the backs of your smoothed pieces of aluminum foil. Bring the sprayed foil back inside, and wrap your foam board shapes. Tuck the extra foil under the bottom of each shape. You don't want any raw foil edges to show. If there is a lot of extra foil under a shape, trim away some—you want each wrapped shape to lie flat when you glue it down.

 To use white vinyl glue: Thin the glue slightly with water. Add a few drops of liquid detergent to your glue. This will enable it to spread on the foil without "resisting." Brush the glue onto the back of each foil piece, and wrap each foam board shape. *Do this one piece at a time;* the glue dries fairly quickly. Wash your brush right away, or the white vinyl glue will dry and ruin the bristles. Don't forget to wrap the base, too. You might want to cover the entire back of either the base or any shape that will protrude from the base. Do this now, before you glue any wrapped pieces together. If you have already attached twisted wire picture hangers to the base, cut small slits in the backing foil for the loops to come through.

6. Working from the base up, attach the wrapped pieces. You can use either a hot-glue gun or white vinyl glue for this.

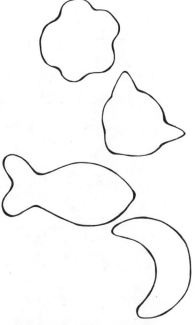

Avoid sharply angled shapes such as stars. Here are some softer angled shapes.

To use a hot-glue gun: Following the safety instructions on page 35, squeeze two or three blobs of hot glue onto the back of each successively smaller wrapped piece. Do this one piece at a time. Quickly position each glued piece, and go on to the next.

To use white vinyl glue: Use thick white vinyl glue for this. If you thin it with water, it will become too weak to hold the stacked shapes—especially if the fin- If you use white vinyl glue rather than the hot glue gun, *allow extra time.* You will need to wait a day for the glue to dry thoroughly before you can "antique" the finished piece.

7. Take some time to look at your sculpture. You may like it the way it is, without any paint on it at all. If so, leave it unpainted! If you think you *might* like to "antique" it, experiment first on a scrap piece of wrinkled foil to make sure.

8. The final step is to "antique" your sculpture. You will brush on thin black paint and then remove some of the color, leaving traces in the wrinkled foil. *You cannot use paints that will dry permanent,* such as acrylic paints; you can't wipe these off when they dry. Tempera paint or watercolor can be used for this project. You could use any color, but black looks especially good. Since the paint will seep into the wrinkled foil, it should be dark for contrast—remember how light the foil is. *You will need to add a few drops of liquid detergent to either the tempera or watercolor,* or it won't spread over the foil without resisting. Whether you use tempera or watercolor, you will mix your paint very thin.

To use tempera: If you are using *dry tempera,* spoon about a tablespoon of the powder into a bowl. Add a few drops of water, and stir the mixture into a paste. Then thin it with water until it resembles a watercolor wash. *Add a few drops of liquid detergent* to the paint. If you are using *liquid tempera,* you will need to thin it with water until it resembles a watercolor wash. *Add a few drops of liquid detergent* to the paint.

To use watercolor: You can buy individual colors of watercolor in tubes, but you will most likely be using the dry watercolors that are sold in sets. Mix your dark

color with a little water in a small saucer or bowl. *Add a few drops of liquid detergent* to the paint. Using a soft watercolor brush, brush the thin dark paint over the sides and edges of your relief sculpture. If the paint won't cover the foil, add a few more drops of liquid detergent to it.

9. Moisten a small sponge, paper towel, or facial tissue with water, and wipe some of the paint from the foil. This will create the "antiqued" look. The paint doesn't have to be completely dry for you to do this, but it can be. Use a cotton swab to wipe the paint from hard-to-reach areas.

A word about the art:
Consider leaving a little more paint in areas that "logically" would be shadowy. The lowest areas of your relief sculpture might be more shadowed. The immediate area around each stacked piece could be more heavily shadowed.

10. If you want, take your dry Antiqued Relief Sculpture outside, and spray it with clear plastic spray. Work on a large sheet of newspaper when you do this. **Always go outside to use any spray, and read the label carefully.**

Variations:

- "Antique" the foil-wrapped surfaces before you glue them together.

- Make a relief sculpture that combines wrinkled surfaces with smooth ones.

- Create a sheer-colored relief sculpture by painting the foil-wrapped surfaces with one or more colors of tempera. *Mix a little tempera paint with white vinyl glue,* and then thin the mix with water. *Add a few drops of liquid detergent* to the paint. The foil will glint through the sheer plastic color. *You will not be able to wipe the dry paint from the sculpture surface;* this variation is painted, not "antiqued."

Display:
Prop your Antiqued Relief Sculpture on a shelf or counter, or hang it from the wire loops you made.

In this Colored Wood Scrap Sculpture, dyed wood scraps and buttons are attached to corrugated board with a hot-glue gun.

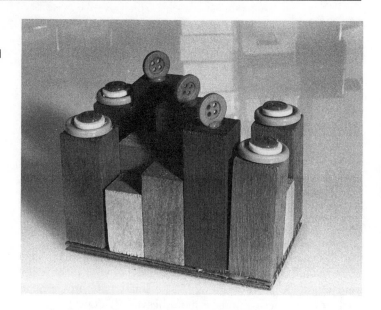

Colored Wood Scrap Sculpture

Here is another relief sculpture; it, too, is three-dimensional but mounted on a flat base. This is a small sculpture that is intended to be displayed flat on a table, shelf, or counter.

Materials:
Choose one of the following for your base:

- Masonite (precut piece in a small size such as 3″ × 5″, 4″ × 6″, or 5″ × 7″)

- Foam board

- Corrugated board

This is a brightly colored project, but Masonite and corrugated board are dull brown. Either one might look better if you prime and paint it before attaching the colored wood scraps. *Prime* the top and sides of the base if necessary with Gesso, white acrylic, or white tempera mixed with a little white vinyl glue. *Paint* the top and sides of the base with: acrylic paint, or with tempera paint mixed with a little white vinyl glue.

Other materials:

- Unvarnished wood scraps: varied short 1″ × 1″ and 1″ × 2″ lengths (you could do the entire project from

these), small balsa wood pieces, dowel scraps, unvarnished wooden spools, etc. *The wood pieces need to be unvarnished, or you won't be able to dye them.* Save varnished scraps for a later activity—see the variation at the end of this project.

● Sandpaper

Bath to dye the unvarnished wood:

● Rubbing alcohol or white vinegar

● Food coloring

Choose one of the following to "glaze" the dyed wood (optional):

● Glossy plastic spray

● White vinyl glue (thin)

● Glossy acrylic medium

Choose one of the following to attach the dyed wood scraps:

● Hot-glue gun

● White vinyl glue (thick)

Optional:

● Picture hanging hooks

● "Eyes"

● Wire

Time:

It will take you about an hour to sand and dye the cut wood scraps. It will take another half an hour for you to assemble the sculpture. The project can be done in two sessions if you want.

Instructions:

1. If necessary, prime and paint your base. The white primer will make your final base color look much brighter. A permanent color, rather than ordinary temp-

era, will keep the base color from coming off on your fingers or on the wood scraps later in the project. Be sure to paint the sides as well as the surface of your base; this will make the finished project look better. Wash your brush right away, or the dried paint will ruin it.

2. Sand all the rough sawn edges of your cut wood scraps. Wipe them clean with a damp paper towel before you dye them.

3. Dye your unvarnished wood scraps. Please see Clothespin Creature instruction #1 on page 94 for how to do this most economically and efficiently. Lift the dyed wood scraps from the dye bath with a slotted spoon, and drain them on old newspaper. The pieces will dry very quickly. *Dye more pieces than you think you will need for the project.*

4. Take some time to play with the colored wood pieces. You have different colors, sizes, and shapes to work with. Stack them in varied ways. Balance the pieces; if you have a hot-glue gun, you will be able to adhere them at precarious angles. Try to come up with a rich and complex composition rather than a scattered one. (Working on a small base makes this easier!)

5. If you want only *some* of the wood scraps to have a shiny finish, "glaze" them now, before you adhere the sculpture pieces. If you use glossy *plastic spray,* work outside on a big sheet of newspaper. **Always go outside to use any spray, and read the label carefully.** If you use *white vinyl glue,* thin it first with water until it looks like thin cream. Brush it on the exposed wood surfaces. It will look milky, but it will dry clear. Let the exposed areas dry, turn the pieces over, and finish "glazing" them. If you use white vinyl glue, you will need to allow extra time for it to dry.

6. Assemble your final Colored Wood Scrap Sculpture.
 To use a hot-glue gun: This is the easiest way to adhere the sculpture pieces. You will work quickly and can glue the pieces with greater variety. Please read page 35 for safety advice on using the hot-glue gun. **Always try to squeeze the hot glue onto the base rather than onto any small sculpture piece you are holding.** *Take advantage of the unique qualities of this adhesive:* You could stack tiny pieces in teetering piles.

You could also adhere sculpture pieces at unexpectedly odd angles.

To use white vinyl glue: Thick white vinyl glue also adheres to wood scraps. This adhesive takes much longer to dry, though. Plan a sturdy stacked sculpture if you use this glue. *Puddle* the thick white vinyl glue where needed on the base, and assemble your final Colored Wood Scrap Sculpture. Don't expect a thin smear of glue to hold these bulky pieces. The glue is white, but it will eventually dry clear.

7. If you want your entire finished sculpture to look shiny, "glaze" it now. If you use glossy *plastic spray,* **work outside on a big sheet of newspaper.** If you use *white vinyl glue* or *medium,* thin it first with water until it looks like thin cream. Brush it on the exposed wood surfaces. It will look milky, but it will dry clear.

Variations:

- Rubber-stamp some of your dyed wood scraps with black ink. It will be easier if you do this before you assemble your sculpture.

- Embellish your glazed sculpture with bright buttons (held by hot glue or thick white vinyl glue), a drift of glitter (adhered with thin white vinyl glue), or rhinestone or sequin highlights (stuck on with thick white vinyl glue).

- Using *corrugated board* as your base, plan a Colored Wood Scrap Sculpture that can hang on the wall. Please see Antiqued Relief Sculpture instruction #4, page 108, for how to make wire picture hanging loops and attach them to the corrugated board. Attach the loops *before* you assemble the sculpture. Keep this project small and lightweight.

- Create a miniature fantasy cityscape from the stacked wood scraps. Pave the streets with gold (or aluminum foil, at least!) while you're at it.

- Use *natural colors* rather than bright primary colors for this project. Your base could be left brown or painted black or some other natural color, or you could cover your base with silver or gold paper. **Use spray adhesive (outside) for this.** (If you plan to hang this sculpture

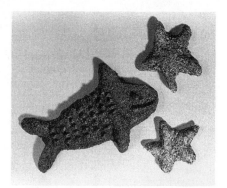

Casting plaster + damp sand = a
Sand Fish!

on the wall, adhere the silver or gold paper with thin white vinyl glue instead or else the weight of the wood scraps will pull the paper away from the base.) Some of the wood scraps could be left plain—or perhaps just "glazed" with glossy clear plastic spray or thin white vinyl glue. Some of the scraps could be dyed a deeper brown: *Mix green and red food coloring to make a rich brown dye.* You could then combine these wood pieces with small twigs, pods, pine cones, or other natural materials.

Sand Fish

This mildly ambitious plaster-casting project can be lots of fun—we used to do it at the beach when I was growing up. You can do it at home, though, if you have access to a sand box—the kiddy kind, not the kitty kind.

The sand will stick to the surface of the poured plaster; this creates a rough, stonelike sculpture surface. This is a good activity to do on a warm day.

Materials:

- Sand box (or beach)
- Fresh water to moisten sand and mix plaster (If you work at the beach, you *must* use fresh water rather than salt water when you mix your plaster.)
- Trowel, old spoon, other digging or poking tools
- Small "molds" such as creamers, etc., for adding compressed sand or impressing "stamp-print" style for different textures
- Plaster of Paris
- Big metal paper clips

Choose one of the following to mix the plaster in:

- Big old rubber beach ball, cut in half (easiest at clean-up time)
- Disposable milk or water container (This is good for mixing a larger quantity of plaster for a bigger sculpture.)

Time:

Allow about an hour for this project—but you can spend as long as you want creating your sand mold. Once you've mixed the plaster, you are on *its* schedule, though—you have about twenty minutes at the most.

Instructions:

1. *First, visualize the entire activity and the finished project:* You will scoop a hollow fish shape out of the damp sand and then refine it with some detail. (Of course, you don't have to make a fish, but you should select a fairly self-contained shape. If you have skinny little shapes poking out, they'll just break off. Plaster can be fragile.) Think in reverse: Every scooped-out place will end up as a plaster bump. Every piled-up lump of sand will yield a plaster hollow. You will mix plaster and pour it into the mold. You can then insert hanging loops into the flat exposed back of the sculpture when the plaster is partly dry. When the plaster is completely dry, you will lift the sculpture from the mold.

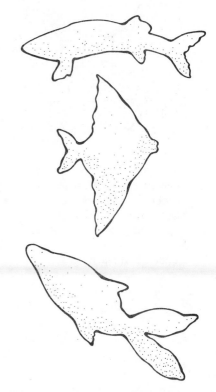

Select a fairly self-contained shape.

2. Now it's time for the real thing. Create your negative mold from the sand. The sand must be damp enough to hold its shape when you scoop some away. If you are working at the beach, work close enough to the shore that the sand is damp but not wet; the mold has to hold its shape. Your first sculpture should be about 8″–12″ long; you can work bigger (or smaller) when you are more familiar with the process.

 No part of your sculpture should ever be thinner than about ¾″—if you pour the plaster thinner than that, it will be much too apt to break when it dries. The sculpture doesn't have to be terribly thick to be strong, though. *Your finished sculpture will be strong enough if it is about 1½″–2″ thick.*

 Hollow out your basic fish shape with your hands or the trowel. Add (or subtract) the details:

 ● Little holes poked into the sand with a stick will result in tiny raised plaster bumps.

 ● Fishy "scales" can be "stamp-printed" into the damp sand with a spoon or other small tool.

 ● A smooth round lump of sand can result in a hollowed plaster eye.

Think in reverse: Every scooped-out place will end up as a plaster bump.
Top: cross-section of scooped-outs and
Bottom: cast plaster shape

Recollect your finest sand castle building techniques, and adapt them (in reverse, for mold making) to this project.

3. Mix your plaster. *Mix only enough plaster to use at any one time;* once you have mixed it with water, it will harden. Start with the water: picture how much water it would take to fill the "hole" that is your mold. (Remember to use *fresh water* for this even if you are at the beach. Your sculpture will crumble if you use salt water.) I have some bad news for some of you—the best way to mix the plaster is *with your hands.* Use a spoon only if you are so repulsed by this that you are about to close the book and go bake cookies instead.

 Sprinkle big handfuls of the dry plaster into the water as you mix with your other hand. Keep on sprinkling and mixing. Keep on sprinkling and mixing. (You'll be surprised at how much plaster this takes.) You'll know you've added enough plaster to the water when the sprinkled plaster "pools" in little islands on the water's surface. I'm not talking about piled-up mountains of plaster but about floating islands . . . Oh, the poetry of plaster!

4. Mix it all together one last time, and rap the container on the ground two or three times—some air bubbles will rise. The mixed plaster may still feel a little thin—like a medium-thin milkshake. Pour the plaster into your mold. (If you miscalculated and don't have enough mixed plaster to fill the mold, quickly mix some more and pour it in.) If you mixed the plaster in half of a big old beach ball, just let the remaining thin film of plaster dry. You can easily clean the bowl later just by turning it inside out into a trash can. *Don't leave any plaster scraps on the beach—I'll find you if you do.*

5. When the plaster is still a little soft, partly unfold two big metal paperclips so that each forms a flat "S" shape. Bend the top loop of each "S" out slightly; these bent loops will protrude from the back of the sculpture so that you can hang it later on. Press the paperclips into the damp plaster, leaving only the little metal loops protruding. Wait for the plaster to finish drying.

6. Dig out from around your sculpture, and gently lift it away from the sand. Rinse the excess sand from the

sculpture. Carefully clean up any plaster bits from your work area—leave no traces. *(See previous threat.)*

7. Take some time to evaluate your work on this first Sand Fish. Do not compare it to Great Sculptures You Have Seen but to itself—to what this particular piece *could* be:

- Could the basic shape be improved?

- Does the work you did on the mold show up well?

- Could you have simplified any parts of the sculpture?

- Should you have exaggerated any parts?

- Have you created interesting shadows on the surface of your sculpture?

If you can take one or two small steps forward each time you work, you are on your way to being the artist you could be.

Variations:

- Cast a unique school of fish to "swim" along a sheltered wall. (The school is unique because . . . each fish is different!)

- Working in reverse, cast your initials: they can be joined together to form a decorative monogram. Here is how to plan the necessary reverse design for your mold: Draw your design big on thin typing paper. When you turn the paper over, you will see the reverse pattern. Copy this pattern when you dig your mold. Another way to plan the reverse design is to draw the joined monogram on big paper, hold it up to the mirror to reverse it, and copy the reversal. Dig that reversed pattern into the sand. Remember to keep any part of the sculpture about 1½"–2" thick—and never thinner than ¾".

- Make a permanent sand castle! Hollow out the castle shape, then pour in the plaster. The sand will stick to the exterior of the castle forever.

- Plaster will wear away if left exposed to rain. If you want to make more permanent sculptures or sculptures that can hang outdoors in all weather, cast them in Hydro-

Partly unfold two big metal paperclips so that each forms a flat "S" shape. Bend the top loop of each "S" out slightly.
Top: flat unfolded paperclip
Bottom: the top loop, bent out slightly

stone or Hydrocal. These can be purchased at building supply stores. It mixes like plaster, but once it hardens it is much stronger than plaster.

TROPHY

The final easy three-dimensional activity combines sculpture, painting, and collage in one project. Obviously, you'll do the project in several sessions over a period of time.

One of the hidden benefits in doing an extended project is that enforced periods of evaluation and reflection are created. Each time you return to the project, you can look at it anew. *Make sure that you do this:* Look at it anew.

At the start of each session, make sure that you say, "What do I have to work with right now?" rather than "Why doesn't it look the way I planned?" Be flexible, and work on taking advantage of the unexpected strengths that will emerge in your art.

This project was inspired by the now happily outdated head-on-the-wall Trophy Room. What a notion! One of my sons came up with the counternotion of assorted papier-mâché hunters' heads, artfully arranged above the fireplace. . . .

That might be too macabre for some of you, but a bizarre mixed-media animal Trophy can make a wonderful addition to (almost) any room.

Materials:
Sculpture

- Newspaper

- 1" masking tape (can be cheap tape)

- Optional: aluminum foil, poster board, hot-glue gun, clean empty soda can or cardboard box for base, plaque for mounting head (available at craft stores)

Papier-mâché

- Flour and water or liquid starch

- Newspaper

- Optional: powdered papier-mâché to model on top of strips

Painting

- Gesso (for primer)

- Tempera paint and white vinyl glue, or acrylics

- Optional: markers; glossy plastic spray, thin white vinyl glue, or glossy acrylic medium

Collage

Choose from all the collage materials you have used in doing the projects outlined so far in the book. These materials include:

- Papers: tissue paper, construction paper, Fadeless art paper, etc.

- Yarn, twine, string, etc.

- Fabric, felt, leather, lace, pompons, trims, etc.

- Sequins, glitter, etc.

- Hot-glue gun, thick white vinyl glue

Time:

The *sculpture* part of the project can be done in two sessions if you want. In the first session, you will form the basic Trophy head from newspaper and masking tape. In the second session you will do the papier-mâché work on this base. This will take a total of two or three hours—possibly more, depending on size, detail, etc.

Painting the head will take at least an additional hour.

The *collage* work will take perhaps another hour.

Instructions:

Sculpture

1. If you are going to mount your finished Trophy on a wall plaque, the size of the plaque will determine the size of the Trophy. This project doesn't need to be mounted, however; it can hang on the wall as is. If you don't mount it, the Trophy can be as big as you want, but I'd suggest making your first basic head shape about 10"–12".

 Think of all the steps you will go through doing this project—sculpture, painting, and collage—and vi-

This basic Trophy head is made from newspaper, aluminum foil, poster board, and masking tape.

sualize your finished sculpture. You want it to make the most of each of these steps. Why else go to all that trouble? Visualize it: It will have a flat back, but it will stick out from the wall—it will be sculptural. It will take up space. Although your finished project might be "lionlike" or "rhinoceroslike," decide in advance that you will not strive for an exact replica of any animal. As with the Stocking Faces activity, you will find that this project will take on a "life of its own." Let it do this; help it do this. You may find that you've created a new species! Could it be a beaked lion? Could it have a pussy-cat face ringed by stegosaurus spikes? Or could it be a Cyclops-eyed, fanged fish head—maybe a saber-toothed trout?

Visualize and plan—up to a point, but leave a little room for serendipity.

2. You will now form the basic Trophy head. The ideal is to get it as detailed as possible *before* doing any papier-mâché work. The head should be as lightweight as possible, and the whole thing should be stable and secure—again, *before* you begin your papier-mâché work. Don't count on the final papier-mâché "skin" to give your sculpture the substance and strength it will need to last; spend extra time on the foundation *now*. It will pay off later. (Reread this for a minor philosophy-of-life message if you like that sort of thing.)

 Wad a couple of sheets of newspaper into the basic compact head shape you want, and secure the shape with lots of masking tape. You will use a lot more tape than you thought. Build up the shape of the head by taping on additional compact wads of crumpled newspaper. Attach each newspaper addition securely with lots of tape—you will even find yourself "modeling" with the tape as you form and wrap the newspaper. Your sculpture will probably take on a mummylike appearance. (Be lavish: Cheap masking tape works fine for this project and may even work better than expensive tape; you won't be as stingy with it!)

 As you work, remember to keep the back of the sculpture flat. Have each newspaper addition to the basic head shape "grow" naturally: If you wish to add a spike, horn, or ear, for instance, don't just plunk a preformed shape onto the head, but have the new shape start from a broader base that can be secured to the head underneath.

 From the very beginning, each part of the head should be as tight and secure as you can make it; don't try to "fix" the head later. It doesn't make sense to do papier-mâché work over a wobbly base—everything will crack and fall apart. *You'll be sorry,* but it will be *too late.* Make the head as detailed as you can with these two simple sculpture materials—newspaper and masking tape.

3. You can use aluminum foil and poster board to add further sculptural details. Tape the tightly twisted or crumpled foil to the newspaper head. Remember that a taped form that "grows" naturally from a broader base will be much more secure than a plopped-down one.

You may find that you've created a whole new species!

Have each newspaper addition to
the basic head shape "grow"
naturally. Here is a side view of
"growing" rhino head shape.

Poster board can be used in two ways at this point:

1) You could cut two-dimensional shapes such as horns, ears, or teeth and tape them to the head. This juxtaposition of flat shapes against a modeled one can be both unexpected and funny—it looks cartoonish. 2) You could plan simple paper sculptures (using lightweight poster board instead of paper) to create noses or ears. Use a ruler and the edge of a scissors blade to "score" the poster board for a crisp fold. Securely tape the folded shape to the head.

Your finished head, pre–papier-mâché, can look like a real hodgepodge of newspaper, tape, foil, and white or colored poster board—as long as it's a *secure* hodgepodge. No wobbles. You have made the "skeleton" and added the "muscles" to your Trophy head—now you are ready to cover it all with the "skin," the papier-mâché.

4. Over the years, I've noticed that there seem to be two kinds of art people: Some people like to get their hands goopy as they work—or at least they don't complain much—and some people hate to get their fingers directly involved with the art materials. And I've noticed that there are two schools of thought on papier-mâché work: Some people like to use a flour-and-water mix, while others prefer to use liquid starch. They find the starch neater, somehow. Even if you're a nongoopy personality, you'll have to "get your hands wet" at this point—but you will probably prefer to use the liquid starch. And if you hate even that—well, it will all be over soon.

How to mix flour-and-water papier-mâché paste: Mix up small batches fresh each time you work. Start with water in a bowl—picture the amount of paste you want to mix, and begin with that much water. (If you start with the flour instead, somehow you'll end up with enough paste to papier-mâché your entire house.) Trickle the flour into the water, and stir it up.

If you really want to loosen up, do this entirely by hand—use one hand to trickle and the other hand to stir. But if you want to stay tight, that's fine too—use a spoon. *You don't have to be entirely loose to be an artist; just stay a little loose—mentally.* Mix the paste

until it looks like thin oatmeal, and then wash your hands. Or wash the spoon. (If you use liquid starch for your papier mâché, no mixing is required. Just use it undiluted.)

5. Tear some newspaper strips. For this first part of the papier-mâché work—the bends and the joins—the strips should be about 1″ wide, or a little narrower, and about 2″ long. An odd fact: If you've never shredded newspaper before—and why should you have, really?— you will discover that you have to tear the strips from the top of the newspaper page to the bottom. If you try to tear from side to side, you will end up with little hunks, not strips. Tear long strips, then tear them into smaller pieces, depending on the length you need. If you've already decided that you want to stay tight, *cut* the strips.

Your first step will be to reinforce all the bends and joins in the head with the short newspaper strips. The glued lengths will be pasted over these potentially weak areas. Dip each strip into the paste or starch, and squeeze off *some* of the excess paste or starch. Apply the strips over the bends and joins, creasing the wet strips if necessary. Tear narrower strips as needed for any intricate joins. Cover all bends and joins with at least one strip before going on to the next instruction— but you don't have to wait for the paste or starch to dry before proceeding. Wrap small strips over the rear edge of the head to the back of the sculpture; this will give your Trophy a more finished look.

This juxtaposition of flat shapes against a modeled one can be both unexpected and funny.
Top: poster board horns and tongue
Center: poster board fins and teeth
Bottom: long poster board ears

6. Now you will papier-mâché the rest of the head. You really need only a couple of layers of well-glued newspaper strips for your finished sculpture to feel hard. More layers will make it stronger, but how strong does it really need to be? And it's hard to keep count of the layers. Determine how many layers you need by feel, not by numbers. When the glued paper is dry, prod it: If it "gives" too much in areas, add another layer or two of papier-mâché. This is an important art message: *Use your own senses and your own common sense* to tell yourself what is working and what isn't. Don't let instructions (even *these* instructions!) intimidate you.

The basic Trophy sculpture is covered with newspaper strips, flour-and-water paste, and powdered papier-mâché.

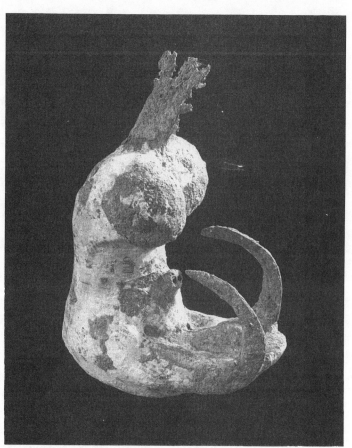

You could plan simple paper sculptures (using lightweight poster board) to create noses or ears.
Top: simple cone shape for ear, nose, beak, or horn
Bottom: ear or long beak

A common mistake people make is to attempt to wrap a long soggy newspaper strip around and around their sculpture. This may seem like a quick and efficient way to work, but it ends up looking sloppy—and you will lose much of the modeled detail you've worked so hard to get. Instead, work in one small area at a time. Crisscross the strips; work in different directions. This will make your sculpture stronger. If you have trouble covering a bulging, rounded spot with strips, tear up little newspaper patches instead.

If you need to stop work for the day in the middle of your papier-mâché work, that's fine—later on you can place the new wet strips right on top of the dry ones. Mix up fresh paste each time, though. Whenever you stop work for the day, run a final pasty finger over the whole sculpture to make sure that the newspaper is lying flat and is well glued. And wherever you put the

sculpture to dry, make sure that air can circulate freely around it. Otherwise, mold will grow on the damp newspaper.

7. Do a final layer of papier-mâché strips across the *back* of the sculpture.

8. Optional: You can add texture, model small details, and fill in tiny flaws with mixed *powdered papier-mâché*. This product combines ground up newspaper with dry paste; all you do is add water and stir. Mix only as much as you'll need for each session; it doesn't "keep" once it's mixed.

 WARNING: **In the bad old days, asbestos was one of the ingredients in some powdered papier-mâché. Don't take a chance: If you are using antiquated art supplies, toss out that cobwebbed packet and treat yourself to some new powdered papier-mâché.**

 When you have mixed up a batch, it will be dark gray and sticky, and it will test even the loosest among you—it does feel weird. But it can be worth it; you can get wonderful effects with it. You can model "hair"— imagine a hippo with bangs and a pageboy! Dip an old fork in water, and use it to "comb" the mixed papier-mâché. You can use small lumps of the mixture to model warts or flaring nostrils. Just don't try to use it snowball-style for large attachments. You should have already formed these from a lighter-weight material. As you did in creating the wadded newspaper base, remember to have these small attachments "grow" from a broader mixed papier-mâché base. You can also use the powdered papier-mâché to reinforce bends and joins or to fill in any little cracks that may have appeared. Dip your finger in water, and slick it over the powdered papier-mâché shapes if you want to smooth them. For a more prickly texture, use an old fork or a twig: Apply the sticky mixture to an area, then spike it up. Use the mixed powdered papier-mâché over wet or dry strips or over dried powdered papier-mâché.

 Sometimes when you start working with the powdered papier-mâché, it's hard to stop; many people have the urge to "frost" their entire sculpture. This is probably because the powdered papier-mâché dries dark gray—it looks funny next to the whitish dried newspaper strips. Since you are going to paint the

sculpture anyway, this color difference doesn't matter. Just use the powdered papier-mâché where you need to, and use the smallest amount possible for the effects you want. Remember that you will be able to add further sculptural details when you do the final *collage* work on the Trophy.

Allow your sculpture to dry slowly and thoroughly before you paint it. This may take several days.

Painting

1. First, you will give your dry sculpture a gesso primer; you could also use white acrylic paint for this. The

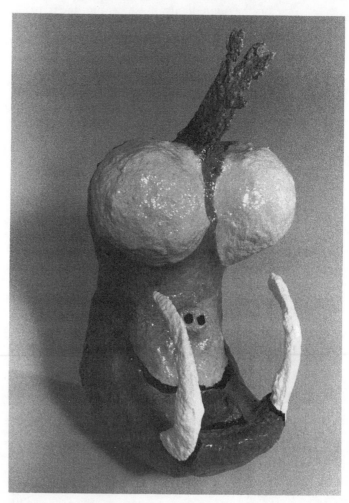

The Trophy sculpture is painted with gesso, acrylic paint, and glossy acrylic medium.

white base coat will seal the sculpture (which is why the sculpture has to be dry, or else the damp papier-mâché will rot under the gesso) and will provide a bright base for it. It will make your colors look brighter. *Do not use white tempera* for the primer unless you mix it with white vinyl glue; if you use plain white tempera, subsequent colors will "bleed" into it, creating unwanted tints.

Working on a big sheet of newspaper, slop the gesso on with a big brush. Get finicky later if you want, not now. If the gesso or acrylic paint is thick, thin it with water—you don't want thick paint to fill in the textured details you've worked so hard to get. You can always paint two thin coats rather than one thick one. Gesso and acrylic paint dry quickly. Wash your big brush right away with water.

2. For the rest of your painting, the best advice I can give is to *start with the big areas and work to the small ones.* The tendency is to work the opposite way—to begin with the "fun stuff," like the eyes, and then to attempt to paint around them. That's like putting on your make-up and then taking a shower.

A word about the paint:
Acrylic paints dry waterproof, and you can layer them easily. They come in tubes and squeeze out like toothpaste; you will want to thin them with water. Add only a little water at a time. Use a piece of aluminum foil for your "palette;" just throw it out when you're done. When mixing larger amounts of a color, you can line a bowl with the foil.

You can also paint with *tempera.* Mixing it with a little thick white vinyl glue will do three things for the paint:

- The colors will look a little brighter once they've dried. (Remember that white vinyl glue dries clear. This means, for instance, that bright blue paint mixed with the glue will look pale when wet but bright blue again when dry.)

- The surface of the dried tempera will look slightly glossy.

- The dried paint will be water resistant. Don't leave it out in the rain, but you will be able to layer your colors without them "bleeding" into one another.

You can really use any brushes with these paints as long as you wash them thoroughly with water right away when you're finished. As you paint, remember that even if you have formed a fairly recognizable creature so far, it needn't be realistic. You could paint a pale orange crocodile head, and spot it with turquoise. You might mix tints and shades of lavender for a retiring hyena. You may decide to leave a snarling tiger's head ghostly white.

Don't be afraid of painting in layers; just use smaller brushes for the more detailed shapes. As you work, think of the varied ways you can use the paint:

- You can thin some paint with water until it resembles a watercolor wash, and use it as a "stain." This thin paint works best as a dark color brushed onto rough textured areas; the dark paint looks "logical" as it sinks into the modeled fissures.

- You could stamp-print polka dots onto a fairly flat surface; if you use a damp sponge piece to print with, it will conform to the slightly uneven surface underneath.

- You might use a ragged damp sponge piece to blot a thin mottled second coat of paint over the first coat; this will create a furry textured look. Don't do this over a rough area you've already modeled with powdered papier-mâché. If you do, these two surface textures will "fight" and cancel each other out.

A word about the art:

There are several ways of making your *painting* more effective.

Size: Pay attention to the comparative size of the various painted areas. The tendency is to make things a little too "even" to be visually interesting—to have stripes evenly spaced and sized, for example, or to have eyes, cheeks, and surrounding polka dots all the same size. A narrow pin stripe, zigzagging back from the eyes, could be more dramatic. Tiny beady eyes might be funnier than big round ones. A furry textured area would look even furrier contrasted with a nearby smooth patch.

Color: Related colors blend together well, and will give your Trophy a harmonious look. Related colors are colors that are next to each other on the color wheel. Complementary colors will give your sculpture a jazzier look; these are colors that are opposite each other on the color wheel. Complementary colors can be "muddy" when mixed together—but that might be just the look you want!

Value: In art, this means light and dark, not how good something is. A strong contrast in value can make your art more interesting to look at. Reemerging artists often get distracted by color and have trouble judging value. To determine comparative value, squint your eyes when you look at the colors. You could contrast a shadowy mane with a lighter snout and a shiny black nose. Pale green eyes might glow from a dark shaggy head.

3. If you want your Trophy to have a glossy finish, take care of it now, before you go on to the *collage* work. If the entire uncollaged sculpture is to be shiny, spray it (outside, and on a large sheet of newspaper) with glossy plastic spray. **Always go outside to use any spray, and read the label carefully.** Or instead, you could brush medium-thin white vinyl glue or glossy acrylic medium onto the sculpture. Both of these look milky when wet but will dry clear.

4. If you are going to mount the Trophy onto a plaque, stain or paint the unvarnished plaque now. A wood plaque can be stained or painted, while a compressed particle plaque will look best painted.

 To stain the plaque: You can make an easy "fake" stain by combining a dye bath of rubbing alcohol or white vinegar with food coloring. Please see Clothespin Creature instruction #1 on page 94 for how to do this. (Red and green food coloring will yield a rich brown stain, but you could also stain the plaque red, violet, or some other unexpected color.) A final coat of glossy plastic spray (used **outside**), medium thin white vinyl glue, or glossy acrylic medium will make the plaque look shiny.

 To paint the plaque: Acrylic paints or tempera mixed with white vinyl glue will provide opaque color that will cover the plaque. Be sure to paint the edges of the plaque, too.

Collage

1. After the paint has dried, you are ready for the final step—collage. You might need to add just one little detail to make your Trophy come alive. A tasteful pair of earrings could adorn your buffalo head. Perhaps the monster you've created would look great wearing a

Feathers, plastic eyes and lashes, and glitter complete this Trophy sculpture, mounted to a plaque with two finishing nails and hot glue.

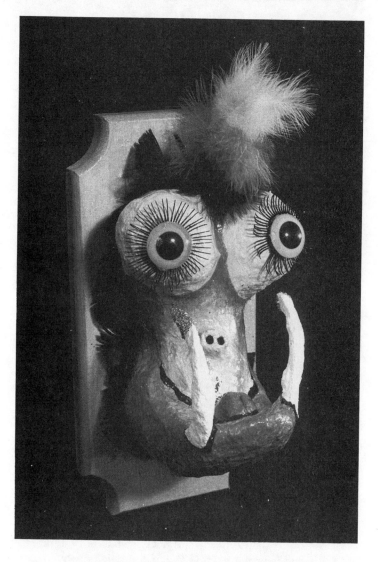

jaunty bow atop its head or with a paper Fantasy Flower tucked behind one of its many ears.

You might decide to do more extensive collage work on your sculpture, however. You could decide to cover a smooth Trophy head with glitter polka dots, for instance. Paint thick white vinyl glue, one circle at a time, on dry paint, and pour on the glitter. Work over a piece of aluminum foil, and use it to funnel the excess glitter back into its jar when you're done. **Be careful not to get the glitter near your eyes.** You could top your Trophy with a romantically decorated straw hat or

fashion a pointed felt cap for a more elfin look. Or what about a bridal veil for your python? Make it from white netting and artificial flowers. You might decide that long pink braids are just what your giant ant head really needs. Or perhaps a drooping yarn mustache would flatter your polka-dot piranha. Maybe you have an old wig or hairpiece stashed away. Could that be just what your Trophy needs? Use a hot-glue gun and/or thick white vinyl glue to attach the collage pieces to the papier-mâché base. **Be careful when you use the hot-glue gun;** squeeze the hot glue onto the base rather than onto any small piece you are holding.

Display:

If you are not mounting the Trophy onto a plaque but want to hang it, adhere two flat-backed picture-hanging hooks to your sculpture. Use a hot-glue gun or thick white vinyl glue for this. Twist on a length of picture-hanging wire, pound a nail into the wall, and hang your Trophy. Using two hooks will make it easier to adjust the sculpture once you've hung it.

If you have prepared a plaque, adhere the flat back of the sculpture to it with lots of hot glue or thick white vinyl glue. The sculpture should be lightweight enough for either of these adhesives to work. For additional security, pound two finishing nails into the front of the plaque before gluing. Poke two holes into the back of the papier-mâché Trophy, and work the Trophy onto the finishing nails. If you are using white vinyl glue as your adhesive, allow at least a day for the glue to thoroughly dry before attaching the hooks and hanging the sculpture.

Part Three

Harder Two-Dimensional Projects

(Mostly) Mixed-Media Projects in Two Dimensions

In Part One, most of the two-dimensional projects can be categorized as either Drawing, Collage, Printmaking, or Painting. But art isn't always that tidy; often, artists mix media to create wonderful art. For example, a drawing can be turned into a collage, a print can be stamped onto a painting, or collage materials can be applied to an underlying drawing. Most of the projects in Part Three encourage you to experiment with mixed media.

In addition, several of the projects in Part One are variations of previous projects. For example, the Hands Outline, Stickers, and Photocopy Art sections each contain several guided projects. In Part Two, you are encouraged to guide yourself through either the suggested project variations or to come up with your own variations. By now, you probably have the expertise to do this with more confidence.

The following projects, while using many of the same materials that you used in Part Two, require more time, advance planning, or initiative than the earlier projects. They're more of a stretch, which makes them a little harder.

The most important "stretch," though, might be in attitude:

- From now on, start to think of each completed project as a beginning, not as something you've put behind you.

- Reconsider a completed project. How would you do it differently? Then do it again.

- Work more slowly, and concentrate fully on each step; give your fullest attention to each small procedure.

- Lose yourself in the art.

- Consider **A word about the art** as a private art lesson rather than a potential stumbling block. (I consider **A word about the art** and **Variations** to be the most important parts to this section.)

- Pay special attention to the project variations; in fact, read the variations even before you begin an activity. By now, you are probably experienced enough with the materials to make your own adjustments to my instructions before beginning work.

NAMES COLLAGE

This fold-and-cut activity is a familiar one—at least at the start. Many of us have done something like this in elementary school or in junior high. However, with better materials and more sophisticated techniques, you can create an impressive, satisfyingly complex collage.

This project combines several symmetrical *names* in an asymmetrical composition.

Materials:

- Fadeless art paper

- Good scissors; manicure scissors

- Utility knife or X-acto knife

- Spray adhesive

Choose one of the following for your base:

- Colored mat board

This Names Collage features "Mirja" (a Finnish name) written above the fold, and with the *j* connected to the fold.

- Canson Mi Teintes pastel paper

- Heavy metallic paper

- Optional: patterned Oriental paper mounted onto the base

Work in an easy-to-frame size from the very start.
Here are some easy-to-frame sizes: 9″ × 12″; 11″ × 14″; 12″ × 16″. Ready-made frames are sold in these sizes.

Time:
This project will take an hour and a half to two hours to complete.

Instructions:

1. First, refresh your memory by cutting a practice name. Fold a piece of paper in half, the longest way. When using Fadeless art paper, fold it colored side in, white side out. Using pencil, lightly write your name in big cursive handwriting against the fold; all letters must be connected and should rest on the fold. If your name includes a lower-case letter that drops below the "line," such as *p* or *y*, for instance, lightly draw a guideline about an inch above the fold. Write your name on that pencil line, and have the bottom of the letter that drops below the line rest on the fold. *Something* has to be on the fold, or the project won't work. Cut around the outside of your name, about ½″ (or less) away from the drawn cursive line.

 Next, cutting into the fold, nip away the little spaces between the cursive lines—again, not right *on* the line. You won't cut wherever the line actually hits the fold. Finally, using either scissors, manicure scissors, a utility knife, or X-acto knife, cut away the interior spaces within rounded letters such as *O, B,* etc. **If you use a utility knife or an X-acto knife, cut on a thick pad of newspaper or an old magazine so you don't damage your counter or table.** Unfold the name, and see how it looks.

 This kind of fold-and-cut activity creates a symmetrical design: It's the same on both sides.

2. Now you are ready to cut out the names for your collage. You will need to cut out several names. You could

This Names Collage features "Antti" (another Finnish name) written on the fold, and with the interior shape of the *A* not cut out.

Cut around the outside of the drawn line.

This symmetrical Names Collage features "Nancy" and "Jerry." Line them up, stack them, and weave them together!

select family names, or the names of a few friends. Each name you choose will have its own character when you're finished with it.

A word about the art:

Value (light and dark) is important in this project. If you put midnight blue and dark brown names against a black background, for example, they won't show up well. Most people realize this. But if you put very pale colors against a light or reflective background, they won't show up well either. Look at your background color; it will determine the colors you select for the names.

There are many *colors* you can choose within any value range. Since this is an art project, don't just choose random colors that you like, but see how they look together against the background color.

You might choose "warm colors" such as pink and orange; these could look good against a black background. You might select intense colors: Vivid purple, green, and turquoise could be effective against a light or metallic background. You might choose tints and shades of one color for your names; your colors could range from palest petal pink to deepest rose. These colors could be mounted onto a lace-patterned Oriental paper (attached to a metallic paper or a richly colored base) or a dark color—forest green or black, perhaps.

Contrast in *texture* can add visual interest to your project. Fadeless art paper has a smooth, even texture. Mat board or Canson Mi Teintes pastel paper is a little rougher. Metallic paper, of course, is much shinier than any of these. Patterned Oriental paper has a soft, cloudy look. Pay attention to these various textures when selecting your materials.

The final thing to consider is *size*. How big will the combined names look on the base? Remember to make your "negative space" (the empty spots in your composition) count. Is there some variety in the comparative sizes of the names? Some should be big, but others can be tiny. (Additional variety can be achieved with the slant of your writing, the exaggeration of some letters, etc.) How beautiful are the cut-out names themselves? Experiment: Unfold each name between cuts. Look at each one as a separate design. You may prefer, for example, not to cut out the interior shapes from some of the rounded letters. If you are skilled at cutting, practice varying the thicknesses of your cut letters: One name might be all curves. Another could be spidery and fragile looking. A third might be a thick-thin design—almost calligraphic in style.

Fold your selected papers in half, white side out, and lightly write a name on each in pencil. Slowly and carefully cut out each name, allowing some space at each side of your cursive line.

3. *Don't glue anything down yet.* Take time at this point to experiment with the different designs you've created. Line them up, stack them, weave them together! Turn them as you play.

4. If you are going to attach patterned Oriental paper to a sturdier paper for your base, do it now. Cut the patterned Oriental paper bigger than the base—you will trim away the excess paper once you've attached the two. **Always go outside to use spray adhesive, and read the label carefully.** Put the Oriental paper face down on a big sheet of newspaper. Spray it lightly with spray adhesive. Test the sprayed surface to see if it's tacky; you won't be able to see the adhesive. *Do not* spray the base—exposed areas of spray adhesive will always stay sticky. Take the Oriental paper inside, and place the center of it on the middle of your base. Gently smooth it out to the edges of the base. Trim away the excess Oriental paper.

5. Plan your final Names Collage composition on the trimmed base. At this point, you'll be looking at the "names" as designs rather than as people. Don't be afraid to have some of them go past the edges of the base . . . it's nothing personal! Figure out which name should be the bottom layer; you'll adhere that one first.

 NOTE: You can use other adhesives for this project, but spray adhesive works best—the sprayed collage pieces will lie perfectly flat. The cut-out names can be fragile, and brushing them with paste or glue might damage them. If you need to use a different adhesive, though, try "Yes" paste thinned with a little water.

 If you've laced some names together, spray the backs of the joined names. Finish adhering all of the sprayed pieces to the base. Trim the edges again if necessary.

This asymmetrical Names Collage features "Patrick," "Tina," "Evan," and "Cassandra." Look at the names as designs rather than as people. Don't be afraid to have some of them go past the edges of the base.

Variations:

● Cut out intricate folded Fadeless art paper names to decorate your family scrapbook.

- Make a "bouquet" of names; throw in a few lacy paper leaves, too. Don't forget to overlap the collage pieces. This creates a more complex and interesting composition.

- Create a collage for yourself made up of words that you love or from names of objects that you love.

- Plan a collage that is determinedly symmetrical from start to finish. You will need to cut the folded words in staggered sizes before stacking them. Align them along an invisible vertical axis.

Display:

A framed Names Collage can decorate a kitchen or family room in a personal way. **If you hang it in your kitchen, make sure that its surface is covered with glass or plastic.** You want it to be protected during food fights.

CONNECTIONS

The next project plays with letters in a different way but still uses them as design elements. When we write in cursive, as in the previous project, the letters are automatically connected—each word is like a wire sculpture.

Connections encourages you to take a new look at the *printed* letters each of us sees every day. The straight lines and curves that make up these letters are beautiful—each letter is

This Connections piece uses white Canson Mi Teintes pastel paper, colored pencil, and marker. It's mounted on black Canson Mi Teintes pastel paper with spray adhesive.

like a separate picture. These little pictures can create pleasing designs when they are combined.

This project was inspired by a connected-lettering design project originally intended for elementary schoolaged children; over the years my older students kept changing the project and adding to it until it became something quite different. The activity now combines lettering with applied color, "negative space" exploration, and collage work to create a satisfying composition.

Materials:

- White paper (at least 9″ × 12″)
- Markers (not permanent)
- Ruler or straightedge
- Colored pencils or crayons
- Good scissors
- Manicure scissors, utility knife, or X-acto knife
- Spray adhesive

Choose one of the following for your base:

- Black mat board
- Foam board
- Illustration board
- Any color mat board covered with a lighter-weight paper

Wait to cut your base to an easy-to-frame size.
Choose one of the following for your background:

- Fadeless art paper
- Construction paper
- Canson Mi Teintes pastel paper

The straight lines and curves that make up these letters are beautiful.

Time:

This activity is made up of four different parts: *lettering, coloring, cutting,* and *assembling.* If you do the entire project in one session, it will take two hours or more. Each individual

part of the project will take about half an hour, although you will probably spend less on some parts, more on others. Take your time; enjoy each part. The prize will go to the slowest person.

Instructions:
Lettering

1. The idea in this project is to use individual letters as design, not to spell out words or messages. Some letters will be printed very big, while others will be small; many letters will be upside down or printed sideways. Select any letters you want. You could choose them randomly or run through the alphabet or print out all your family names.

 Begin with a large letter. Draw it slowly and carefully, and make it beautiful. If you want to, you can draw the straight lines with a ruler or straightedge. Give the paper a quarter turn, and draw another letter. *It has to be touching the first letter somewhere.* All of the letters will be connected—there will be no "floating" letters. Turning the paper helps keep you from "reading" the letters.

A word about the art:
You could do this entire part of the project in only one color and still make it interesting, but you can use as many colors as you want. Vary the size of the letters and the thickness of your line. Use a skinny marker for some of the letters. Mix upper- and lower-case letters; perhaps have a few large lower-case letters encrusted with some tiny capital letters. Vary and exaggerate proportion. Some letters can be tall and narrow, while others can appear flattened.

2. As you work your way out to the four edges of the paper, take the plunge and draw letters going right off those edges. (Work on a piece of newspaper to avoid marking your table.)

3. Look at your drawing from all angles, and see where you might add some final connected letters. Could some little spiky *M*s march around a large *O?* Are there enough curves to make it interesting? Throw in a few *B*s or *C*s. Did you accidentally "float" some letters? Connect them to their neighbors with additional letters.

Coloring

1. The next part of the project involves looking at "negative space." There are two kinds of negative space created by the letters in this project.

 Enclosed negative space is always found in letters like *B, D, O,* etc. You have probably already spent time in school coloring in these spaces during stimulating lectures. *Created* negative space is made by placing letters next to each other or by running them off the edges of your paper. (Each straight edge is an additional "line" in your drawing—for now, at least.)

 You will select *some* negative spaces to color in for the next part of the project. Other spaces will be left white.

There are two kinds of negative space created by the letters in this project. This is enclosed negative space.

A word about the art:
You can use colored pencils, crayons, or watercolor markers for this—alone or combined. You will have the most control using colored pencils. You can mix and layer colors if you use colored pencils or crayons. Dark marker lines may "bleed" into lighter colors, but markers provide vivid areas of color.

There are several ways to select which spaces to color.

- You could start in the center, coloring several adjacent spaces, then work your way out to the edges, coloring narrow connected spaces. You will create a radiating design.

- You could start at one side of your drawing and snake your way across to the other side, coloring only connected negative spaces.

- You could color all of the edge spaces and leave the center plain.

When you color, you can work right up to the drawn line or leave a narrow margin, as you did when cutting the Names Collage. Use any colors you want—and as many or as few as you like. *Do not use black* for this part of the project; bright colors or light applications of color work best.

2. Complete your selected coloring. Remember to turn the paper as you work.

This is created negative space.

Cutting

1. Now you are going to cut into your colored drawing and throw away parts of it—even some of the areas you've just colored. ("Oh no! But I spent *all that time . . .*") Don't worry—it was all for the good of the project. And anyway, you can allow a margin as you cut; this will yield a jazzy narrow border that you'll love later on.

 First, you will cut into the four edges, using a good pair of scissors. You want to open it up, make it lacier and lighter—you want to lose some of that boxy confining border. Don't be afraid to cut a couple of big hunks away from your drawing.

2. Next, you will cut away some of the interior spaces. You can use manicure scissors for this, but a utility knife or an X-acto knife will work better. **Always work on a thick pad of newspaper or an old magazine when using either knife.** The shapes you cut away could be enclosed spaces, created spaces, or larger combined spaces.

 Following the suggestions given for *coloring,* remember that:

 ● You could plan a design working from the center out.

 ● You could work from one edge to another.

 ● You could work from the edges in toward the center.

 Any one such "theme" will look better than random spotty cuts. Remember, also, to at least occasionally allow some margin between your drawn and cut lines— it will look good later on. It can be visually interesting to vary the size of this margin. *Take your time* when you cut, and avoid raggedy pulled corners.

Assembling

1. First, place your cut paper against a black background just to see how it looks. Too often, we neglect to use black. Then test it against various colors of Fadeless art paper and bright or dark construction paper. One or two colors apart from the black will look especially good under your design. Place your design on different base

The shapes you cut away could be enclosed spaces, created spaces, or larger combined spaces.

sizes, too. It will fill a 9″ × 12″ base or be "showcased" more on a larger base. Whatever base size you finally choose, make sure it is an easy-to-frame size such as 9″ × 12″, 11″ × 14″, or 12″ × 16″. Just in case.

2. Plan your final collage. You may want to change its size or color from your original plan—be flexible! Perhaps you now like the way a smaller base looks; you could even tilt your drawn and cut design so that it falls off the edges of the base. Trim it later.

Maybe you now like intense red rather than black as your base color; attach a big piece of Fadeless art paper to the foam board, illustration board, or mat board. Use spray adhesive (outside) for this, and trim away the excess paper later. **Always go outside to use spray adhesive, and read the label carefully.** You might want to add a second color to your base before attaching the drawn and cut design. This can provide a formal "framed" look as well as a jolt of color. A smaller taxicab-yellow rectangle mounted onto your black base could be just right. A dramatic black rectangle adhered to a lime green base might be perfect. Use spray adhesive (**outside**) to mount the smaller rectangle to the base.

In planning your final composition, *do not be afraid* to extend the fragile cut letters past the edges of this smaller rectangle or even past the edges of the base.

3. Take your drawn and cut design outside, and place it face down on a large *clean* sheet of newspaper. (Change newspaper often when using spray adhesive.) Spray the back lightly but thoroughly with spray adhesive; you won't be able to see the adhesive, but you can feel that it's sticky. ***Do not* spray the surface of the base—spray adhesive will always stay sticky.** Carry the sprayed design inside, and place it lightly on the prepared base. Smooth it down from the center out to the edges.

Variations:

● Whatever variation or repetition of this activity you choose to do, you will now be better able to "see" negative space and plan an improved design.

● You could do this entire project with only one or two letters, such as your initials.

● You might do a smaller version of this project; 5″ × 7″ is a small easy-to-frame size.

Display:

As with other framed work, **if you plan to hang this in the kitchen, make sure that its surface is covered with glass or plastic.**

Banner

The idea of a personal coat-of-arms or a heraldic banner is foreign to most of us. Even when we see one, it's hard to know what it means—the designs are handed down through the centuries and often need interpretation.

This lighthearted project gives each of us the chance to create an individual "banner," one that reflects our own personality. This is really a collage rather than a flutter-in-the-breeze banner, but if you're good at sewing, you can whip up a real banner from the design you create.

For simplicity's sake, the design of your banner will be made up of three parts: an area made up of color, one made up of pattern, and one with a personal symbol on it. *Your* banner, for instance, might include a patch of azure blue for color, bright blue and white zigzags for pattern, and crossed skis as your symbol. Or your chosen color might be bright red, with red polka dots on a navy blue background for pattern, and

your initials coiled in braided trim for the symbol. Ahoy!

The shape of your banner is up to you. It could be pennant shaped, for example, or long and notched. You will experiment with several different shapes before finally selecting one.

You will begin the project by doing "thumbnail sketches" of a few possible designs, then you'll choose one of them (or parts of each of them) for your Banner collage. The term "thumbnail sketch" just means a small working drawing, by the way—it doesn't really need to be as small as a thumbnail. But you want to plan your design; in art, you plan. You don't always just do the first thing that pops into your head. (You may end up with your first plan, but you'll know why!)

Materials:
For the thumbnail sketches:

- Typing paper or index paper

- Markers and/or colored pencils

Choose one of the following for the collage base:

- Foam board

- Mat board

- Illustration board (for a smaller Banner)

Other collage materials:

- Utility knife

- Assorted fabrics

- Assorted papers: Fadeless art paper, construction paper, tissue paper, metallic paper, velour paper

- Assorted trims

Choose among the following for your adhesive:

- Spray adhesive

- White vinyl glue

- "Yes" paste, "Stitch Witchery," "Wonder Web," or other fusible fabric (these are sold by the yard) and an iron

- Hot-glue gun

This Banner is made from foam board, Fadeless art paper, and gingham (with spray adhesive).

The design of your Banner will be made up of three parts.

You will use more than one adhesive; the collage materials you use will determine the adhesives.

Time:

Allow half an hour for the "thumbnail sketches" and at least an additional hour to complete your collage.

Instructions:

Thumbnail Sketches

1. First, draw out several possible banner shapes. The basic shape you decide on will determine much of your design. For instance, if you decide that your symbol will be an artichoke, you obviously won't try to put it at the very end of a skinny pointed banner.

2. Next, explore the different ways you can divide up these shapes into thirds for the three parts of your design. You may finally decide just to have straight lines separating equal chunks of banner, but this should be a conscious choice. For now, experiment. Exaggerate.

3. Using markers and/or colored pencils, begin to plan some possible designs.

 Color: Select a color that you like—select a color that you love. Try several colors on your Banner sketches. Choose a color that expresses the way you feel, that expresses your mood, or simply one that makes you look good!

 Pattern: One section of your Banner will be made up of a pattern—a repeated design. You may end up creating this section from patterned fabric, or you might assemble it on your own from papers, fabrics, and trims. It will probably include the color you've already selected.

 • A flowered pattern might look good on your collage and convey something about you.

 • Stripes or a plaid could convey something different.

 • Polka dots might be selected for their inherent humor.

 • Or perhaps the "real you" is a more random repeat design—lightning bolts, perhaps, or floating "blobs."

Do not limit yourself to patterned fabric remnants that you know you already have on hand—you can fashion your own pattern with collage. Come up with a pattern (and colors within the pattern) that is just what you want. Color several sample patterns on your thumbnail banners.

Symbol: The trick in planning this part of your Banner is to come up with a symbol that is simple and uncluttered but that still vividly says something about *you*. This will take some planning. The tendency is to try to say too much; remember, this symbol only needs to say one thing about you, not everything about you!

- It could be as simple as your initials—these are, after all, symbols of your name, which is a symbol of . . . you.

- You could choose a symbol of your work: What about an apple (for a teacher), a coat hanger (for a fashion designer), a gleaming badge (for a police officer), or a dollar bill (for a lawyer)?

- It could be a symbol of a hobby of yours. You could select a tennis ball, a stamp, or the telephone to represent you.

- The chosen symbol could somehow express something of your spirit: It could be a heart, a wishbone, or a question mark.

Think of a way to include your symbol in the Banner design. Consider repeating your selected *color* and even your *pattern* in the *symbol* section.

4. Draw the final Banner sketch on a clean piece of paper. Color it in with markers and/or colored pencils. If you keep a journal, this drawing would make a good addition to it. Put the date on the back of the drawing.

Collage

1. Using the utility knife, cut your Banner base. **Always work on a thick pad of newspaper when you cut.** If you are cutting a very long shape from foam board or mat board, cut one section at a time, moving the board

You will begin the project by doing "thumbnail sketches."
Top: thumbnail sketches of Banner shapes
Bottom: thumbnail sketches of possible symbols

so that you are always cutting on the thick pad of newspaper.

2. Assemble your collage materials. These will probably consist of an assortment of fabrics, papers, and trims, many of which you may already have on hand. Perhaps you will have bought something just for this project— half a yard of corduroy or calico, a piece of gold metallic paper or velvety brown velour paper, or a yard or two of fabric trim.

3. *Wait!* Before you attach anything to the base, plan which adhesive to use for each collage material.

A word about the adhesives:
Your goal is to have each collage piece securely attached without any warping, bubbles, or wrinkles. You want the adhesives to do their work invisibly and not to seep through the collage pieces or leak out around the edges.

Spray adhesive will attach most papers and lightweight materials, though. **Always go outside to use spray adhesive, and read the label carefully.**

White vinyl glue: If your base is foam board, you probably won't have severe warping no matter what adhesive you use. Mat board and illustration board are thinner, though, and will warp more easily. Avoid using white vinyl glue if warping will really bother you. Brush thick white vinyl glue onto the base to attach sturdy fabrics, don't just dab it on in spots. White vinyl glue sometimes seeps through thin synthetic fabrics and is apt to wrinkle most papers. A bead of thick white vinyl glue can be used to attach final trims.

"Yes" paste is good for adhering papers and medium- to lightweight fabrics. Collage materials lie flat with this adhesive. It will not hold heavy or bulky collage materials, however.

"Stitch Witchery," "Wonder Web," or other fusible fabric will bond fabric to fabric, or even fabric to paper perfectly flat. Please see Fabric Appliqué Gift Tags instruction #4, page 31, for how to use fusible fabrics.

A *hot-glue gun* can be used to attach final trims or heavy or bulky collage items such as buttons, pompons, tassels, or other decorations.

4. Attach your collage materials to the base.

A word about the art:
Work in layers, and work from the base up. *Do not* cut exact "puzzle pieces" to fit the base shape; cut pieces slightly bigger than the base, attach them, and trim them later. Then attach your smaller collage pieces to the top of the newly covered base. Avoid having pencil or pen guidelines visible on your collage pieces—these can really wreck the look of the project.

Although you are using fabrics this isn't a "hemmed" project. You need to pay special attention to the edges of your collage pieces. Paper, felt, and leather pieces will cut clean. Many fabrics can be cut with pinking shears to yield a decorative, nonfraying edge. Some loose-woven fabrics, such as burlap, can be deliberately unraveled to create a softer edge. A torn edge can be interesting, too. You can always cover some unsatisfactory edges with fabric or paper trims at the end of the project. Don't neglect black for this final work—it could be just what your project needs to pull it together.

5. Look at your almost-finished project from across the room. Turn it, and look at it from another angle. Do you like it better? Which way does it look best?

6. Finish adhering your final smallest (or bulkiest) collage pieces.

Variations:

● Make a family Banner or coat-of-arms with a section (and symbol) for each family member.

● If you like to sew, make a personalized appliqué throw pillow from an original design. Combine *color, pattern,* and *symbol* in one square.

Display:

This project is an odd shape, and you won't be able to frame it. You could, however, adhere flat-backed picture-framing hooks to the back of your Banner and hang it directly on the wall. Use a hot-glue gun or thick white vinyl glue to attach the hooks.

Two-Fold Nature Collage

In the Names collage project, you created a complex single fold-and-cut collage. This activity is more of a stretch.

For one thing, you will fold your paper twice before cutting it—your unfolded design will be that much more intricate. But the most challenging part of this project is that you will be cutting free hand—without a pattern, just with "nature" as your guide.

This project also asks you to recall some of the things you've learned so far about "negative space." You will be cutting some nature-themed negative spaces from your collage pieces—leaf-shaped holes, for instance, or dragonfly spaces. You will also assemble your final collage with a special awareness of the importance of negative space to your total composition.

Materials:

- Fadeless art paper or good construction paper
- Good scissors; manicure scissors
- Utility knife or X-acto knife
- Spray adhesive
- Optional: metallic paper or patterned Oriental paper (to cover base)

Choose one of the following for your base:

- Foam board
- Illustration board
- Mat board
- Canson Mi Teintes pastel paper

Cut the base to an easy-to-frame size such as 9″ × 12″, 11″ × 14″, or 12″ × 16″. (I also like a square base for this project, although it won't be as easy to frame later on.)

Time:

The project will take an hour and a half to two hours to complete. This allows enough time for you to repeat the activity, using the skills you've sharpened the first time around.

Instructions:

1. First, experiment with cutting a two-fold design. Fold a 9″ × 12″ piece of paper in half, then in half again. You now have a 4½″ × 6″ folded rectangle. When working with Fadeless art paper, fold it with the white

This Two-Fold Nature Collage is created from Fadeless art paper on Bristol board (with spray adhesive).

side out. The adjoining "L"-shaped folded sides of the rectangle will be the skeleton of your design. No matter how much you cut away, some of this bent skeleton must remain.

Your goal is to come up with a cut design that uses *both* folds. When you unfold your paper, you don't want to find a design that you could have gotten with only one fold. (You could always do some of those deliberately, and include them in your collage, though.)

Starting at one of the two unfolded sides, cut out a 2″-wide folded "L." If you were to unfold it, it would look like a cross. Keeping it folded, cut away a little more along the two unfolded sides. Think "nature." You could cut joined half leaf shapes or butterfly wings. For example, maybe you prefer an undulating wave or serpent pattern.

Center your design on the two folded sides.
Center and bottom: negative design cut away from folds

Finally, cut away *something* from the two folded sides. You could cut out shapes similar to those you created along the outer edges. Perhaps you'd prefer to introduce something new, such as a "negative" blossom or cloud shape. Unfold the paper, and see what you have.

2. Fold and cut a second practice paper. This time, *do not* cut out a preliminary wide "L" shape. In fact, try to use some of that previously-cut-away area in your new design.

3. You will assemble your final collage from several of your best fold-and-cut designs. Cut enough that you will have an assortment to choose from and experiment with. Select a few Fadeless art paper colors that look good together and look good on your base color. Your base can be any color—you can always cover a stiff base with paper before attaching the cut designs to it. Don't worry about making the colors that you select "realistic" such as green for leaves, or yellow for daisies. Just choose colors that you like. Fold and cut various sizes and proportions. The only thing that these need have in common is two folds.

4. Prepare your base if necessary. If you are covering foam board or illustration board with Fadeless art paper, metallic paper, or patterned Oriental paper, cut the paper a little bigger than the board. Use spray adhesive (**outside**) to attach it, then trim the edges. **Always go outside to use spray adhesive, and read the label carefully.** You might decide to inset a second color on the base. For instance, your 11″ × 14″ base could be black, and a red 9″ × 12″ rectangle could be joined to that. Black, green, and pink cut-out designs could then be mounted onto the red rectangle. Or a big silver circle could be attached to a dark blue 12″ square base, and black and blue cut-out papers could creep across the circle's edge.

5. *Don't glue anything down* on the prepared base just yet. Play with your fold-and-cut designs first. Stack them in different ways.

- Did you cut away enough from the folds to create airy, open designs? Fold and cut some more if necessary.

These Two-Fold designs are cut from illustrated compositions. The top, center, and bottom designs correspond to the top, center, and bottom illustrations on page 156.

- Is there contrast between the sizes of your "positive" designs, or are all leaves the same width, all flowers the same size?

- Is there enough variety in the sizes of your positive and negative spaces? People often inadvertently make these spaces the same. For instance, you might accidentally cut regular ½" blades of grass with a ½" space between each blade, or have equal 1" spaces between your 1" wide leaves.

- Did you cut enough of your collage pieces in different sizes and in varied enough proportions—long and skinny, for instance, or short and squat?

Your Two-Fold Nature Collage will be more interesting to look at if there is this kind of variety. If you need to recut any designs or to cut any new ones, do it now.

6. Plan your final composition.

A word about the art:
These fold-and-cut designs are all symmetrical. You can use them in a symmetrical composition, or you can plan an asymmetrical composition. Experiment with both. Whichever way you decide to work, remember: Do not be afraid to have some collage pieces go off the edges of your base; it may strengthen the design. You can trim them later. Do not neglect to make the negative spaces (*around* your designs as well as *within* them) work for you as strong parts of your total composition.

Think "nature."

7. You will use spray adhesive to attach the designs to the prepared base. Place the cut-out designs face down on a large sheet of newspaper. Spray them with the adhesive. Change the newspaper if necessary—don't put your designs face down on a sticky sheet of paper. Carry the sprayed pieces inside, and position each one, center first, on the base. Smooth each one down from the center out to the edges. You can reposition your designs if necessary, but be careful not to tear them—they will be fragile.

8. Using your utility knife, trim away any parts of the design that extend past the edges of the base. Put the collage face down **on a thick pad of newspaper,** and make your cuts with a sharp new blade. You could also use scissors to trim the edges.

9. If you have time, *repeat* the project. Try to make time! Choose your colors carefully. Cut your designs a little more skillfully. Plan a dramatic composition. Spray and position your collage pieces perfectly.

Variations:

- If your final project was symmetrical, make another. Plan an exaggerated asymmetrical composition.

- Create a composition in which the negative space takes up more room than the positive space does.

- Using very small two-fold cut designs, make a set of post cards or note cards. Attach a contrasting color to the card, and then mount the cut-out design on it. **Use spray adhesive (outside) to flawlessly attach the papers to each base.** Remember to spray the backs of the papers—don't spray the base. Exposed areas of spray adhesive will always stay sticky.

- If you sew, appliqué a pillow using a two-fold design.

STAMP CARVING

In Part One, several projects using store-bought rubber stamps were outlined. Those stamps are fun to collect and use, but you have to content yourself with what's available.

You can make a simple stamp quite easily, though. It's a quick and inexpensive project, too. While you won't be able to work big or in tremendous detail, you will be able to find many ways to use these home-made little stamps.

Materials:

- Art-gum erasers (buy several if possible)
- X-acto knife
- Inked stamp pads (These come in several colors—even with swirled colors!)

Time:

It will take only a half-hour to do the Stamp Carving and another half-hour to stamp-print a couple of small projects.

Top: positive hearts
Bottom: negative hearts

Instructions:

1. First, dust off an art-gum eraser, and stamp-print one of the square ends. That prints as a positive square. You will cut a little design into that end first. Don't clean off the ink before you carve. In fact, the ink will make it easier for you to "see" the way your design will print. *Do not cut very deep* into the eraser—about ¼″ is fine. A deeply cut design won't print any better than a well-cut shallow design. In fact, you should be able to cut away several unwanted carvings and start fresh on the square end of each eraser.

2. Plan your first Stamp Carving.

A word about the art:
If you are still a little hazy about "positive" and "negative," take some time now to understand these concepts. Should you decide, for example, to create a heart, it could be cut and printed either way: If you want a *positive* heart, you will cut away the edges of the eraser square, leaving a raised heart shape. That's what will print—you won't see any of the square at all. If you want a *negative* heart, you will cut a heart-shaped hole in the eraser square. What will print is a (negative) heart in the middle of a square.

Letters of the alphabet must be carved in reverse.
Left: carved image
Right: stamped image

Remember that, as with other printmaking projects, your stamped image will be the *reverse* of what you've carved. This won't make any difference with a heart, but it will if you carve your initials!

Keep your carved design simple. Silhouetted shapes work best—avoid a lot of interior detail. You can always combine your carved stamp with other designs if you're feeling ambitious.

3. Carve your design. **Be careful—the X-acto knife is sharp!** (At least it should be.) You can draw your design out first with a skinny marker. Now, using the X-acto knife, "draw" the design in a vertical cut about ¼″ deep. Next, either carefully cut away the square eraser edges, right up to the vertical cut (to create a positive image), or scoop out the design (to create a negative image). Many people find it easier to cut straight lines at first.

You could carve a recognizable object such as a letter, a flower, or a star; or you could simply carve a negative pattern into the square. These nonobjective

Make two diagonal cuts, creating a negative "notch." These stamps are notched art-gum erasers, printed dark to light.

This daffodil composition combines two stamped images.

designs are the easiest to make and often look the best when printed. (If you are carving out long "lines" for a nonobjective design, you will make two diagonal cuts, creating a negative "notch," rather than vertical cuts.

4. Test-stamp your design, and correct it if necessary. If you decide just to start all over again, slice off the carved end of the eraser (or carve the other end!). Make sure that you slice it with a nice straight cut, or else you won't get an even print later on.

5. Here are some things that you could make with your Stamp Carvings:

 ● Print your design in the corner of a post card, note card, or envelope.

 ● Make a custom design for a party, then stamp-print it on place cards or small paper napkins.

 ● "Stencil" a design in a doll house—just stamp print a tiny pattern along a wall.

 ● Stamp-print your design on tissue paper or Fadeless art paper to make a unique gift wrap.

Variations:

 ● Plan a composition in which you print your design more than once. You could overlap two hearts, for instance. You could also scatter several balloons or flowers across the top of a page. (Draw in the balloon strings with a skinny black marker.)

 ● Plan a little composition using two or more Stamp Carvings. You could print your design in one or two colors. For example, you could print black spots on a red ladybug. You could print stars hanging above clustered pine trees. You might carve each initial (reversed!) in your monogram, and then combine them.

Here are some stamped balloons with drawn strings.

- Carve an ant, and march it across a paper picnic table-cloth.

- Design a tiny paw print, and stamp it along the border of your kitchen cutting board. Yikes! Use black *acrylic paint* for this.

- Print your design in white along the top of a clay flower pot. Use *gesso* for this—paint it directly onto the carved stamp for each separate print. Wouldn't a procession of snails enhance your pot?

Ants!

The last two variations provide an introduction to the next project, Pillow Pattern, in which a formal design is stamp-printed onto fabric.

- Using heat-set fabric dyes (such as Peintex Fabric Dyes from Sennelier), stamp-print a little design on a pocket or sleeve. Please see Fruit and Vegetable Prints, page 58, for how to use these dyes.

- Print your design in a big formal pattern. Fold a piece of tissue paper into crisp squares or rectangles, then unfold it. Use these creases as your only guidelines. You could "checkerboard" your pattern. You might decide to print only on every folded "intersection." Iron your finished composition if you want, and mount it onto a sturdier base. Use spray adhesive (**outside**) for this.

Pillow Pattern

We enjoy decorative design every day—in clothing patterns, wallpaper, curtains, and gift wrap, for instance. But most of us have never learned how to plan and make a patterned design for our own enjoyment.

In some countries, decorative design is a regular part of art education, but in the United States we are "exposed" to it only if a teacher has a special interest in it. (And isn't it strange how often we say "exposed to it" when we're talking about art? It sounds so deadly.) That's a shame, because even a very simple design can look impressive when printed in a formal repeat pattern. It's a satisfying process.

This project gives you a chance to learn this for yourself. It is called Pillow Pattern because your printed fabric can be used to make a throw pillow, but you don't need to be able to sew to do the project. Maybe you're just not a throw-pillow kind of guy. . . .

This stamp is carved from an art-gum eraser, then is printed with gesso, on a clay flower pot.

This same project can be mounted and framed instead. Or the same grid-ironed printing method can be used to decorate a pillow slip border, sweatshirt back, or T-shirt.

Read through the Pillow Pattern activity to decide which of these you'd like to try—the basic planning and printing methods are the same for all of them. Remember, though, that dyes are transparent and should be printed on white or light fabrics. If you use acrylic paints instead, you can print on darker colors, but the printed image will feel a little stiffer.

Materials:

Choose one of the following for your fabric:

- Muslin

- Medium-weight white cotton

- Unprimed canvas

If you have at least two squares or rectangles, you will be able to practice on one. Work 15" or larger; allow an inch on all sides for sewing the pillow. Wash and dry the fabric before printing it if you're concerned about shrinkage.

Optional:

- Pillow slips

- Aprons

- Sweatshirts

- T-shirts

Create your stamping image or repeat design from one or more of the following:

- Stamp Carvings made from art-gum erasers (please see Stamp Carving, page 158)

- Sliced fruits or vegetables (Please see Fruit and Vegetable Prints, page 58, for suggestions.)

- Simple carved potato design

- Hand-painted designs

The "apple" of this stamp-print image is created from a sliced apple.

You could print any one of these alone, or you could combine them. Here is how you might combine all of these methods to create a repeat pattern: You could slice a small apple in half and print it in red. Then you could carve apple seed shapes into an

art gum eraser and print them on the apple in black. You might then carve a leaf shape from a potato half and print it on top of the apple in bright green. You could then hand-paint a little apple stem or a darker green leaf vein.

To make a stamp pad:

- Styrofoam meat tray, aluminum foil, or big plate
- Paper towels, flannel scrap, or old washcloth

You may get a clearer stamped image if you paint directly onto the stamping image with a good small brush. ("Good" means that the bristles don't fall out when you paint.)

Choose one of the following to stamp-print with:

- Heat-set fabric dyes (Choose a brand like Peintex Fabric Dyes from Sennelier, which are available at an art supply store or through a catalog. *Be sure to get dyes that can be heat-set by ironing.* You will need only a small quantity of one or two colors.)

- Acrylic paints

You should be able to wash fabrics printed with either heat-set dyes or acrylic paints. (I advise against combining heat-set dyes and acrylics in any one project though. There's no technical reason for this; I just don't like the way they look together.)

Time:

If you have already prepared your Stamp Carvings and potato prints, this project will take about an hour. Allow extra time for practice-printing, for printing complex patterns, or for repeating the project.

Instructions:

1. Fold your fabric in half, and iron the fold. Then fold it smaller, ironing a crisp crease each time. Unfold the fabric, and see if you like the pattern of ironed creases that you've created. You may want to iron in a few more "lines." You will use these lines to plan your patterned design. You might print inside the squares or rectangles that you've created. Maybe you will print directly on the folded lines. You could print your pattern on the creased intersections where the ironed lines cross.

 Plan a simple patterned design using one stamped image or a combination of them.

You will use these ironed "lines" to plan your patterned design.
Top: design printed on the ironed line
Center: design printed at diagonally ironed intersections
Bottom: design printed inside ironed lines

2. If you are going to make a stamp pad for this project, do it now. The stamp pad can be a useful tool, and it creates a distinctive stamped image. However, you may prefer to hand-paint your stamping image each time if:

- Your stamping image is a little uneven

- You want a less coarse stamped image

- Your stamping image is very detailed

- You are using acrylic paints and you tend to work slowly

 Here is how to make a stamp pad: Slightly dampen folded paper towels, a flannel scrap, or an old washcloth with water. Place the dampened material on a Styrofoam tray, piece of aluminum foil, or big plate. Don't use too much water to dampen the material, or you'll inadvertently lighten your dye color. Paper towels or flannel will give you a finer-textured print; a washcloth will yield a coarser print that may be just what you want. Brush the dye onto the damp pad. *If you are using heat-set dyes,* label each color—they can look alike before you set them with the iron.

3. Print your planned pattern on the grid-ironed practice piece of fabric. You may end up liking this piece the best when you're done with the project. Because of this, even when practicing, always try to do the best job that you can.

A word about the art:
When overlapping transparent colors, print the lightest colors first. Try to repeat combined designs as precisely as possible. Print your pattern going off the edges of the fabric, even if you know that you'll lose parts of it later when you assemble the pillow or frame the piece. Don't be afraid of the empty spaces. You could print only a few scattered nosegays on the material or you might checker tiny broken hearts across your fabric. Remember that this is a composition—don't overload it.

4. If you printed with heat-set dyes, "develop" the colors with the iron. Follow the instructions that came with the dyes.

5. *Take some time now to evaluate what you've done.*

- Is your pattern interesting to look at?

- Could it be improved by overlapping a design (the same stamped image or another image) or by adding another design?

- Do you like your color choices?

- Is your design too fussy—is there anything that you can take out?

- Are you happy with the quality of your stamp-pad printing, or do you want to try hand-painting the designs?

- Did you print the pattern with enough control and precision?

Print your second piece of fabric. There should be some improvement!

6. Iron the fabrics to remove all of the creased lines.

7. If you are good at sewing, use one of the printed squares or rectangles as the front piece for a throw pillow.

Variations:

- *Mat and frame* the printed fabric instead. You may want to trim the fabric to a smaller or easier-to-frame size first. Cut foam board, illustration board, or mat board to your frame size. Mount your finished project onto the cut board. If your fabric is thin enough, use spray adhesive to attach the fabric to the board. **Always go outside to use spray adhesive, and read the label carefully**. If the fabric is heavy, such as unprimed canvas, you may need to use "Yes" paste instead. I suggest choosing foam board as your base if you use "Yes" paste. Thin the paste with a little water if necessary. Brush the paste onto the foam board, then press the fabric onto the pasty board. If you decide to have a window-cut mat over your fabric, select a beautiful color. Cut the window with your utility knife (**on a thick newspaper pad**) or have the window cut. Save all mat board scraps—even small ones—for other projects.

- Grid-iron the border of your child's *pillow slips,* and stamp-print his or her initials. (Please see Stamp Carving, for instructions, and remember to reverse the initials.)

- *Aprons* can be grid-iron printed too. Iron a small grid

T-shirts can be printed using any
of these ideas.
Top: stars printed on diagonally
ironed grid
Center: clover printed around neck
and at hem
Bottom: Mice printed on pocket

across the top of the apron, or iron even guideline "pleats" along the bottom hem. Cut a little muffin shape into a potato half, and print it evenly on the grid. Print a sliced mushroom standing at attention on each ironed "pleat." If you want a more informal print, paint the dye onto a sprig of parsley, and then stamp-print the parsley onto an apron pocket.

● *Sweatshirt* backs can be ironed to a small grid, or a sharp crease can be ironed down each sleeve. Use these lines as printing guidelines. Paint and stamp-print a soft leaf onto the grid in a repeat pattern. Drop a line of tiny exclamation marks down one sleeve. (Please see Stamp Carving, for how to carve an art-gum eraser.)

● *T-shirts* can be printed using any of these ideas. Iron a diagonal grid on a T-shirt back, and print multicolored stars onto the grid. Prepare the stamping images from art-gum erasers (please see Stamp Carving,) or a sliced potato. Ring a T-shirt neck evenly with a carved four-leaf clover design. Line up three little mouse silhouettes along a T-shirt pocket. If you are printing on thin T-shirt fabric, put newspaper inside the shirt so that the dye doesn't seep through and spot the other side.

● Cut a simple square and triangle from an art-gum eraser (please see Stamp Carving) or a sliced potato. Print a *quilt*-type design using only these two stamping images.

● Try at least one *hand-painted* grid-ironed project. This looser approach combines well with the structured composition. Your painted design can be very simple. If you're nervous about your brush work, begin with the puffy squeeze-on fabric paints and glitter now available. Iron a grid or a sharp crease on the fabric. Squeeze a simple pattern onto the lines. Intersect three short paint lines to form a star. Squeeze little dots of paint to form a design. Combine dots and lines to create a repeated "happy face" pattern—or at least a moderately cheerful one. Later, try a brush painted design. The exactness of the grid will make even a simple pattern look good.

FANTASY CARDS

This activity is really very simple, but it will *look* like it was hard! It's one of those projects that developed more by

accident than design but—typically—is almost universally admired.

Philosophically, there are two things that I especially like about this project. First, it combines many different types of paper and thrives on torn edges. You will work big, loose, and fast, and you won't think too much. We hardly ever work this way.

Second, the project finishes with a random division of this preliminary work—and turning over your cut Fantasy Cards is like opening a surprise package. It's fun!

In this one project you will make several sets of post cards, but you could also cut the collage smaller to make gift tags or bookmarks. As always, you could also change the project. You might do the initial collage on paper, cut it into patchwork squares, and mount them onto note cards.

If you're looking for something to make for a fund-raising activity, this project could provide the answer.

Materials:
For your base:

- Bristol board (Bristol board is sold in individual sheets. The sizes run 20″ × 30″, 23″ × 29″, and 30″ × 40″. If possible, buy "medium surface" two-ply board in one of the two smaller sizes.)

- If you can't find Bristol board, do the project on lightweight poster board.

These Fantasy Cards are created from Fadeless art paper, Oriental papers, and metallic paper on Bristol board (with spray adhesive).

Use any or all of the following for your collage:

- Assorted papers: tissue paper, Fadeless art paper, construction paper, metallic paper, velour paper, patterned Oriental paper, marbled paper, gift wrap, aluminum foil, doilies

- Newspaper, magazines, old letters, old snapshots

- Stickers, rubber stamps, paper trims

Other materials:

- Spray adhesive

- Yardstick

- Utility knife or good scissors

Optional:

- Skinny black permanent marker
- "Yes" paste

Time:
This project will take about an hour to complete.

Instructions:
There are two parts to the project. First, you will make a big collage on a full-size sheet of Bristol board. Then you will turn the collage over, divide the board into small rectangles, and cut the board. You'll do all of this without peeking; you want to be surprised when you finish—and you will be!

1. Assemble the papers you want to use for your collage. Even if you plan to do more than one collage, work on only one at a time. At least some of your papers should be big—you want to cover the board quickly and then build up areas with more collage work.

A word about the art:
This is really a crazy-quilt, patchwork approach to collage, but there are several ways you can make the project look good.
Color: You can still have a "color scheme" when combining many different papers. "Warm colors" are red-violet, red, red-orange, orange, yellow-orange, and yellow. "Cool colors" are yellow-green, green, blue-green, blue, blue-violet, and violet. Or what about black and white and red all over?
Texture: Try to come up with papers that feel different (and look like they feel different) from one another. Metallics, foils, and magazine papers are glossy. Velour paper is fuzzy. Construction paper has a matte surface. Fadeless art paper looks a little slicker. Tissue paper and Oriental paper provide a soft-looking texture. The U.S. Postal Service doesn't require all mail to feel the same!
Pattern: Your collage could be all patterned papers or all solid colors, but a mix of the two can be visually interesting. Even with a mix, your collage will feel "pulled together" if you repeat the same pattern or color elsewhere on the collage. You could make a collage from newspaper pages (pattern), aluminum foil, and red tissue and Fadeless art paper. You might combine a big torn sheet of floral gift wrap (pattern) with peach velour paper, gold metallic paper, dark green tissue, and doilies.

2. Make your big collage. Start with big shapes.

A word about the art:
Make the first shapes nonobjective; don't cut out elaborate images. Save detailed cutting for later in the project. The *worst* way you could begin would be to cut out little recognizable paper shapes and scatter them around on the Bristol board. The *best* way to begin is to tear several big pieces of paper into long pieces and attach them to the bristol board. Use spray adhesive (outside) for this. **Always go outside to use spray adhesive, and read the label carefully.** Spray the adhesive onto the backs of the papers, not on the board. Turn the board as you work—this project doesn't have a top or a bottom. (And don't fall in love with it—you're going to cut it up later.) Make the whole collage surface equally interesting. Just keep layering big areas until the board is covered.

Torn edges work extremely well for this part of the project. *Overlap* some of the pieces. *Vary* the size, direction, and width of the pieces—as well as the color, texture, and pattern mentioned earlier. *Go off* all four Bristol board edges. Don't let your collage pieces form an "island" that hovers nervously in the middle of the board.

3. Enrich your big collage with some additional work. Strips or patches of fancier paper (metallics, velours, marbled papers, etc.) can be added. Special collage materials such as doilies, snapshots, or paper trims can be attached. Use "Yes" paste if the collage paper is too heavy for spray adhesive to hold. If you like to cut out magazine pictures with detailed decoupage-type cutting, add these now. Stickers can be applied to the collage surface. Rubber stamps can be printed now, too.

A word about the art:
Don't treat these additional collage pieces with too much reverence. Stickers can hide part of an old snapshot. Metallic lightning bolts can fly across decoupage-cut zinnias. A fragile doily can partially cover dark "Postage Due" stamps. Build it up—your final collage will look richer if you do.

Look at your finished collage from all angles; turn it. Does any part look skimpy? Is everything firmly attached? Trim away the excess paper from the Bristol board edges. There should be something to trim from all four edges.

4. Turn the collage over. The next step is to divide the

Bristol board with a post card–sized grid. Most post cards are 3½″ × 5½″. If you make bigger post cards, you will have to use more postage. Use a yardstick and pencil when you draw your grid, and keep the pencil lines very light. To check your measurements, make *three* marks for each line. Grid the entire Bristol board with faint pencil lines. There will be some board left over; you can use even the narrowest leftover strips as bookmarks.

5. Cut the measured board into little rectangles. *If you use a utility knife* for this, cut against a ruler or straight-edge. Use a new blade for this. **Be careful, and always cut on a thick pad of newspaper when you use the utility knife.** When you have finished cutting, erase any visible guidelines with an art-gum eraser.

6. Turn the rectangles over. Ta-da! If a few of them look really bare, tart them up with some collage scraps. But most of the post cards will be perfect just as they are.

7. Optional: Draw a line down the middle of the blank side of each card. Use a ruler and a skinny black permanent marker for this. You could also draw little "stamp" squares in the upper right corner of each card. If these are to be gift sets, though, be a sport! Paste a *real* post card stamp on each card. Package sets of four or six cards in small plastic bags.

8. If you need a few gift tags, cut into some of the small post-card rectangles. Gift tags can be any shape or proportion, remember. Using a single-hole punch, punch a hole in a corner of each tag, and loop narrow ribbon or metallic cord through each hole. Cut the collage scraps into bookmarks, and write something mushy on the blank sides.

Variations:

● Plan more of a "theme" for your initial collage.

A Valentine's Day collage might be a composition of pink and rose tissue, crimson Fadeless art paper, floral gift wrap, decoupage-cut flowers, gold metallic paper, heart stickers, stamped cupids, and a couple of old love letters.

A Christmas collage could combine red and green Fadeless art paper, red and green tissue, black velour

paper, lacy white Oriental paper, scattered gold stars, Christmas stickers, and stamped evergreen sprigs.

Or if you have a striking sheet of turquoise and lime green patterned gift wrap, you could have that be your initial inspiration. Combine it with like-colored areas of tissue or Fadeless art paper with bottle green as an accent color. Then bring in some white (doilies, Oriental paper) and black (velour, Fadeless art paper); perhaps silver (metallic paper, foil, or paper trim) would enrich it, too.

- Cut part of the big Bristol board collage into a square, then make a simple puzzle. Lightly pencil in the puzzle lines on the blank side of the square. Carefully cut the square into puzzle pieces. Keep the puzzle in a clear plastic bag.

- As mentioned in the introduction to the project, you could do the collage on paper instead of Bristol board. You could use a big piece of paper for this, or you could work on a smaller size. A 12" × 18" piece of construction paper or Fadeless art paper can serve as your collage base. Even an 8½" × 11" piece of index paper could serve as your base. *As long as you use spray adhesive,* your collage base can be fairly thin; it still won't buckle or warp. Cut this thinner collage into smaller pieces, and attach them to folded note cards.

- You could also cut a thinner collage into small squares. Select the most interesting ones. Turn them around; place them next to one another in different combinations. Mount six or nine of them on a piece of colored mat board or Canson Mi Teintes pastel paper in a new grid pattern. (Cut the base to an easy-to-frame size first.) Leave a narrow border of the base color showing around each collage square.

- Take some of the post cards and add a final meticulously cut magazine picture to each. Don't always "float" these pictures—have them go off the sides of the cards. Trim the cards later. Use spray adhesive (**outside**) to attach the pictures to the cards. Spray the backs of the pictures, not the cards.

- As in Collage Portrait (**Variations**), create a set of surreal post cards entirely from beautifully cut magazine pictures.

FEATHERS AND STICKS

Many reemerging artists think of drawing only as something that they can't do; in fact, maybe it was Art Waterloo for some. But drawing can not only make beautiful art, it gives the artist a unique opportunity to "know" what is being drawn.

This drawing project is "pen and ink" without the pen. Rather than drawing the way you write, or balance your checkbook, or make grocery lists, you will draw with two tools that you've probably never used before. You will use a feather for one drawing and a stick for the other.

And why not have a connection between your drawing tool, what is being drawn, and the way you draw it? In Feathers and Sticks you will draw each subject logically, the way it "grows." Your drawing tools are perfect for the subject matter, and they will encourage you to break away from fussy school-type lines.

Materials:

- Feathers and sticks—some to draw with, some to draw
- India ink
- Aluminum foil
- Pencil; art-gum eraser or kneaded eraser

Choose one of the following for your paper:

- White drawing paper (avoid slick papers)
- Watercolor paper
- Oriental papers (light colors)

Optional:

- Mount drawings on colored mat board cut to an easy-to-frame size
- Spray adhesive or "Yes" paste to mount the drawings onto the board

Time:

Allow an hour for a leisurely feather-and-stick gathering walk and another hour for drawing.

This design is drawn with feathers.

Instructions:

1. Go for a nice long walk with a friend. Look for likely feathers and sticks—you'll need several of each. These needn't be spectacular; don't chase any peacocks or shinny up redwoods. One of the points of this project is that beautiful things are all around us, even under our noses. And that's where you'll find your feathers and sticks. Go home, and sort through your treasures. Select a feather to draw—maybe one with a nice curve, dramatic markings, or fluff at the bottom. Select a stick to draw—perhaps one with interesting knobs and bends or even a modest branch. (Your drawing stick will be simpler.)

2. Cut your drawing paper into smaller pieces. You can work very small, and you can either cut the paper to easy-to-frame sizes or mount an odd-sized finished drawing onto an easy-to-frame base later on. If your base is 5″ × 7″, the drawing will need to be smaller.

 It will take a while to familiarize yourself with this kind of drawing. You will draw several feathers and several sticks before you will be satisfied. Since your paper is absorbent, and since India ink stains, **work on a newspaper-covered surface.** And wear an apron over that sharkskin suit if you're feeling messy.

3. *Take some time now to experiment.* Discover all of the different lines you can draw. Don't skimp—do this on the same kind of paper you'll be doing your "real" drawings on later. And just draw lines, don't think "feathers" or "sticks" just yet.

This design is drawn with a stick.

A word about the ink:
It is black, and it is permanent. Watch out! Artists like to use ink because it won't fade and it is waterproof. You can use watercolor over it later, for instance, without any "bleeding." Rather than plunging the feather or stick into the ink bottle for each stroke, puddle a little ink on a piece of aluminum foil. That way, you can control the line better. And now here is a disgusting little secret about drawing with India ink: If your drawing tool keeps running out of ink midstroke, do what all great artists do, and *spit* (sorry!) on the aluminum foil. It just takes a little, but if you mix it in with the ink, your drawn line will go farther. I don't know why this works, but it works.

These are pulled-feather lines.

A word about drawing with feathers:
We all know that people used to write with quill pens, but you won't be using your drawing feather like that. Don't clench the feather or hold it like a ball-point pen. Try pulling a line from the end of the feather shaft and one from the tip of the feather. Try using the soft edge of the feather to draw with; you can get both a narrow, fluid, expressive line and a broad sweep of ink that way. Experiment. Wash off your drawing feather, and pat it dry.

A word about drawing with sticks:
Don't try to turn these into pencils—loosen that grip. Pull a line, and watch how it naturally goes from thick/dark to thin/light. That's what will work for you later on. Draw some lines with knobbly stick ends or with the skinny tips. Then dip a length of the stick into the ink puddle and drag it along the absorbent paper. Don't fight with the stick; rather, try to discover all of the lines hidden within each stick. And finally:

A word about the art:
Stay loose! If your shoulders are hunched, your fingers are cramping, and your tongue is poking out, maybe you should rethink the project—or your approach to it. If you decide to continue, stretch and touch your toes a few times. Then start again—maybe drawing with your left hand this time.

4. Put your first model (feather or stick) on a piece of white paper. Try to have the paper be the same size as your drawing paper. *Take some time now* to look at your model. How does it divide the space on the paper? What is the main visual "point" of the model?

 ● Is it curved?

 ● Is it sharply angled?

 ● Is it bent or broken?

 Now look at the practice lines you drew. Which of them can you use to best express the subject? You'll probably combine two or more of the practice lines in your final drawings. *For now, use a feather to draw the feather and a stick to draw the stick.*

5. You will draw the feather or stick the way it "grows"— from the center out. Start each drawing with this center line. *Feather:* You will draw the shaft of the feather first. *Stick:* Draw the basic "line" of the stick. Do this without any preliminary sketching, and try to draw this

center line in one stroke. Again, draw the line the way the feather or stick "grows"—start with the widest end and work to the narrowest end.

6. Use a pencil to *lightly* sketch in the basic silhouette of the feather or structure of the stick. Make your pencil lines very light; they may be hard to erase later, depending upon the paper you use. *Do not* let these lines take over—they are merely guidelines.

 For your Feather drawing, you can then break away from an outline approach and concentrate more on working out from the center with the ink. Rhythm and direction are what is interesting; the confining outline of the feather can really be invisible.

 For your Stick drawing, you can "register" the basic configuration in pencil and then concentrate on line quality when you draw with the ink.

7. Finish your ink drawings. When you start a stroke, always do it logically—begin the line where it "should" be strong, then draw it out to where it needs to be more fragile.

8. Repeat drawing the subject several times before moving on to the next model. When the ink is completely dry, you can gently erase your faint pencil guidelines with an art-gum eraser or a kneaded eraser. To avoid smearing the ink, it is safest if you wait a day before doing this.

9. Look at both series. What do you think? Turn the drawings upside down; place different drawings next to one another. If you don't like them, don't be too harsh on yourself (or on me). Remember something: *A drawing of a feather is a drawing, it isn't the feather. It can be an interesting drawing even if it would make a "bad" feather.*

 Don't throw away any drawings just yet—instead, *put* them away for a while. You may be pleasantly surprised later when you look at them again.

These are pulled-stick lines.

Variations:

- Use these tools to draw other subjects.

- Experiment with other unusual drawing tools.

- Whenever you draw, and whatever you draw, remem-

ber: Stay loose! You're not filling out tax forms, you're making art. It's different, and the way you use your drawing tools should be different. You are making drawings that are as "real" as the objects being drawn are real. But they're different—no one is going to confuse a drawn flower with a real one. Why should that be your goal? The flower is already perfect. Now *you* do a good job on the drawing. And keep on drawing! It's an intimate, immediate, and valuable connection with the physical world.

Display:

If you are going to mount your drawing onto mat board, place the drawing face down outside on a clean sheet of newspaper. Using spray adhesive, lightly spray the back of the drawing. **Always go outside to use spray adhesive, and read the label carefully.** Carry the drawing inside, and position it on the precut base. Don't spray the base—spray adhesive doesn't dry. You can then frame the mounted drawing. If you'd prefer, use "Yes" paste to mount the drawing onto the base. Thin the paste with a little water if necessary.

Landscape Collage

The final project in this section is a Landscape Collage. You will work with related colors of tissue and use many of the skills you've learned so far—planning, simplifying, tearing, gluing, and trimming, for instance.

Start with an image—a landscape—that you love, not just one that you think will look good in your family room. When you are going to spend time and energy on art, the image should mean something to you even before you begin.

When you are trying to relax, or when you are daydreaming of a quick getaway, what mental landscape hovers in your imagination? Sometimes I think that there is such a landscape imprinted within each of us. Some people immediately "see" the ocean—waves, swells, the horizon, clouds. Others "see" tall trees looming around them with shafts of sunlight (or moonlight!) glancing off the trunks. Some of us long for great flat stretches of desert to surround us or for swelling dunes to encircle us. Or maybe it's fields we "see"—green, golden, or just the rich brown plowed earth. Some of us yearn for the mountains—peaks, cliffs, ravines, fissures, waterfalls. Add the dimension of time to your mental image, too. What time of day is it?

Take just a little time to "see" your interior landscape.

That is the one you should use as your inspiration for this project. Don't analyze it or argue with it—just do it.

If you are a person who is "at two with nature," as the saying goes, you can still do this project! You might decide to create a "cityscape"—tall buildings, billboards, light poles. You could scale down your vision and create a "tablescape" or still life rather than a landscape. The art materials and methods are the same whether you depict the Grand Tetons or a bowl of plums.

Unless we are describing an aerial view, most of the landscapes we envision are primarily vertical (cityscapes or forests or mountains) or they are horizontal (oceans, deserts, or "amber waves of grain"). So next, "look" again at your interior landscape and decide: vertical or horizontal? (Naturally, your finished landscape won't be *completely* one or the other.)

The next step is to "see" the colors; take a look at the colors in your interior landscape. Silver, gray, and charcoal might blend together for a foggy morning at the beach. Roses, lavenders, and purples might describe a desert sunset. Sharp greens and soft browns could combine in a soaring forest dreamscape.

There is one thing to keep in mind when planning the colors that you will use, though—limit them. Think about "your" landscape, or look through a magazine like *Arizona Highways* or *National Geographic*. The landscape colors that you see belong together naturally. Your art doesn't have to have every single color that you possess in it.

I know that you have a packet of tissue crammed with twenty-five alluring colors; I know that it will be hard to use only two or three of those colors. Do it anyway.

Even if your subject matter doesn't demand this approach, the material (tissue paper) will. The paper is thin, and colors will blend as you overlap them. Related colors work best for this project.

Read completely through the project before you begin. There are different approaches that you can take; your subject matter and your own nature will determine your approach.

Materials:

- Masonite or foam board for base

- You could also use corrugated board for your base if the slight ridges don't bother you. (It's cheaper but is still stiff enough to use for this activity.) Work in an easy-to-frame size such as 9″ × 12″, 11″ × 14″, or 12″ × 16″.

This vertically composed Landscape Collage, entitled "Eucalyptus Trees," uses tissue on foil, with flour-and-water paste as the adhesive.

(Illustration board or mat board will warp unless you use *only* spray adhesive—and that might not be the best adhesive for your particular landscape.)

- Aluminum foil

- To attach foil to base: white vinyl glue; "Yes" paste; acrylic medium; or spray adhesive. If your base is Masonite or corrugated board and you choose not to cover it with foil, you will need to prepare its surface instead with a coat of gesso.

- Tissue paper

- Utility knife or good scissors

Choose one of the following for your adhesive:

- White vinyl glue (When you use this adhesive, your overlapped tissue colors will blend together more than with other adhesives.) The tissue dye will probably "bleed" a little into surrounding areas. The dried surface will be glossy and may look a little hard. If you use white vinyl glue, you will thin it first with water until it looks like milk or thin cream.

- Acrylic medium works like thin white vinyl glue.

- Liquid starch: Children often use this as their adhesive

This horizontally composed Landscape Collage, entitled "Smoggy Sunset," uses tissue on foil, with white vinyl glue as the adhesive.

when they do tissue collage. It works for grown-ups too! When you use liquid starch, the tissue colors will blend together well. There will still be some "bleeding." The dried collage surface will look a little softer than a white vinyl glue surface will; it will look a little less shiny. A tissue collage using liquid starch may be a little more apt to eventually peel, but the starch is simple to use. If you plan to build up lots of tissue layers and you want to make sure your collage lasts, though, use another adhesive. To enable the liquid starch to spread on the foil-covered base without beading up, add a few drops of liquid detergent to the starch.

- "Yes" paste: Pastes yield more of a "matte" finish in tissue collage than either glue or liquid starch does. Matte doesn't have to be the same as dull, though; this soft finish might be perfect for your landscape. The blended tissue colors will be more opaque than transparent. There is still some "bleeding" with this and other pastes, but it is more controlled—the adhesive isn't as wet, so the dye doesn't spread as much. If you use "Yes" paste, thin it with a little water.

- Flour-and-water paste: This sounds like a crude adhesive to use for your tissue collage, but a simple flour-and-water paste can give your collage surface a more solid painterly feel than other adhesives can. Please see Trophy instruction #4, page 124, for how to mix a simple flour-and-water paste. The dried collage surface will be matte. There will be very little color "bleeding," and the blended colors will be more opaque than transparent. *NOTE: You will brush all glues or pastes onto the base as you work, not onto the tissue pieces.* Extra adhesive that then ends up on the collage surface will become a final "glaze"—either glossy or matte.

- Spray adhesive: This is certainly the tidiest adhesive that you can use for this project. Your tissue pieces will lie perfectly flat. There will be absolutely no "bleeding," but there will also be practically no color blending at all. This is an advantage if you are using colors that look terrible together when overlapped. (Those colors might look great in your garden but not so great in transparent layers of tissue.) The collage texture will be the same as that of the original tissue. **Always go outside to use spray adhesive. Read the label carefully and follow the instructions.** You will spray the backs

of the tissue pieces—you won't spray the adhesive onto the base.

One of these adhesives will be the best choice for the Landscape Collage you have in mind. Each adhesive has its good points and its drawbacks. Whichever adhesive you choose, don't fight it! Embrace even the drawbacks, and make them work for you.

Time:

This project will take a total of two hours to complete. Try to do the collage in two sessions. In the first session you will do the preliminary collage work, and in the second you will complete the final collage details. Work slowly, and allow time between the sessions to think, to daydream, and to evaluate your work.

Instructions:

1. First, you will cover the base with aluminum foil. You could use gold metallic paper if you'd prefer to. A reflective surface works well under tissue collage and will glint through the tissue when you're done. It will enrich your final collage. The foil will show up *more* if you use white vinyl glue, acrylic medium, or liquid starch and *less* with pastes or spray adhesive.

 If you don't want a foil-covered base, work on a stiff white base instead. If your base is brown Masonite, prepare it with a coat of gesso or white acrylic paint. Do not use white tempera to prepare your base. Most adhesives will render the tissue somewhat transparent, and it will then look terribly dull against the dark brown base.

 To cover your base with foil, tear off a piece of foil that is slightly larger than the base. If you are working on a very big base, you may need to overlap two pieces of foil. That's fine; the seam won't be visible later on.

This Landscape Collage uses white vinyl glue as the adhesive. The tissue dye will probably "bleed" a little into surrounding areas. (Not all colors will bleed as much as this one.)

Brush your adhesive evenly onto the base, all the way out to the edges. Press the foil onto the base, and smooth it down from the center out. Wrinkles or creases are okay—just squash them as flat as you can. When the adhesive has dried, you will trim away the excess foil. **If you use a utility knife for this, place your base face down on a thick pad of newspaper before you cut.**

2. Select two or three tissue colors for the main landscape background. (You can use additional colors later if you want.)

 You might decide to use related colors. Related colors are next to each other on the color wheel. Yellow, yellow-orange, and orange could be used for glowing horizontal fields. Turquoise, green, and yellow-green might depict a vertical underwater kelp garden.

 Sometimes a monochromatic color scheme will be best. "Monochromatic" means tints and shades of the same color. Pale blue, dark blue, and black might be used for moonlit mountain ranges. Whites, tans, and browns could be overlapped to create shimmering sand dunes.

 If you want to juxtapose other colors, first make sure that they will look good even if they blend. Gray and pink could unite beautifully to form a sunny cliff face. Bright green and brown could come together to create an enchanted forest.

 Select colors that you see together when you go outside and look around you.

3. You are going to use torn paper for this stage of the project—and perhaps for your entire project. Why? The torn edges come closest to the natural forms that you are depicting. You couldn't cut more natural shapes if you tried all day long. (If you were doing a collage with a more technological subject matter, such as "Computers" or "The Car of the Future," for instance, you would probably want a cut edge.)

This Landscape Collage uses flour-and-water paste as the adhesive. The dried collage surface will be matte.

You can either tear big quick rips or you can control the tear (to some extent) with your fingertips. In either case, do not tear off little tissue "mosaic" pieces for this project. Tear long strips; they will overlap either vertically or horizontally and go off the edges of your base. The long straight line of the untorn tissue edge may enhance your composition; fairly straight lines appear in nature, after all. Perhaps a straight line can serve as your horizon. But avoid letting the *short* tissue edges break up either your vertical or horizontal design. And sharp tissue corners are the worst! Play with your torn tissue pieces for a while before you attach any of them.

A word about the art:
You can get some idea of how the collage will look later, but the adhesive will change a few things. In general, it will be best if you start with the lightest colors and work to the darker ones. And you don't have to cover all of the foil; you may want to leave a narrow strip gleaming at the ocean's horizon, for example, or leave tiny slices of foil visible to glimmer through ropy jungle vines. Avoid inadvertently laying down your tissue in evenly spaced bands—unless that is really the look that you're after. Often people take a methodical approach to collage: an inch of blue, an inch of green; an inch of blue, an inch of green, etc. This isn't very interesting to look at, and it doesn't look "natural," either. Add drama to your composition by consciously and deliberately varying the spacing. *NOTE:* When you attach the tissue, the adhesive will create additional soft vertical or horizontal bands wherever you overlap the tissue pieces.

4. Attach the tissue pieces to the base. You will probably start with the lightest colors. Remember to brush the glue or paste onto the base, not onto the tissue. When you have attached one strip of tissue, gently brush another thin layer of adhesive right on top, and position another tissue piece. Wrinkles and creases are fine and

This Landscape Collage uses spray adhesive.

may even add to the beauty of your final collage—just avoid air bubbles. When you have finished positioning the torn tissue strips, let the collage dry. *This preliminary collage will look different when it dries,* so wait until then to make your final design decisions.

5. When the collage is dry, trim the raggedy tissue from the edges of the base. **If you use a utility knife for this, put the collage face down on a thick pad of newspaper before you cut.**

 Take some time now to look at your preliminary collage. There will probably be some surprises! New bands (of new color) will have been created by the overlapped tissue. Tissue wrinkles will have created unexpected shades. The dry glue or paste will have affected both the color and texture of your collage. Make your peace with these little surprises.

6. Next comes an optional intermediate step: You may wish to go back into the collage with some additional tissue strips. (Your lightest colors won't work too well at this point.) Perhaps you wish to create more varied spacing. You might want to change your planned composition slightly, taking advantage of a newly created area, color, or effect. This is also a good time to patch up torn tissue spots or to repair any bubbled or peeling tissue.

7. Finally, you will plan some last descriptive details for your Landscape Collage. These will need to be in a medium to dark value range. Light tissue won't show up well when attached to darker tissue (unless you sneak in a little piece of foil underneath!). These final details may be fingertip-torn or cut. *NOTE:* Complicated torn shapes are often more beautiful if they are pieced together rather than torn from one piece of paper.

 A big red sun could sink to the horizon of your seascape. A foil moon could hang in the violet sky. A dark cactus silhouette might accent your desert landscape. Pointed leaves could bristle from the vines in your underwater scene.

 Think of some final detail that will help define the "where" and "when" of your landscape. Attach these final collage pieces. Of course, if you like the collage just the way it is, don't do anything more. Why tamper with perfection?

8. Check the surface of your finished collage to make sure that it looks unified. If it looks patchy, and if that bothers you, consider brushing on a final coat of thinned acrylic medium—glossy or matte finish. Like white vinyl glue, acrylic medium will look milky until it dries.

Variations:

- Try doing the same basic Landscape Collage again, but with a different adhesive this time. The whole project will look different.

- Create a nature collage that uses diagonal lines as its inspiration.

- Plan a tissue collage that uses only cut tissue. Your design or subject matter (if there is a subject) should be one that lends itself *best* to a cut design.

- Try a Two-Fold Nature Collage (page 153)—but with tissue paper rather than Fadeless art paper.

- Design a stained-glass window using this collage method. The patchy "mosaic" approach is fine for this variation. Use white vinyl glue, acrylic medium, or liquid starch as your adhesive. A final lacy "framework" of black tissue can surround your window design.

Display:
Prop your trimmed collage on a shelf, and enjoy it. If you want to mat the collage (or have it matted), select a mat color that is strong enough. Black might be a good choice.

Part Four

Harder Three-Dimensional Projects

Creating in the Round

Once upon a time, four months into an alabaster stone carving, I gave my sculpture a little chisel tap with my newly Popeye-muscled arm, and . . . the sculpture split in two. It was very discouraging.

It was, in fact, so discouraging that I lost interest in sculpture for a long time. It wasn't just that one setback that did it, though; the kind of sculpture I had been trained in just didn't fit in with my own nature (or abilities). I liked the demands of three-dimensional work and didn't mind waiting for results or even throwing myself on the mercy of my materials, but I realized that I'm more of a building-up person than a chipping-away person. And the projects in this book inevitably reflect that bias.

But I also feel that these building-up projects are easiest for most reemerging artists to begin working on. Rather than hunting for the subject deep within the medium, which process has its own requirements and fascinations, in these projects the artist creates the subject a little at a time.

Many of the projects in Part Two were relief sculpture projects. Relief sculpture (flat-backed sculpture) can be seen as a sort of "bridge" between two-dimensional and three-dimensional work. In this part, most of these slightly harder sculpture projects are truly three-dimensional. They will require a different set of "mental muscles" as you work. Still, the activities are fun to do, failure-proof, and rewarding.

FOUND OBJECTS

Found objects is a term given to miscellaneous unrelated items used as art materials. But *found* is really too passive a word for what I think this expression truly implies.

When we are involved in making a specific piece of art, our senses are temporarily sharpened. We notice things more. It's a little bit like being in love.

And we can't help but wonder: What would it be like to feel this way all the time? Is it even possible?

I don't know if it is possible, but I feel that it is more likely if we go on making art. This is one of the gifts that art gives us. To me, the term *found objects* expresses a state of readiness, an openness to our surroundings that is one of the signs of increased awareness. Finding everyday objects to use in our art is building a bridge between ordinary experience and the experience of art. It breaks down one of the art barriers that we have erected over the years—the one that says that art materials are

San Francisco artist and film-maker Jerry Barrish creates sculpture from objects he finds on the beach. This assemblage is entitled "Statute of Liberty." Photograph copyright © 1989 by Mel Schockner.

expensive, hard to find, and difficult to use. In addition, you will be looking at your "found objects" with "new eyes"—you will relate unrelated objects in unexpected ways.

Finding objects to use for art isn't just a matter of tripping over them on the sidewalk, though. Sometimes that will happen, but usually you will have to *actively* search the objects out.

This is an important point. In fact, it's much like the process of finding time for your art. Sometimes you'll be faced with a long boring afternoon and will look for some activity to fill it, but more often you will have to hunt for the time—search it out. And then the time (or the "found object") is all the sweeter for the hunt.

Search for "found objects" over a period of time. Search in toy chests, at yard sales, in dime stores. Look down when you trip on the sidewalk.

There are two different projects that I'll describe here; an unusual Christmas ornament and a lapel pin, although there are many variations that you could try. For these projects, you

This Jerry Barrish found-object scupture is entitled "Equus." Photograph copyright © 1989 by Mel Schockner.

will use very small objects. Of the two projects, the Christmas ornament is the more difficult; it requires you to work "in the round"—literally! *WARNING:* The finished project may be a little *too* unusual if you are a holiday traditionalist.

Materials:

- "Found objects": costume jewelry; buttons, sequins, etc.; bottle caps; old game pieces; tiny toys; nuts, bolts, etc.; wires; shells, pine cones, pods, etc.; stickers, magazine pictures, etc. Look around you, and keep an open mind!

- Hot-glue gun (This is much the easiest adhesive to use for this project. In a pinch, you can use thick white vinyl glue instead for flat-backed Found Object projects.)

For Christmas ornament:

- A plain round glass ornament
- *Optional:* acrylic paints

For lapel pin:

- Mat board or illustration board (This is a good time to use up the scraps that you've been saving.)

This Jerry Barrish creation is entitled "Claw." Photograph copyright © 1989 by Mel Schockner.

- Utility knife
- Pin-back mount or big safety pin and felt
- Optional: acrylic paints; glossy acrylic medium or white vinyl glue; spray adhesive, rubber cement, or "Yes" paste to mount pictures on a lapel pin base

Time:

 I don't know how long it will take you to collect your *found objects*, but it will take about an hour for you to do this project.

Instructions:

1. Gather together more *found objects* than you'll need for your project. You want to have a real assortment to choose from.

2. Prepare your base.
 Ornament: You may wish to paint your plain ornament before attaching the objects to it. Use acrylic paint for this. A dark color will create a "logical" feeling of depth beneath your collage pieces. Carefully remove the little metal ornament cap before you paint the plain ornament.
 Pin: Cut the mat board or illustration board to your desired pin shape. Use a utility knife for this—

This Jerry Barrish found-object sculpture is entitled "Roy's Dog." Photograph copyright © 1989 by Mel Schockner.

Toys and seashells can be applied
to old ornaments with a hot-glue
gun to create a most unique
Christmas tree decoration!

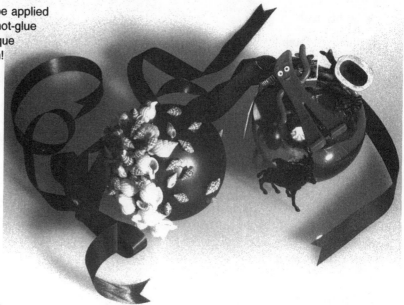

carefully. **Cut your shape on a thick pad of newspaper
or on an old magazine—this will protect your ta-
bletop or counter.** Your pin can be any shape and
almost any size. If you want to, you can paint the pin
base. Remember to paint the edges too, and if you're
a real perfectionist, paint the back of the pin base.
Don't get too detailed, though; remember that you will
be covering up much of this preliminary work. Instead,
or in addition, you can cover the flat base with a maga-
zine picture or a photograph. Again, remember that
you will be covering up much of this later in the pro-
ject. Use spray adhesive (**outside**), rubber cement, or
"Yes" paste to attach a picture to your base. (**Always
go outside to use spray adhesive, and read the label
carefully.**) With these adhesives you can be sure that
your picture will lie flat. Optional: If you want any of
this preliminary work to look extra shiny, brush on a
little glossy acrylic medium or thin white vinyl glue. Let
it dry before you proceed.

3. Take some time now to play with your "found objects."
 Don't glue anything down yet! Cluster the objects in
 different combinations. Don't think of their original
 purposes when you look at them; look at size, color,
 value, and texture. You can always change any of these
 design elements, by the way.

- Break apart a too-big item; use it in pieces.

- Paint a "found object" with acrylics before attaching it, or spray it with spray paint. (**Always go outside to use spray paint.**)

- Give an object a shinier texture by brushing on a coat of glossy acrylic medium or thin white vinyl glue. Again, do this before attaching the object.

- Create a rougher texture by brushing thick white vinyl glue onto an item and then dipping it in glitter.

Remember that you are making a three-dimensional sculpture; use your *found objects* accordingly. Work toward a rich, complex, layered look—be generous. Avoid the spotty, skimpy approach. Stack collage items. Turn them on their sides. Look at the individual items from all angles, as you will look at your sculpture-as-a-whole from all angles while you work.

Top: safety pin stitched to a little piece of felt
Bottom: pin-back mount

4. Attach the collage items to your base. If you are making an ornament, you may want to poke a vertical support into the uncapped end of the ornament. This will make it easier to do the project. You will use a hot-glue gun to attach the items. The glue dries almost instantly and so immediately attaches and holds collage materials onto bases that otherwise would be awkward to use— such as Christmas ornaments. The adhesive also enables you to stack and tilt your collage materials in unexpected ways. **Be very careful when you use a hot-glue gun.** Don't touch the wet glue or the nozzle. If necessary, use a toothpick to move very small collage pieces onto the hot glue. Just a little glue will usually hold a collage piece.

5. If you want a shiny finished surface, you can brush glossy acrylic medium or thin white vinyl glue onto your sculpture. If you want your sculpture to be all one color, you can paint it with acrylic paints or spray paint. **Always go outside to use spray paint, and read the label carefully.**

6. Attach the pin-back mount to your pin with a hot-glue gun. Or, if you wish, securely stitch a safety pin to a little piece of felt, then attach the felt to the back of your pin. *NOTE: Little collage pieces will fall off from*

This whimsical Portrait is composed of foam board, gingham, buttons, dyed wood excelsior (for the sideburns and mustache), glasses, a rhinestone, and paper. Spray adhesive was used for the fabric and paper; a hot-glue gun was used for the glasses, buttons, and hair.

time to time, so be careful not to let very young children play with these sculptures.

Variations:

- Create a pair of earrings, or decorate plastic haircombs using this collage method.

- In a project that you invent, combine your "found objects" with the stickers, rubber stamps, Stocking Faces, or dyed wood scraps that you've worked with earlier.

- Make your own Found Objects sculpture entirely from treasures you've scrounged.

PORTRAIT GALLERY

There are some wonderful art programs going on in our schools. This project was inspired by a display of children's art that I saw a few years ago. The project has a real folk-art feel to it.

This is primarily a two-dimensional activity—it's basically flat. Yet when these finished head-and-shoulder "portraits" are backed and displayed, they become sculpture.

I describe a way to make a small Portrait Gallery—perhaps a grouped family portrait, for example—one that could cluster on a mantel or bookshelf. But, as I will suggest in **Variations,** you could also work much larger to create life-sized sculptures.

Materials:

- Foam board
- Pencil
- Utility knife
- Spray adhesive
- Watercolor markers (nonpermanent)
- Cloth tape (to attach hinged backing)

Choose one of the following to attach optional collage items:

- Hot-glue gun
- Thick white vinyl glue

● Optional: Fadeless art paper; construction paper; acrylic modeling paste; gesso; oil pastels; collage items such as yarn, fabric, buttons, trims

Time:

It will take you an hour and a half to two hours to do this project, depending upon how many people are in your Portrait Gallery and how detailed they are. Try to make at least two heads at a time. Work assembly-line style.

Instructions:

1. Lightly sketch simple head-and-shoulder shapes with your pencil. Most foam board is faced with paper, so this is easy to do. Have the heads all be about the same size. They can be "personalized," though; squint at your subject's silhouette (or look in the mirror) to discern distinctive outline features—hair or ears, for instance. Don't get too fussy at this stage of the project; keep the shapes simple. You can always add collage details later on.

 NOTE: Avoid making the necks too skinny! Reemerging artists often create "pencil necks," for some reason. Look in the mirror: Even the slenderest neck really needs to be a sturdy column capable of holding up a heavy head.

 Using your utility knife, cut the simple head-and-shoulder shapes from the foam board. **Work on a thick pad of newspaper or a big old magazine when you cut. This will protect your tabletop or counter.** Optional: To seal ragged foam board edges, carefully rub on an even layer of acrylic modeling paste. Allow this about an hour to dry.

2. As stated earlier, most foam board is faced (and backed, for that matter) with paper. If the paper suits you, you can draw directly on it.

 Gesso: You may wish to brush a coat of gesso onto the foam board before you draw, though. The gesso will provide a good drawing ground and will cover pencil lines and even the acrylic modeling paste that you may have used to seal the foam board edges. Gesso dries quickly and is waterproof once it dries. Wash your gesso brush right away, though, or it will be ruined.

 Paper: You might want to cover the foam board

Lightly sketch simple head-and-shoulder shapes with your pencil.

Draw the facial features and any other desired details.

shapes with colored paper before proceeding. Use any light or bright color of Fadeless art paper or construction paper for this; you don't have to be realistic. *NOTE:* Markers are transparent and will show up best on light or bright colors. If you want to cover the foam board with a darker color, plan to create the features with collage rather than through drawing. If you really want to draw features on a very dark base, use oil pastels. Oil pastels are a little messier than markers, but they are opaque and look great on dark paper.

To cover a foam-board shape with paper: Cut a preliminary paper shape that is a little bigger than the foam-board shape that you're covering. Spray the foam-board with spray adhesive (**outside**), and press the paper onto the board. (**Always go outside to use spray adhesive, and read the label carefully.**) Put the covered board face down on a clean pad of newspaper, and trim away the extra paper with your utility knife. Or instead, you could use good scissors to do this. If you want, attach other paper shapes and colors. Remember to keep the colors light or bright if you're going to draw on them with transparent markers.

3. Draw the facial features and any other desired details. Don't worry about making things too lifelike; these portraits are meant to be simplified and a little (or a lot!) humorous.

If you want to do a lot of layered "coloring" with the markers: Start with the lighter marker colors and work to the darker ones. That way, color "bleeding" won't be as apparent. Work with a paper towel under your hand as you draw. This will keep your hand from smearing the watercolor marker lines.

Pattern can enhance your drawing. It might show up in the way you draw the hair—with straight, wavy, or curly lines. It could show up on what the subject is wearing. Apparel can be drawn or added later with collage. If you are drawing with oil pastels, always work with a paper towel under your drawing hand. Oil pastels smear.

You can also create facial features with collage or combine collage features with drawn ones. You could draw features on different colors of paper, cut them out, and attach them. You could cut features from magazine pictures and attach them. This can add an air of surreality to your Portrait Gallery. Don't worry about

having all of the features be proportionally correct. Use spray adhesive (**outside**) to attach the collage features to your prepared base. Never spray the surface of the prepared base—spray adhesive doesn't dry.

4. If you want to add final collage elements to your portraits, do it now. Work in layers, not in "puzzle pieces."

 Yarn fuzz, strands, or braids could decorate the heads. Use thick white vinyl glue to adhere yarn fuzz or strands. Use thick white vinyl glue or the hot-glue gun to attach braids.

 Fabric can be used flat to "clothe" the upper torsos. Attach thin fabric with spray adhesive and thicker fabric with "Yes" paste. Remember that it usually ends up looking better if you trim away a slightly-too-big collage piece from the base's edges after you attach it rather than try to fit a traced collage piece exactly to the base. A *bow, barette,* or *buttons* could embellish a portrait. Use a hot-glue gun or thick white vinyl glue to attach bulky collage pieces.

A word about the art:

Remember *color, value, pattern,* and *texture* as you work. Think "art" rather than realistic "portrait"—no one is going to confuse your Portrait Gallery with real people no matter how good a job you do!

Color: Complementary colors (colors that are opposite one another on the color wheel) often look especially vibrant in collage work.

Value: Squint your eyes from time to time as you work. Lights and darks sort themselves out quickly when you do this. A strong value contrast will make your Portrait Gallery more interesting to look at.

Pattern: Apart from drawn pattern, mentioned earlier, you might also choose to use patterned fabrics. Be aware of the proportions of your various patterns, in relation to one another and to your drawn areas. Vary them. Sometimes people draw eyes, nose, and mouth all about the same size and then select a pattern that's eyes-nose-and-mouth size. The viewer's eyes bounce back and forth across this same-patterned surface and never find a place to rest.

Texture: Variety in texture is another way of adding interest to your Portrait Gallery. Remember, there are many different textured papers (construction paper, foil, velour, sandpaper) and fabrics (silk, corduroy, "fun fur," felt). Juggle all of these ideas as you work.

Pattern can enhance your drawings.

5. Cut a long skinny foam board triangle to back each head in your Portrait Gallery. One angle in each triangle should be a near-right angle; this will prop up your portrait. Use your utility knife to cut the foam board. **Cut on a thick pad of newspaper.** Next, cut a length of cloth tape and attach one half of its width to the long side of your triangle. Then, creasing the long middle of the tape with your finger, attach the triangle to the back of the portrait. This one-sided taping enables you to store your portrait flat. If you want to prop it upright right away: Cut a second length of cloth tape, and attach it to the other long side of the triangle, again creasing the long middle of the tape. Do this for each portrait in your Portrait Gallery.

Variations:

- Work bigger! You could even trace around someone's head for a realistic (and obviously life-sized) base.

- You may have already created a family portrait. Make a small group portrait for a reunion—perhaps your theme could be "The Way We (Wish We) Were."

- Create collage portraits to serve as a centerpiece for a birthday or anniversary celebration.

- Make a series of self-portraits reflecting you, the artist, at different ages.

- Illustrate characters from a favorite book. Scarlett O'Hara and Rhett Butler could be propped at the front of a shelf of books. Or maybe you'd like to honor George and Martha, Marshall and Allard's wonderful hippo friends!

- Fashion unflattering replicas of your enemies, and then throw wadded pieces of paper at them. Two points for knocking one down!

Top: long skinny foam-board triangle with one near-right angle
Center: the triangle placed against the back of the finished piece
Bottom: the triangle taped to the back of the piece with cloth tape

Display and Storage:

These backed portraits are easy to display. Their triangle backings prop them up. To store a portrait flat, remove one strip of cloth tape and swing the hinged triangle flat against the back of the sculpture. Keep each sculpture in a clear plastic bag to protect it and to hold any collage pieces that might fall off during storage.

FAIRYTALE DIORAMA

In just the last month, I've seen two shoebox sculptures that children have done. Seeing them brings back the memory of creating a unique little world this way—even if it *was* for a geography assignment! Maybe you remember fashioning a rain forest or desert in a shoebox and recall propping pythons or rattlers in the foreground.

This next project brings back those good old days. But this time, the project will be much more personally relevant, and your craftsmanship will be improved.

It may have been a while since you've thought about fairytales. Think about them again. They are often the first stories to enter our lives, and they stay with us always. You probably can remember one or two very vividly right now—they've "stayed with you" for some reason. It may be an important reason.

If no fairytales come immediately to mind, give yourself a treat and reread some Grimm's fairytales. You'll probably be a little shocked at how . . . well, how *grim* many of them are. As you read, search for the one that will jump out at you—that's your fairytale.

Maybe Rapunzel speaks to you, locked as she is in her solitude by the sorceress. Perhaps you read Rumpelstiltskin and side with him; after all, he was just trying to collect on a promise. Red Riding Hood (Little Red Cap) is fascinating; maybe you've gotten into trouble straying from the path. Or maybe you're afraid to ever stray from the path. These are the familiar stories, but there are scores of other tales to read. We aren't likely to have heard of them all, but some of them "speak" to us anyway, even if we're reading them for the first time. The Prince Who Feared Nothing went through hell, but it paid off. Maid Maleen was locked in darkness for seven years by a father who was trying to break her "spiteful spirit." The Tailor in Heaven fast-talked his way into paradise, tried to "play God," then got kicked out. I'm not sure if he learned anything.

Some of these stories are eerily relevant to our lives, some are curiosities, and some are just plain weird. But you'll like rereading them.

Materials:

- Shoebox, or other sturdy box (same size or smaller)

For the exterior: Optional

- Acrylic modeling paste
- Gesso
- Acrylic paints

If there is printing on the outside of the box, or if you dislike the color, you can cover it. If you want to create a strengthening stiff textured surface for the box's exterior, you will need acrylic modeling paste. You will apply the paste with a plastic knife, let it dry for a day, then paint the surface with acrylics. Instructions will describe this in more detail. A preliminary coat of gesso under acrylic paint will make your colors look brighter. If you just want to change the color of the box, you will gesso it and paint it with acrylics. Both modeling paste and paint will warp the box slightly. If you will be bothered by this, plan to cover the box's exterior with collage. Spray adhesive or "Yes" Paste used as your adhesive will yield a nonwarped final surface.

For the interior:

- Magazine pictures (especially from magazines such as *Arizona Highways* and *National Geographic;* both have big landscape pictures)
- Black (or other dark) acrylic paint
- Utility knife; good scissors; manicure scissors
- Foam board scraps, mat board scraps, or illustration board scraps
- Assorted papers, fabrics, trims
- Spray adhesive
- Hot-glue gun
- "Yes" paste, and/or thick white vinyl glue

Time:

Allow a week of reading (and dreaming) to select your fairytale. If one just leaps into your mind right away, though, that's the one that you should use. But reread some other tales just for fun. You won't be depicting the entire fairytale, by the way—just the one part that you like best. And even then, change things around some! If the Brothers Grimm could do it, so can you. The "art part" of the project will take two or

three hours, but the activity can be broken up into several sessions.

Instructions:

1. First, take that week I talked about and read some fairytales. Choose one for your Fairytale Diorama.

2. Next, picture your finished project as completely as you can: The interior of your box will be completely covered with magazine pictures. These will form an intimate background to the drama of your fairytale scene. Additional drawn or collaged details might be added to this rich background. Then two-dimensional images, drawn or collaged, will be mounted onto a stiff backing and attached to the interior of your box. The exterior of the box might be textured, painted, or further collaged. *Let this preliminary mental image be a guide to materials and methods as you work, but don't let it tyrannize you.* Stay flexible.

These pictures cover the five areas that make up the inside of your box. Attach these background pictures with spray adhesive.

3. Go through your magazines, and select the pictures that will form your background. You will be creating more of a mood than an exact replica of a fairytale landscape. These pictures will cover the five areas that make up the inside of your box. You will fit together different pictures; they don't have to make complete "logical" sense. But you do want them to make sense visually—to look good in the box. Here are two collage methods that will help make your collage background look good; choose one.
1) Paint all of the inside corners of the box with black (or other dark) acrylic paint. Paint the inside rim of the box, too. Even if your magazine pictures don't fit perfectly into the box, the background will still look "finished." Working on your selected magazine pictures, trace around each section of the box's exterior to ensure correct fit. Cut out each shape. Try them out inside the box. You can always trim away a little more from the pictures if they're too big. Working outside, put the pictures face down on a big sheet of newsprint, and spray them lightly with spray adhesive. (**Always go outside to use spray adhesive, and read the label carefully.**) Take the sticky pictures inside, and position them inside the box.
2) With the "wraparound" method, your magazine

pictures will be longer than needed to cover any one area. You will fit the pictures into the box and sharply crease them in the correct places with your finger. Do this *before* spraying the pictures with adhesive. These creased areas will take care of at least some of the inside corners. Paint the other corners with black (or other dark) acrylic, and paint the inside rim of the box, too. Use spray adhesive (**outside**) to attach the magazine pictures flawlessly to the interior of your box.

If you want a solid-colored interior instead, paint the inside of the box with gesso and acrylics, or use Fadeless art paper, construction paper, metallic paper, or velour paper to create your background.

4. Next, add any drawn or collaged details that you want to the prepared interior. Pale shells cut from a nature magazine could decorate a seashore. Carefully cut-out flowers might stud a hazy meadow. These details don't need to be correctly proportioned or even realistic, though—create a dreamlike background. A collaged crystal chandelier could glow from a dark forest. Gaudy fish might "swim" across an overcast sky.

A word about the art:
Remember that the "ceiling" and "floor" of your box are both important. Don't neglect them; each of the five exposed areas is an important part of your composition.

When you work with smaller magazine pictures, cut your detailed shapes as perfectly as possible. This will add to the "magical reality" of the interior. Use manicure scissors to cut these intricate shapes. Often, creasing one or more of these smaller magazine pictures and having it "bridge" an interior corner will add to the richness of your box's interior.

If you decide to add a heavier or bulkier collage detail to one of these five areas at this point, use a stronger adhesive. "Yes" paste will attach flat fabric or heavier paper, or you might want to use thick white vinyl glue. A hot-glue gun will attach bulkier items quickly.

5. Plan the figures or other details that will stand in the foreground of your Fairytale Diorama. These additions could be drawn or done with collage. They will be two-dimensional—attached to a stiffer backing, cut out, then mounted. Two dark trees could form "curtains" for your fairytale drama. Part of a figure might rise from an ocean floor. A cottage could be surrounded

Plan the figures or other details that will stand in the foreground of your Fairytale Diorama.

by the forest that covers your box's interior. You can create as many of these details as you'd like. Two trees, a rock, and a giant frog might illustrate your fairytale, for instance.

Plan the final "staging" for your Fairytale Diorama. The stiff pieces are attached with a hot-glue gun.

A word about the art:
What you are trying to achieve is the illusion of depth. Obviously the viewer won't really be fooled by this illusion, but he or she can be "drawn into" your sculpture through it. One way that you can create the illusion of depth is by staggering the images, overlapping them. You've overlapped images before, but in this sculpture the pictures don't have to be touching one another to be overlapped. The viewer's eye will do some of the work.

Plan to position some of the pieces at least partially behind other pieces. Cluster them. Don't just "polka dot" the details evenly across the sculpture floor. And you don't need to confine these two-dimensional details to the sculpture floor, by the way. A shaggy wolf's head could peer from the side of your box's interior. A soaring bird might be mounted to the clouded "ceiling" of the box. Giant tree trunks cut from magazines might rise from the bottom of the box clear up to the top.

Play with proportion, scale, and placement before you attach any of the details. You can draw or collage these detailed images directly on white foam board or illustration board, or you can work on white paper and then mount it onto the board. If you want a stiff colored image, work directly on colored mat board, or work on colored paper and then mount the paper onto the board. Use spray adhesive (**outside**) for this; spray the backs of the paper details, then mount them onto the board. Use your utility knife to exactly shape the prepared foam board, illustration board, or mat board. **Be careful—the knife is sharp! Work on a thick pad of newspaper as you cut.**

The one very straight cut that you'll need to make is at the edge that will be attached to the side of the box. Use a ruler or a straightedge when you make this cut. *NOTE:* It is easier to cut the base scrap's exact final shape after you have attached the drawing or collage. You will also create much more realistic shapes if you work this way.

6. Add any desired collage embellishments to these images *before* you mount them in the box. You may need to change adhesives; spray adhesive will hold only the very lightest (and flattest) collage materials.

7. Plan the final "staging" for your Fairytale Diorama. Using a pencil or a skinny black marker, draw a straight line where the straight edge of each piece will be mounted in the box.

8. Now you are ready to assemble your sculpture. The hot-glue gun will make this process easy. Please see page 35 for suggestions on how to safely use a hot-glue gun. Squeeze a bead of hot glue onto a line you've drawn. *Mount only one piece at a time, and start at the back of the box. Do not try to squeeze the hot glue onto the narrow edge of the collage piece that you are holding.* Quickly position the collage piece on the bead of hot glue. The glue will dry very, very quickly—you'll need to hold the collage piece for only a few seconds. Position all of your collage pieces until you get to the front of the box.

9. You may want to decorate the outside of your Fairytale Diorama. If you want to texture its surface, apply the thinnest possible layer of acrylic modeling paste with a plastic knife. Don't use a good knife for this—the paste can be hard to clean off once it has dried. Apply the paste like a skimpy layer of frosting, in any simple pattern or design, or just swirl it on stucco-style. Do not weigh down the box with great slabs of the paste, though. Give the acrylic modeling paste a full day to dry. Clean your knife immediately, or just throw it away.

10. Paint the dry exterior of the box with a coat of gesso. Gesso provides a good waterproof base for subsequent

Mount only one piece at a time, and start at the back of the box.

colors. You may like the look of the gesso so much, though, that you will decide to leave the exterior white. If your gesso seems too thick, thin it with a little water. Allow the gesso an hour or so to thoroughly dry; clean your brush with water right away, though. When the gesso has dried, you can paint the exterior of the box with acrylics. Again, thin the paint with water if necessary, and clean your brush with water right away.

It may seem as though it would be easier to decorate the exterior of the box first. I feel that it is important, however, to have your sculpture begin with its substance—the interior—rather than risk having the exterior dictate too much. In addition, as stated previously, exterior modeling and painting may slightly warp your box. This would then make your interior work more difficult to do.

Variations:

- Juxtapose just two contrasting ways of working. All of your staggered two-dimensional images might be drawn, with the entire background made up of magazine collage. Your own snapshot portraits could be mounted, trimmed, and displayed against a torn and overlapped Fadeless art paper background. The staggered images might all be cut carefully from magazines and sit surrounded by a metallic or velour paper background.

- Use a different theme to inspire you. Here are a few suggestions, if you need a jump start: My Childhood; Choose-a-Myth; Everything I'm Scared Of; If I Won the Lottery; Exactly Where I Want to Live Someday.

Display:

Nestle your Fairytale Diorama on a shelf. If you don't feel like talking about it, put up a little "gallery sign" saying your nephew did it. When the chatty viewer says, "I remember doing this!" say, "Me too."

AERIAL MAP

This is a relief sculpture with a difference. The dimension of time is added to the usual length, width, and depth.

This Aerial Map is made from foam board, acrylic modeling paste, thin acrylic paint, and a photograph.

You will take yourself on an imaginary journey as you work. You will begin at one end of your long narrow base and work your way to the other end, imagining the terrain as you go. You will end up with an Aerial Map—a topographic map—of both the terrain and the journey.

Working on a long skinny rectangle for a change will encourage you to break out of the old 9″ × 12″ rut. It's true that the base won't come "ready made;" you'll have to cut it or have it cut. But the unfamiliar proportions will require you to both plan and work differently than you have before.

This sculpture will not be a true topographic map—one that exactly depicts a specific landscape. Your Aerial Map will be more of a textured dreamscape, one that combines modeling with collage and painting. And, since it is art, you'll always be conscious of the way the sculpture looks. The way it looks may, in fact, take precedence over the logical "facts" of your journey.

The finished Aerial Map will look "nonobjective"—that is, not like a recognizable object—to everyone but you. Whenever *you* look at your Aerial Map, you will be reminded of both your private dream journey and the pleasure you had in making the sculpture. To you it will look real.

Materials:

- Foam board or corrugated board (cut to any long rectangle)

The rectangle could be relatively small, such as 5″ × 20″, or it could be cut from a much bigger board. Corrugated board is cheaper than foam board but is stiff enough to support the modeling paste. *Do not use illustration board, mat board, or poster board* for this project—any of these will warp too much. You could have Masonite cut to size for your base, but you can cut foam board or corrugated board yourself.

- Utility knife
- Acrylic modeling paste
- Plastic knife, skewer or toothpick, etc.
- Gesso
- Flat-backed picture hangers

Choose one of the following to "stain" your map:

- Thin acrylics
- Thin tempera

Optional:

- Magazine pictures or snapshots
- Thin white vinyl glue, "Yes" paste, or acrylic medium to attach pictures
- Thin white vinyl glue or glossy acrylic medium to glaze the map

Time:

This project is basically made up of two parts—modeling and painting. The *modeling* will take you one and a half to two hours or longer, depending upon the size of your base. You will need to allow a full day for the modeling paste to dry. *Painting* the Aerial Map will take another hour or so.

Instructions:

1. First, cut your long skinny rectangle from the foam board or corrugated board. Use a utility knife for this. It is often easier to work on the floor when you are cutting bigger shapes. You can usually put more weight on the knife when you cut this way. **Always cut on a thick pad of newspaper to protect the surface underneath.**

2. Take some time now to daydream as you look at the rectangle. Put it on a flat surface; stare at it. Imagine that you are floating over it, looking down. Begin to imagine a journey across the board.

 You might see your journey as a "line." Maybe you are canoeing down a river some afternoon, sur-

Imagine that you are floating over
it, looking down.
Left: curved-line composition
Center: squares composition
Bottom: radiating composition

rounded on both sides by meadows. Perhaps it is night,
and you are following a narrow sinuous path that loops
through the woods.

Or you might look at the board and see your
journey in a different way. Maybe you picture the days
and nights of your travels as separate units—squares,
perhaps—and each one is complete in itself. Your land-
scape could be more of a patchwork quilt of textured
areas that represent the passage of your journey
time—a wavy patch for travel on water, an undulating
combed patch for travel across fields, etc.

You might not "see" yourself working from one
end of the board to the other; your journey might be
depicted all at once, perhaps with elements of it
(smooth parts, rough parts, obstacles) surrounding a
central image.

3. If you want to, use a pencil to lightly block in your
composition on the board. Optional: You may wish to
have collage—a magazine picture or a snapshot—as

part of your Aerial Map. If so, the pictures that you select should not be actual landscape elements—mountains, trees, flowers, etc. Your modeling work will better depict these things. (A possible exception would be actual "aerial perspective" photographs of these elements.)

You will attach the pictures to an area of the board that you envision as remaining flat—though you can change your mind about that later. Although it may be difficult to paint around these pictures later on, now is the time to attach them, before the modeling paste is applied to the board. Your pictures will be selected for color or pattern, or they can be images that reflect the "spirit" of your journey. *NOTE:* The picture will be at least partially covered by modeling paste or "stain" later, so don't become too attached to it as a separate thing. It will work for the whole composition.

This image does not have to make literal or logical sense. Perhaps a giant eye will stare up from your desert floor. A heart could be surrounded by a prickly textured area. A childhood snapshot might begin your journey. Maybe a printed word is what you will select—but which word? Make your choice a thoughtful one. Trim the picture and attach it with thin white vinyl glue, "Yes" paste, or acrylic medium. Smooth away any air bubbles or wrinkles.

4. Begin your modeling. You will work slowly and carefully. Enjoy the process; don't rush to "get through it." Hum a little. *You will need to work in only one small area at a time* because the paste dries fairly quickly. But you can always add more paste to an area after that area has dried—you can "work wet on dry." *Do not attempt to attach great lumps of the paste to your board, "snowball"-style.* Refine your modeled areas; create them with the least modeling paste possible. You will improvise various tools to use with the paste. Use whatever works, but remember that when the paste dries, it's a little like cement. It won't get soft again with water. If you use a kitchen tool (such as a garlic press, to create grassy "squiggles"), soak it in water *immediately* so that you can clean it when you're ready.

A word about the art:
Contrast in texture will make your sculpture more interesting to look at.

- A plastic fork or comb can create parellel lines.

- A small plastic knife can form buttery waves or sharp ridges.

- A skewer or toothpick can yield dense, finely textured areas.

- A finger dipped in water can slick down the smooth spots.

Pay attention to the shadows that the variously modeled areas will create.

NOTE: To give your Aerial Map a more finished look, rub modeling paste into the edges of the rectangle. This will seal any gapped or crumbling spots. Allow the modeling paste a full day to dry.

5. If you want to, you can further build up some landscape areas. Model the wet paste right on top of the dry areas. Allow another day for the paste to dry.

6. Paint your Aerial Map with a coat of gesso. Gesso thins and cleans with water but dries to a waterproof white base coat that will make your subsequent colors look brighter. *Do not gesso the magazine pictures;* paint around them. If your gesso is very thick, thin it with a little water. If it is too thick, it may clog up delicately textured areas. You can give your sculpture two coats of very thin gesso, if you want. When you are finished, wash your brush with water right away; once gesso dries, you can't clean it off the brush easily. Allow the gesso an hour or so to thoroughly dry.

7. Take some time now to look at your work-in-progress. Turn it different ways; you may settle on a different perspective than the one you started with. (It might not be the one you end up with, either!) Picture different colors on your relief sculpture. Your color choices do not have to be logical ones. A sinuous river could glow a deep red. Turquoise, pink, and violet might make up bright patchwork fields.

8. Now you are ready to paint your Aerial Map.

A word about the paint:
Whether you paint with acrylic or tempera, you will be using very thin paint. This painting method is a little like "antiqu-

ing" with a "stain." The idea is to bring out the textures that you've modeled—to exaggerate them. The thin paint will sink into the lowest places in your modeled areas, and the modeled textures will thus be enhanced.

It makes better "visual sense" if these sunken areas of color are darker than the surface colors. To make the sunken areas lighter is to try to trick the eye; that can be fun to do sometimes, but you probably won't want to do it after working two hours to model these areas in the first place. Any thin paint, dark or light, will gather in the sunken areas. Any thick paint, dark or light, will stay primarily on the surface. *For this project it will work best, and make the most "visual sense," if you paint with overlapped areas of thin paint, working from light to dark.* Since these paints will be transparent, you should select colors that will look good together. You might choose related colors such as yellow and yellow-orange, blue and blue-green, or violet and red-violet. You could select any one color and black to create a dramatic "antiqued" look or you could mix a little black into the color to make a shade of that color.

There is one big difference between acrylic and tempera paint: Once acrylics are dry, they are waterproof. You can paint subsequent colors over your first acrylic layer of paint, and the first layer won't thin or "bleed." Tempera paint, on the other hand, will always be affected by subsequent brushings, no matter how long you wait for it to dry. This quality can be an asset in an "antiquing" project: Use a damp sponge to "buff" the final tempera-painted sculpture surface, creating dramatic highlights. *NOTE:* If you want more of a waterproof surface but you don't have acrylic paints, add a little white vinyl glue to your tempera paint.

To mix paint for "staining":

- Acrylic: Line a small bowl with aluminum foil. Squeeze a little acrylic paint into the bowl. If you are going to mix a special color, it is easier to do it while the paint is still thick; stir the pasty colors together. When the colors are mixed, thin the paint with acrylic medium and/or water. Add just a little of either at a time, and stir the liquid into the thick paste. Add more of the thinning liquid. This way you can keep the thinned paint smooth.

- Dry tempera: Pour some dry tempera into a bowl. Add only *a few drops* of water. Stir the mixture into a very thick paste. Then add more water, a little at a time, until you have a smooth thin mixture.

- Liquid tempera: Add water, a little at a time, until your paint is thin enough to use. With a soft brush—a watercolor brush, perhaps—brush on your lightest color. Your paint will dry quickly.

If your paint is thin enough, you can "stain" the surface of your collage work. Test the paint first on an extra magazine picture, though. Don't forget to paint the edges of your relief sculpture. Wash acrylic paint from your brush right away; use water for this.

9. If you want to "glaze" your sculpture with a shiny finish, brush thinned glossy acrylic medium or thin white vinyl glue onto the surface. Both of these will look milky until they have dried. Clean your brush right away when you use either acrylic medium or white vinyl glue.

Variations:

- Attach a picture (snapshot or magazine) to a foamboard base, then model a textured "frame" around it with acrylic modelling paste. "Stain" and "glaze" the modeled area.

- Create a pictorial modeled landscape. Pretend that you are looking out of the window, and re-create that imagined scene with various textures. Paint your modeled picture with thin acrylic or tempera.

- Line the inside of a small box with magazine pictures. Use spray adhesive (**outside**) to flawlessly attach the pictures. Texture the outside of the box with acrylic modeling paste. You can encrust the surface with little shells, sequins, jewels, etc., or you can impress patterns with pods or other small objects. Imbed small collage items in the wet modeling paste, and paint around them later. If you'd prefer, attach these collage items to the dry painted box with the hot-glue gun. Squeeze the hot glue onto the box, not onto the small collage item that you are holding.

Display:

Look at your finished Aerial Map as if for the first time, and decide where the top is. Your finished relief sculpture can be displayed vertically, horizontally, or diagonally. Attach two

flat-backed picture hangers to the back of your sculpture. Even if these hangers are "self-adhesive," use a hot-glue gun or thick white vinyl glue to attach the hangers. Or, easiest of all, display your map flat on a tabletop.

THE CREATURE: MY WORST NIGHTMARE

This final activity is a mixed-media invention that combines sculpture, painting, and collage. It is similar to the Trophy project that closed Part Two, but this sculpture will not be mounted on the wall. You will work fully "in the round." Another difference is in the papier-mâché work; rather than using strips and pulp, as before, you will use only the papier-mâché pulp to model your sculpture.

One of the best things about this activity is its theme: My Worst Nightmare. The theme encourages exaggeration and fantasy. If you decided to create a sculpture called My Favorite President or My Best Friend—one with a more realistic theme, in other words—you would be inviting disappointment and possible disaster. (You might have to retitle your sculpture My Ex-Best Friend when you're done.) It's hard to model a realistic likeness, especially out of soda pop cans and papier-mâché!

And, as you have probably already discovered in doing some of the other projects in this book, an art project can take on a "life of its own." Eyes get bigger, colors get brighter, fur gets shaggier, angles get sharper, legs get longer than you had originally planned—but the changes look good, so you change your initial concept.

It's easier to do this with a fantasy theme. And there's something strange that many people discover: No matter how scary an assignment you give yourself (My Worst Nightmare, for instance), taking it out of your head and making it into art usually makes it less scary. The art process often even turns the thought from scary into funny!

Attach two flat-backed picture hangers to the back of your sculpture.
Top: vertical
Bottom: horizontal

Materials:

For the sculpture:

- Clean empty soda can

- Newspaper

- 1" masking tape (can be cheap tape)

- Powdered papier-mâché (**Check to make sure that you are not using an ancient craft powder that has asbestos in it.**)

Optional:

- Aluminum foil
- Poster board
- Stapler

For the painting:

- Gesso (for primer)

Choose one of the following:

- Tempera paint and white vinyl glue
- Acrylics

Optional:

- Markers
- Glossy clear plastic spray, thin white vinyl glue, or acrylic medium

For the collage:
Choose from all the collage materials you have used in doing the projects so far in the book, including:

- Papers: tissue paper, construction paper, Fadeless art paper, etc.
- Yarn, twine, string, etc.
- Fabric, felt, leather, lace, pompons, trims, etc.
- Sequins, glitter, etc.

Other materials:

- Hot-glue gun
- Thick white vinyl glue

Time:

The *sculpture* part of the project can be done in two sessions if you want. In the first session, you will form The Creature from the soda cans, newspaper, and masking tape. This will take about an hour and a half to two hours. In the

second sculpture session you will apply the papier-mâché pulp to this base. This will take an additional hour and a half or so, depending upon how detailed your modeling work is. *Painting* the sculpture will take another session of an hour or more. The *collage* work will take about another hour.

Instructions:
Sculpture

1. Rinse your empty soda can with water. If you don't, ants may creep over your sculpture forever after.

 Next, visualize your Creature: Is it standing on two, three, or four legs? Is it legless? Is it sprawled on its back? Is it sinking into a briny swamp? How big is its head? What shape and size are the ears?

 The soda can will be the base, and you will form the big sculptural details from newspaper and masking tape. As with the Trophy project, the idea is to get the

The basic Creature sculpture is created from a soda can, newspaper, poster board, and masking tape.

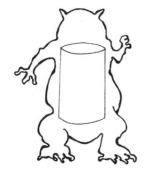

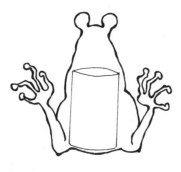

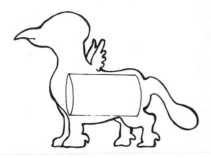

The first decision you'll need to make is whether to work with the can upright or on its side.
Top: upright can; standing creature
Center: upright can; half creature
Bottom: can on its side; standing creature (remember to keep the legs short)

sculpture as detailed as possible *before* doing any papier-mâché work. The first decision you'll need to make is whether to work with the can upright or on its side. Then you'll form the newspaper-and-tape body. Be lavish with the tape.

As you work, build up the body slowly with wadded and twisted newspaper; half sheets are a good size to work with. Use lots of tape to securely attach the compact wads and twists of newspaper. It is important to create a firm foundation—a sculpture with no wobbles and very little "give." Have each newspaper addition to the basic shape "grow" naturally; have each new shape start from a broader base that can be secured to the body underneath. When you are attaching arms or legs, twist two at a time from one big piece of paper. Flatten each twist at the center, and tape it to the back of your base. Then form the two ends of the twist into arms or legs.

You might have a big Creature sitting back on her great haunches, waving tiny Tyrannosaurus arms in the air. Your sculpture might stand swaybacked on four (or five) sturdy muscled legs. You could model only the menacing top half of a Loch Ness–style monster and display it rising from a square mirror "lake." His webbed fingers might be frantically trying to attract attention—after all these years. . . .

It will be very hard to balance this necessarily bulky creature on long slender legs, but apart from that—whatever works, works. Long twisted appendages (doubled back and modeled) will be much more stable than cigar-rolled arms or legs that you then attempt to stick to the body. Build up muscles or other additions with smaller wadded and taped pieces of paper. *Get rid of the can shape;* build up a more natural-looking body, no matter how unnatural your Creature is.

2. You can use aluminum foil and poster board to add further sculptural details. Tape the tightly twisted or crumpled foil to the newspaper body. Remember that a taped form that "grows" naturally from a broader base will be much more secure than a plopped-down one.

As in the Trophy project, poster board can be used in two ways at this point: 1) You could cut two-dimensional shapes such as horns, ears, claws, or spikes and tape them to the body. This juxtaposition of flat shapes

against a modeled one can be both unexpected and funny. 2) You could plan simple poster-board sculpture additions (stapled cones, for instance) to add to the body.

You have made the "skeleton" and added the "muscles" to your Creature. Now you are ready to cover it all with the "skin," the papier-mâché pulp. *Do not plan to model major sculptural features from the pulp.* Check your sculpture one last time for wobbles before you begin your papier-mâché work.

3. Mix the papier-mâché pulp. Mix only as much as you can use at any one time, and either line your mixing bowl with aluminum foil or use a disposable container (such as a Styrofoam meat tray) for mixing. Powdered papier-mâché combines ground-up newspaper with dry

Have each new shape start from a broader base that can be secured to the body underneath.
Top: side view of can with "growing" wadded newspaper shapes
Bottom: what the finished sculpture might look like

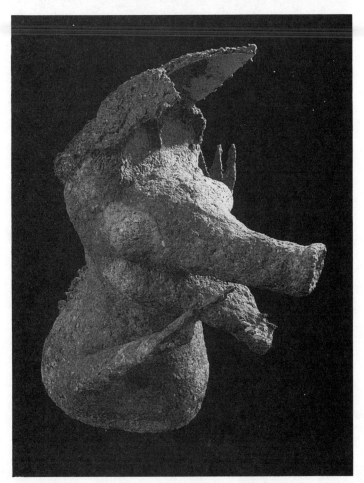

Now you are ready to use the papier-mâché pulp. The powdered papier-mâché is mixed and applied to the base.

Try simple paper sculpture using taped or stapled poster board.
Top: little horns
Center: big ears
Bottom: long beak

paste; all you do is add water and stir. Pour some into the mixing bowl, being careful not to inhale the dust. Add a little water, and mash it into the powder with an old disposable fork or spoon. Then add a little more water. *If you want to model details* in the papier-mâché pulp, keep the pulp a little stiff—like gray bumpy peanut butter. *If you want a fairly smooth surface,* the pulp should be a little thinner.

Now you are ready to begin to apply the pulp to a section of your Creature. Use your fingers or a disposable utensil (fork, knife, or spoon) for this. **Work on newspaper to protect your table or counter.**

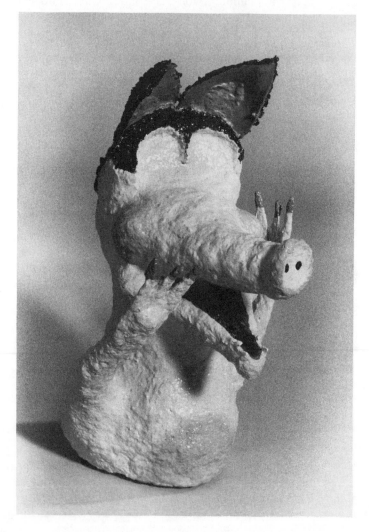

This Creature is painted with gesso, acrylic paint, and glossy acrylic medium.

A word about the pulp:

As in the Trophy project, you might want to begin by using little lumps of the pulp to reinforce bends and joins in the sculpture. This will make your finished piece much stronger. Just don't use the pulp snowball-style for large attachments; these should already have been formed from the newspaper and masking tape. *For a smoother surface,* dip your finger in water and slick it over the surface of the applied pulp. *For a rougher surface,* texture the pulp with an old comb or fork, or punk it up with a knife. Remember that you will be able to add further textural details when you do the final collage work on the Creature.

You can work with wet papier-mâché pulp on dry pulp areas, or your sculpture can be damp when you resume work, but *the sculpture must be completely dry before you paint it.* Do not attempt to keep the applied pulp moist by covering the sculpture between sessions. Make sure that air can circulate freely around the drying sculpture. Take your time as you work, and keep mixing up small batches of pulp as needed.

Painting

1. First, you will give your completely dry, gray sculpture a gesso primer. This white base coat will seal the sculpture (which is why the sculpture has to be dry, or else the damp papier-mâché will rot under the gesso) and will provide a bright base for the colors. It will make your colors look brighter. *Do not use white tempera for the primer;* subsequent colors will "bleed" into it, creating unwanted tints. Working on a big sheet of newspaper, slop the gesso on with a big brush. Get finicky later if you want, not now. If the gesso is too thick, thin it with water—you don't want too-thick gesso to fill in the textured details you've worked so hard to get. You can always paint two thin coats of gesso rather than one thick coat. Gesso dries quickly. Wash your big brush right away with water—once the gesso dries, it's permanent.

2. For the rest of your painting, I suggest using tempera paint mixed with a little white vinyl glue, or else using acrylic paint. Either of these paints will enable you to work in layers, "wet on dry," with no "bleeding." If you want your layered colors to blend together, use plain tempera—or else paint fast, in small areas, working "wet on wet." Both tempera and acrylic thin with water and clean up with water.

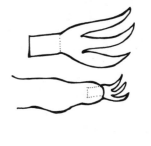

Two-dimensional poster-board shapes can be to add to your sculpture before painting (anchor with pulp).
Top: claw; taped to papier-mâché arm
Center: teeth; taped to papier-mâché jaw
Bottom: spikes; taped to papier-mâché back

Please see Trophy (**A Word about the paint**), page 129, for suggestions on working with these paints. You may find that a highly textured surface invites thinner paint, for more of a "stained" or "antiqued" look. The thin paint will sink into the fissures that you've modeled.

Please see Aerial Map (**A word about the paint**), page 210, for instructions on mixing and applying very thin paint.

A word about the art:

In general, remember to *start with the big areas and work to the small ones.* Paint the whole furry body, then the face, then the facial features. Paint an entire body section, then paint on the stripes or spots. Paint the horrible paws, then the talons, then the blood dripping from the talons. For crisp color changes, wait for the first layer of paint to dry before painting with subsequent colors.

Remember paint surface *variety*—all of the ways you've used paint in doing the projects throughout this book. These include: *"staining," stamp-printing* (use a damp sponge piece to print a shape onto an uneven surface), and *sponge-painting* (use a ragged damp sponge piece to blot a mottled second coat of paint over the first coat for a furry textured surface). As in the Trophy project, remember that *color, value,* and comparative *size* are all tools that you can use to make your sculpture more interesting to look at.

3. It's hard for many people to paint small details, but you can always draw them. Just remember that *markers are transparent,* so you will always have to draw with a marker that is darker than the paint color underneath. You could draw with either permanent markers or watercolor markers. If you use watercolor markers, you may wish to coat the finished sculpture with glossy plastic spray so that the marker lines will never smear.

 You could draw tiny flower sprigs across a yellow painted abdomen for a calico beast. You might pin-stripe your Creature, or draw sneakers on her feet. You could draw a cartoon-style face with a black marker. You might print an ominous trail of frightening words across your Nightmare's back.

4. If you want your Creature to have a glossy finish, take care of it now, before you go on to the *collage* work. If you coat the sculpture with glossy plastic spray, work

outside on a big sheet of newspaper. **Always go outside to use any spray, and read the label carefully.** Don't spray too close to the sculpture, at least at first, or the watercolor marker lines might "bleed." Or instead, you could brush thin white vinyl glue or acrylic medium onto the sculpture for a shiny finish. These brushed "glazes" might disturb watercolor marker lines or plain (no white vinyl glue added) tempera. Both of these "glazes" will look milky when wet but will dry clear.

Collage

1. After the paint and the "glaze" have dried, you are ready for the final step—*collage.*
 This could add to the scariness of your sculpture.

 ● A doll part could protrude from powerful jaws.

This finished Creature collage incorporates plastic eyes, fake flowers, netting, a favor basket, and a rhinestone ring. (Shh—she thinks it's a cubic zircon!) A hot-glue gun was used for the adhesive.

- A claw might clutch an old chicken bone (or a wishbone!).

- A swamp creature might have fake aquarium plants hanging from his arms.

- A shaggy coat of dark "fur" could cover part of your sculpture. (Clip tiny bits of wound-up yarn into a plastic bag for the "fur." "Paint" thick white vinyl glue onto one small area at a time, then press the clipped yarn bits onto the wet glue. You don't need to cover the entire body—maybe your Creature has a mohawk, chest hair, or fuzzy feet!)

- A pile of feathers or a doll's little red jacket might lie at the feet of your Nightmare.

Or take a fresh look at your sculpture: You might suddenly decide on an incongruous collage detail.

- Your coiled serpent might be wearing granny glasses.

- Your beast could be covered with glitter spots. ("Paint" a patch of thick white vinyl glue onto a small area, then douse the wet patch with glitter. **Be careful not to get the glitter near your eyes.**)

- Your Nightmare might suddenly turn into a different sort of creature of the night—one with "real" false eyelashes, shiny violet lips, and a sequinned beauty mark (or five).

- Your threatening monster might be overcome by a sudden fit of modesty; fashion a net tutu for it, or cut out a fig leaf for it.

Use a hot-glue gun to attach bulky collage items to the papier-mâché base. **Be careful when you use a hot-glue gun;** squeeze the hot glue onto the base rather than any small piece you are holding.

Variations:

- Make a companion for your Creature. Display them together on Valentine's Day!

- Create a sculpture for a child; look through children's books for favorite characters. You might make a monster inspired by Maurice Sendak's *Where the Wild Things Are,* for instance, or one roughly based on de

Brunhoff's *Babar* characters. (Don't give a sculpture to a very young child, though, if he or she is apt to nibble on the collage additions.)

● Model a funny portrait of your family pet. Then photograph the pet and the sculpture together!

Display:

Showcase a water creature on a square mirror. Plunk a land dweller on a scrap of fake grass (maybe from an old doormat), or mount it on a sanded and stained block of wood. Please see Clothespin Creatures instruction #1, page 94, for how to stain unvarnished wood bright colors.

Create a tableau for your sculpture—add a little drama. Set it up on the kitchen table or on top of the TV (Then you can say, "Guess what's on TV?") Search out the props; involve your family. Ask for polite suggestions and help. Little plastic soldiers will add instant stature to your Creature. Tiny Lego houses might await demolition. Your monster could peep from behind a Boston fern.

The point is—even if it's not perfect, even if things didn't work out just as you'd planned, enjoy your art!

Closing

Y ou did it! You started making art again. Now, here are some suggestions on how to keep making art—and how to make art a part of your everyday life.

In the Introduction, I said that there were three important things that you could learn from doing the projects in this book. The first thing, the knowledge of art materials and methods that you have gained through first-hand experience, can give you both the confidence to continue with art and the freedom to make art your own way.

The second "art lesson" you have learned is playfulness—adaptation, experimentation, and plain old fun. You can take something seriously and work hard at it while still retaining the underlying playful spirit that is an important part of creativity.

The third thing learned, the rediscovery of the creator in yourself, can stay with you always. This lesson is not something that is over with when you finish a project or close this book; the book is just a beginning for you. And you are the one who did all of the work. Congratulations!

In experiencing the "art process" firsthand, you have discovered many of the pleasures of making art—and some of the discomforts, too. Remember these discomforts: I hope you realize that things aren't any easier for "real artists." There are the obvious art discomforts—isolation, lack of financial reward (in spite of society's "rich artist" fantasies), and even the realization of a generalized vague hostility to artists taking the

time, space, attention, and money needed for art. You may
have experienced all of these things to some degree.

Never forget that "real artists" feel these things, too; they
are dealing with these issues every day as well as enjoying the
pleasures and privileges of making art.

Apart from the "process," the act of making the art, and
the "product," the art itself, your firsthand art experience can
enable you to look at art (you own and others') with the eyes
of an artist.

Visit art galleries often. Did you know that visiting gal-
leries is free, and that most galleries are open at least from noon
until 5 P.M., Tuesdays through Saturdays? Did you know that
you won't be expected to buy something just because you
walked in? Good galleries welcome browsers and questions. (If
you ever feel snubbed at a gallery, be assured that you wouldn't
have been snubbed by the artist.) Did you know that all gal-
leries have mailing lists? You can ask to be included even if you
don't buy anything. You'll be invited to art openings (again,
free) and other events.

Visit museums, but this time look around with the eyes
of a reemerged artist. And remember that museum going isn't
something to undertake once a year, like a flu shot. Go more
often than you have before and leave sooner. Look at just a few
pieces—but look thoroughly. Buy two postcards from the mu-
seum bookstore of each favorite piece; send one and save one.
Join museum support groups if you can. You'll be invited to
parties, and you'll probably get a discount in the museum
bookstore, too. In the olden days only the rich could be patrons
of the arts. Now more people can be a part of this important
tradition.

Use your rediscovered art vocabulary. When you look at
art in a gallery or at a museum, try to guess what art materials
the artists used. Galleries and museums both include some
materials information next to each piece displayed—"acrylic
on canvas," for example. Maybe this will give you inspiration
for work of your own; you don't necessarily have to use materi-
als exactly as the artist did. Your own experience will tell you
a lot about what the materials can do and which methods can
be combined.

Choose a piece of art that you really like, and use as many
words as you can to describe it. Start with your "gut reac-
tion"—"pretty," "scary," etc.—but then try to remember the
art words you've relearned. The same words that you used in
making your own Landscape Collage or Fairytale Diorama can

be used to describe a famous painting in a museum—color, value, pattern, texture, size, etc. You'll find even more things to like in your favorite works when you look at them carefully, and you'll probably discover more and more art to like.

As I stated in the Preface, I suspect that the experience of making art can help develop increased flexibility and problem-solving skills. These assets can be useful even when you aren't making art.

In art, you have to make a lot of choices. You have to accept the limitations of art materials and then make the most of them. You have to compartmentalize: If something isn't working, you don't necessarily throw the whole thing out and walk away; you use the parts that work—or at least you learn from them.

In art, you have to adapt when things don't go as planned. You develop the patience to persevere and the confidence to say "I'm done." You learn to be constantly receptive to what is actually happening; you aren't ruled by what *should* be happening or by what you *want* to have happen. You become more able to see things as they really are.

Even if you don't see life as a series of "art lessons," you can try consciously to recall that distinctive state of awareness—of receptivity—that happens so often when you make art. You know what it feels like, now. Making that feeling happen at other times is a trick that you already have in you; learn to perform it at will. It can enrich your life.

Another way to enrich your life through art is by collecting art. Did you know that you don't have to be rich to be a collector? And did you know that the smartest collectors collect for love rather than for investment value?

You may already have an enjoyable collecting habit, even if you don't collect fine art . . . yet. Sometimes our collections serve to complete us in some way:

- Maybe you are a button-down person who collects Hawaiian shirts, bowling jackets, or vintage tie-dye T-shirts.

- Maybe you spent a doll-less childhood and now live surrounded by dolls.

- Maybe you always wanted a train set—and now spend thrilling weekends hunting for additions to your famous collection.

- Maybe you grew up in such exquisite surroundings that all you dream of is adding to your collection of old

lunch boxes, costume jewelry, hand-painted ties, or naughty postcards.

Sometimes, our collections begin as accidental accumulations and then turn into satisfying obsessions.

- You might have fun collecting stickers; they aren't just for children.

- A box of old buttons is relaxing to sift through and easy to add to.

- Rusty tools can remind us of times past and are often strikingly sculptural as well.

- Old valentines can start us daydreaming. Write a short story or poem about each valentine in your collection.

Whatever you collect, make it something that you truly care about—and then take pleasure in taking care of your collection. Nurture it; protect it.

And consider collecting fine art, too. Art schools usually have student sales once or twice a year—attend. Get on mailing lists. Community art associations sell members' work, and there may also be galleries in your area. Did you know that they will often let you buy art "on time"?

Buy what you love, for whatever reason, and not what you think you "should" like or what you think will become "more valuable" some day. What could be more valuable than what you love right now?

But . . . *buy art. Serve as its trustee. Encourage other artists in your community.*

Every artist goes through bad times when the slightest encouragement or interest can make a crucial difference in his or her life. That sounds dramatic, but it's true. You will probably never know, but maybe even your slight support at an important time will make a difference in someone's life.

By the way, it is far wiser to buy original art (drawings or paintings, for example) or from true "limited editions" than it is to risk wasting your money. Don't buy a signed poster—even one signed by a "famous artist"—that is masquerading as a limited edition print. A good signed poster shouldn't sell for more than $25–$30, unframed; it might be just what you want, but you should know what you're buying.

There is room for some form of art in every life; take the time to discover your art. Then *slow down* and make room for it in your life. Is *music* your art? It's not too late for music

lessons! If you can't master the guitar, try the autoharp. Attend concerts and recitals when you can; buy records, tapes, or CDs if possible. Support your art! Is *theater* your art? Join a community theater group. Memorize poems. Support theatre organizations; buy season tickets if possible. Is *dance* your art? Take ballet, tap dance lessons, or join a folk dancing club. Attend dance performances—that's what other dancers have trained so hard for.

If *visual art* is your art, keep on making it! Redo some of the projects in the book; do some of the project variations; use the "materials and methods" knowledge that you have gained to invent your own art activities.

And you might consider taking some art classes. Community college and university extension classes are open to the public. That's you! Many classes require no prerequisites—just enthusiasm and a willingness to learn and work hard.

If you enroll and then don't like a specific teacher or subject, just get what you can from the class and then go on. Don't give up. No matter how discouraged you get, *don't let other people define you.* If you see yourself as an artist, keep on making art.

When you started making art again, you started to reinvent yourself . . . as an artist. You have reclaimed your creative self. Art is no longer just a memory from childhood but is part of your recent experience.

That makes you a new artist and, I hope, a person whose life will always have a place for art.

Appendix 1
List of Art
Materials

T he following materials are mentioned throughout the book. Please see Appendix 2 for where to buy them. Art materials used for a limited number of specific projects are so listed in this first appendix; other materials can be used for many projects.

Papers, etc.

> White drawing paper (sold by the sheet or in packs)
> Typing paper (sold in packs; try to get 20-pound or 24-pound paper)
> Index paper (sold in packs)
> Newsprint (sold in packs or tablets)
> Construction paper (sold in packs or tablets of assorted colors)
> Fadeless art paper (sold in packs of assorted colors)
> Tissue paper (sold in packs of assorted colors)
> Poster board (sold by the sheet or in small packs; comes in assorted colors)
> Corrugated board (sold by the sheet, or cannibalize boxes)
> Foam board (sold by the sheet)
> Bristol board (sold by the sheet)

Illustration board (sold by the sheet; get cold press)

Mat board (sold by the sheet; comes in assorted colors)

Marbled paper (sold by the sheet)

Velour paper (sold by the sheet)

Metallic paper (sold by the sheet)

Canson Mi Teintes pastel paper (sold by the sheet; comes in assorted colors)

Patterned Oriental paper (sold by the sheet): Two-Fold Nature Collage, Fantasy Cards

Oriental papers (sold by the sheet): Feathers and Sticks

Paper trims (sold by the pack)

Waxed paper; aluminum foil; doilies

Round coffee filter papers (Rockline, Sheboygan, Wisconsin 53081)

Magazines, especially: *Arizona Highways* (landscape), *Life* (people), *National Geographic, Ranger Rick* (animals)

Paints, etc.

Tempera paint (white, black, colors; liquid tempera colors are brighter than powdered tempera)

Acrylic paint (sold by the tube or jar; Liquitex or Golden are good brands)

Watercolors (sold by the pan or tube; a pan of eight colors is probably sufficient for these projects)

India ink (sold in little bottles)

Gesso (pronounced "JESS-oh"; sold in jars)

Acrylic modeling paste (sold in jars)

Acrylic medium (sold in jars; buy "glossy" if you want a shiny finish)

Peintex Fabric Dye from Sennelier (sold in little bottles; or use any heat-set dye): Fruit and Vegetable Prints, Pillow Pattern

Food color (sold in little bottles): Clothespin Creature, Colored Wood Scrap Sculpture

Blue food color (sold in bottles at cake decorating supply stores)

Bleach (sold in bottles)

Rubbing alcohol (sold in bottles)

Glossy plastic spray (sold in cans)

Inked stamp pads (sold in black, also assorted colors, swirled colors)

To prepare a base for further painting, choose from:

● Gesso

- White acrylic (to prepare a small base)
- White tempera mixed with white vinyl glue

(*Do not* mix gesso with white vinyl glue. It's not dangerous, but it won't work; it glumps up like tar.)
To "glaze" a project, choose from:

- Thinned acrylic medium
- Thin white vinyl glue
- Glossy plastic spray

Other painting supplies:

Brushes: big brush (for gesso), watercolor brush, small "acid" brush (for glues and pastes)
Sponges (ordinary household sponges are fine)
Spray bottle, eye dropper: Fantasy Flowers

Drawing supplies

Watercolor markers (sold in sets)
Skinny watercolor markers (colors sold in sets; also black sold individually)
Skinny permanent markers (sold individually: black)
White Stabilo pencil
Colored pencils (Derwent makes beautiful pencils; these are sold in sets)
Oil pastels (sold in sets)

Sculpture supplies

Plaster of Paris (sold as "casting powder"): Sand Fish
Acrylic modeling paste (sold in jars): Aerial Map, Fairytale Diorama
Powdered papier-mâché (sold in powder, small packages): Trophy, The Creature
Unvarnished wood clothespins (sold in packs): Clothespin Creature
Wood scraps (sold by the pound at some lumberyards; sold by the box through catalogs): Colored Wood Scrap Sculpture
Polyester fiber (sold by the package): Stocking Faces
Aluminum foil, masking tape

Adhesives

White vinyl glue (available in large bottles)

Flour-and-water paste

Liquid starch (sold in bottles)

Acrylic medium (sold in jars; it's an adhesive, too!)

Spray adhesive (sold in cans)

Rubber cement (sold in jars)

"Yes" paste (sold in jars)

Hot-glue gun and glue cartridges

"Stitch Witchery," "Wonder Web," or other fusible fabric (sold by the yard): Fabric Appliqué Gift Tags, The Circle in the Square

Cutting Tools

Good scissors

Manicure scissors (or buy a pair of small "craft" scissors)

X-acto knife

Utility knife

Fabrics, etc.

Muslin, white cotton (sold by the yard): Pillow Pattern

Unprimed canvas (sold by the yard): Pillow Pattern

Felt (sold by the yard or by the piece; also sold in packs of assorted scraps)

Leather scraps (sold in packs)

Yarn

Pompons (sold in packs)

Pipe cleaners (sold in packs of assorted colors): Fantasy Flowers

Green chenille wire (sold in skeins): Fantasy Flowers

Green florist's wire: Fantasy Flowers

Ribbons, trims (sold by the yard)

"Stitch Witchery," "Wonder Web," or other fusible fabric (sold by the yard): Fabric Appliqué Gift Tags; The Circle in the Square

Thread, string

Glitter (sold in little bottles)

Sequins (sold in small packs)

Pin-back mounts (sold in small packs): Found Objects

Miscellaneous Supplies

Masking tape (1″ wide; sold in rolls)

Double-sided tape (sold in rolls)

White self-adhesive labels (sold in packs)

Ruler, yardstick

Art-gum eraser: Stamp Carving

Kneaded eraser

Single-hole punch, metal ring, stapler, big metal paper clips

Inked stamp pads, rubber stamps, stickers

Cloth tape (sold in small rolls): Stickers, Counting Book, Portrait
 Gallery

Liquid Paper for photocopies (sold in small bottles)

Glossy plastic spray (sold in cans)

Flat-backed picture hanging hooks (sold in small packs)

Picture-hanging wire

Masonite (sold in large sheets or small pieces; have it cut if
 necessary): Bean Mosaic, Landscape Collage

Appendix 2
Where to Buy Art
Materials

Y ou already have some art materials around the house—newspaper, liquid starch, aluminum foil, or paper towels, for instance. Here are some suggestions on where to buy materials you may need.

Art Store

Papers, etc.

White drawing paper (sold by the sheet)

Newsprint (sold in tablets)

Construction paper (sold in packs of assorted colors)

Fadeless art paper (sold in packs of assorted colors)

Tissue paper (sold in packs of assorted colors)

Corrugated board (sold by the sheet)

Foam board (sold by the sheet)

Bristol board (sold by the sheet)

Illustration board (sold by the sheet; get cold press)

Mat board (sold by the sheet; comes in assorted colors)

Marbled paper (sold by the sheet)

Metallic paper (sold by the sheet)

Canson Mi Teintes pastel paper (sold by the sheet; comes in assorted colors)

Patterned Oriental paper (sold by the sheet)

Oriental papers (sold by the sheet)

Paints, etc.

Tempera paint

Acrylic paint (Liquitex or Golden)

Watercolors (pan of eight colors)

India ink

Gesso (pronounced "JESS-oh")

Acrylic medium (buy "glossy" for a shiny finish)

Peintex Fabric Dye

Glossy plastic spray

Brushes

Drawing supplies

Watercolor marker sets

Skinny watercolor marker sets

Skinny black watercolor markers (Pilot or Flair)
Skinny black permanent markers (Pilot or Tombow)
White Stabilo pencil
Colored pencil sets
Oil pastel sets

Sculpture supplies

Plaster of Paris (sold as "casting powder")
Acrylic modeling paste
Powdered papier-mâché

Adhesives

White vinyl glue (available in large bottles)
Acrylic medium
Spray adhesive
"Yes" paste

Cutting tools

Good scissors
X-acto knife
Utility knife

Fabrics, etc.

Unprimed canvas

Miscellaneous supplies

Masking tape (1″ wide)
Art-gum eraser
Kneaded eraser
Flat-backed picture hanging hooks
Picture-hanging wire

Craft Store

Papers, etc.

Paper trims

Paints, etc.

Peintex Fabric Dye from Sennelier

Glossy plastic spray
Stamp pads (swirled colors), rubber stamps, stickers

Sculpture supplies

Unvarnished wood clothespins
Polyester fiber

Adhesives

White vinyl glue
Spray adhesive
Hot-glue gun and glue cartridges

Cutting tools

Good scissors
"Craft" scissors
X-acto knife
Utility knife

Fabrics, etc.

Felt
Leather scraps
Yarn
Pompons
Pipe cleaners
Green chenille wire
Green florist's wire
Glitter, sequins, beads
Pin-back mounts

Miscellaneous supplies

Masking tape
Flat-backed picture-hanging hooks

Stationery Store

Papers, etc.

Typing paper (20-pound or 24-pound)
Index paper
Newsprint (tablets)

(Continued)

Construction paper (tablets)
Poster board
Magazines

Paints, etc.

Watercolor sets
India ink
Glossy plastic spray
Inked stamp pads, rubber stamps, stickers

Drawing supplies

Watercolor marker sets
Skinny watercolor markers
Skinny permanent markers
Colored pencil sets

Adhesives

White vinyl glue (if they have large bottles)
Spray adhesive
Rubber cement

Cutting tools

Good scissors
X-acto knife

Miscellaneous supplies

Masking tape (1″ wide)
Double-sided tape
White self-adhesive labels (1½″ × 4″ or 2″ × 4″)
Ruler
Art-gum eraser
Single-hole punch, metal ring, stapler, big metal paper clips
Inked stamp pads, rubber stamps, stickers
Cloth tape

Hardware Store or Lumberyard

Sculpture supplies

Plaster of Paris (sold as "casting powder")
Wood scraps

Adhesives

White vinyl glue (large bottle)
Hot-glue gun and glue cartridges

Cutting tools

Good scissors
Utility knife

Miscellaneous supplies

Masking tape (1″ wide)
Yardstick
Glossy plastic spray
Flat-backed picture-hanging hooks
Picture-hanging wire
Masonite (have it cut if it's too big)

Fabric Store

Sculpture supplies

Polyester fiber

Adhesives

"Stitch Witchery," "Wonder Web," or other fusible fabric

Cutting tools

Good scissors

Fabrics, etc.

Muslin
White cotton
Felt
Yarn

Thread
Pin-back mounts

Supermarket or Pharmacy

Papers, etc.

Typing paper (20-pound or 24-pound)
Newsprint (tablets)
Construction paper (tablets)
Poster board (small packs)
Waxed paper, aluminum foil, doilies, coffee filter
 papers
Magazines

Paints, etc.

Watercolors
India ink
Food color (blue food color is sold at cake-deco-
 rating supply stores)
Bleach
Rubbing alcohol
Sponges
Spray bottle, eye dropper

Drawing supplies

Watercolor marker sets
Skinny watercolor markers (Flair or Pilot)
Skinny permanent markers (Pilot or Tombow)

Sculpture supplies

Unvarnished wood clothespins
Aluminum foil

Adhesives

Liquid starch
Rubber cement

Miscellaneous supplies

Art-gum eraser
Single-hole punch, big metal paper clips
Liquid paper for photocopies

Catalogs

(Please see the end of this section for some cata-
log addresses and specifics.)

Papers, etc.

White drawing paper (packs of 500 sheets)
Newsprint (packs of 500 sheets)
Construction paper (sold in packs of assorted
 colors; may also be ordered in packs of one
 color)
Fadeless art paper (sold in packs of assorted col-
 ors)
Tissue paper (sold in packs of assorted colors)

The following papers are sold by the sheet. When you
order paper by the sheet from a catalog, there is neces-
sarily a minimum order (shipping is so expensive).
Check with individual catalogs for their minimum
paper order; often it is $25. Find some friends to order
with, or purchase paper at an art supply store.)

Foam board
Bristol board
Illustration board
Mat board
Marbled paper
Velour paper
Metallic paper
Canson Mi Teintes pastel paper
Patterned Oriental paper
Oriental papers

Paints, etc.

Tempera paint
Acrylic paint
Watercolors
Gesso
Acrylic medium
Peintex Fabric Dye
Brushes

Drawing supplies

 Watercolor marker sets
 Colored pencil sets
 Oil pastel sets

Sculpture supplies

 Acrylic modeling paste
 Powdered papier-mâché
 Unvarnished wood clothespins
 Wood scraps

Adhesives

 White vinyl glue
 Acrylic medium
 "Yes" paste
 Hot-glue gun and glue cartridges

Fabrics, etc.

 Felt (by the yard or in packs of assorted scraps)
 Leather scraps
 Yarn
 Pompons
 Pipe cleaners, green chenille wire
 Glitter
 Sequins
 Pin-back mounts

Here are four catalogs that you can order from. The supplies for the projects in this book are listed under each catalogue.

1. S & S ARTS AND CRAFTS
 Colchester, CT 06415-0513
 (203) 537-3451

 Buy the basic materials offered in this catalog, rather than the kits.

Papers, etc.

 White drawing paper (500 sheet ream, 9" × 12" or 12" × 18")
 Newsprint (500 sheets, 12" × 18")

Construction paper—assorted colors and one color (50 sheets, 9" × 12" or 12" × 18")
Tissue paper—assorted colors (50 sheets, 12" × 18")
Poster board
Metallic paper, velour paper (20 sheets, 8½" × 10")
Doilies

Paints, etc.

 Tempera—liquid and powder
 Watercolor sets
 Gesso
 Brushes

Drawing supplies

 Watercolor marker sets
 Colored pencil sets
 Kneaded erasers

Sculpture supplies

 Wood plaques
 Plaque hangers
 Unvarnished wood clothespins
 Powdered papier-mâché
 Scrap wood by the box
 Polyester Fiber

Adhesives

 White vinyl glue
 Rubber cement
 Hot-glue gun and glue cartridges

Fabrics, etc.

 Felt (by the yard, in squares, or scrap)
 Leather scrap
 Yarn
 Pompons
 Pipe cleaners
 Green chenille wire
 Glitter

Sequins, buttons, beads
Pin-back mounts

Miscellaneous supplies

Stamp pads (colors)
Glossy plastic spray
Magnetic tape
Masking tape

2. EASTERN ARTISTS
5 West 22nd Street
New York, NY 10010
(212) 645-5555

Paper, etc.

White drawing paper (100 sheets, 9″ × 12″ or 12″ × 18″)
Newsprint (500 sheets, 12″ × 18″)
Construction paper—assorted colors and one color (100 sheets; 9″ × 12″ or 12″ × 18″)
Tissue paper—assorted colors (20 sheets)
Canson Mi Teintes pastel paper
Foam board
Bristol board
Illustration board
Mat board

Paints, etc.

Tempera—liquid and powder
Acrylic paints
Watercolor paint sets
India ink
Gesso
Acrylic medium
Brushes

Drawing supplies

Skinny markers—watercolor and permanent
Colored pencil sets

Sculpture supplies

Plaster of Paris (sold as "casting plaster")

Acrylic modeling paste
Powdered papier-mâché

Adhesives

Acrylic medium
Spray adhesive
Rubber cement

Cutting supplies

X-acto knife
Utility knife

Miscellaneous supplies

Masking tape (1″ wide)
Art-gum eraser
Kneaded eraser
Cloth tape
Plastic frames, other frames
Flat-backed picture hangers
Picture-hanging wire

3. DICK BLICK
P.O. Box 1267
Galesburg, IL 61401
(800) 447-8192 (orders only)

Papers, etc.

White drawing paper (500 sheets, 9″ × 12″ or 12″ × 18″)
Newsprint (500 sheets, 9″ × 12″ or 12″ × 18″; also pads of 50, 80, or 100 sheets)
Construction paper—assorted colors and one color (50 sheets, 9″ × 12″ and 12″ × 18″)
Fadeless art paper—assorted colors (60 sheets; 12″ × 18″)
Tissue paper—assorted colors (24 sheets)
Canson Mi Teintes pastel paper
Oriental papers
Velour paper (sheets)
Metallic paper (rolls)
Bristol board
Illustration board
Mat board

Paints, etc.

Tempera—liquid and powder
Acrylics
Watercolor sets
Gesso
Acrylic medium
Brushes

Drawing supplies

Watercolor marker sets
Colored pencil sets
Oil pastel sets

Sculpture supplies

Plaster of Paris (sold as "casting plaster")
Acrylic modeling paste
Unvarnished wood clothespins
Wood scrap (in die-cut shapes)
Wood plaques

Adhesives

White vinyl glue
Acrylic medium
Spray adhesive
Rubber cement
Hot-glue gun and glue cartridges

Cutting supplies

X-acto knife

Fabrics, etc.

Muslin (by the yard)
Unprimed canvas (by the yard)
Felt (by the yard, in squares, or scrap)
Leather scrap
Yarn
Pompons
Pipe cleaners
Green chenille stems (12″)

Florist's wire
Glitter
Sequins, beads
Pin-back mounts ("findings")

Miscellaneous supplies

Glossy plastic spray
Masking tape
Art-gum eraser
Kneaded eraser
Cloth tape

4. DANIEL SMITH
4130 First Avenue South
Seattle, WA 98134-2302
(800) 426-6740

Paper, etc.

White drawing paper (sheets and pads)
Newsprint (pads)
Canson Mi Teintes pastel paper
Patterned Oriental paper
Oriental papers
Marbled paper
Foam board
Bristol board
Illustration board
Mat board

Paints, etc.

Acrylics (including Golden)
Watercolor sets
India ink
Gesso
Peintex Fabric Dye
Brushes

Drawing supplies

Colored pencil sets
Oil pastel sets

Adhesives

 Acrylic medium
 Spray adhesive
 "Yes" paste

Fabrics, etc.

 Unprimed canvas (by the yard)

Miscellaneous supplies

 Art-gum eraser
 Kneaded eraser
 Frames
 Picture-hanging wire
 Spray masks and mask cartridges

Appendix 3
Where to Buy
Copyright-Free
Illustrations and
Designs

Did you know that even after an illustrator, painter, or photographer has sold a piece, he or she probably still owns the copyright to that image? If you want to reproduce an image, you need to get permission first.

Still, there are lots of illustrations and designs available for you to use that are now "copyright-free"—the copyright has expired. You can use these images however you want, without permission, and you won't get in any trouble.

Magazine-sized collections of copyright-free images are available at many *art supply stores.* They can be used in the Photocopy Art projects as well as for business or organizational design needs. If you have trouble finding them, or finding the ones you want, here are two sources:

1. GRAPHIC PRODUCT CORPORATION
"Graphic Source Clip Art"
1480 South Wolf Road
Wheeling, IL 60090-6514
(708) 537-9300

> *Holidays* (GS-305)
> *Floral Ornaments* (GS-313)
> *Shadowed Borders and Frames* (GS-317)
> *Animal Silhouettes* (GS-328)
> etc.

2. DOVER PUBLICATIONS, INC.
31 East 2nd Street
Mineola, NY 11501-3582
(516) 294-7000

> *Traditional Chinese Designs* (25347-3)
> *Scandinavian Folk Designs* (25578-6)
> *Decorative Alphabets and Initials* (20544-4)
> *Mythical Beasts* (23353-7)
> etc.

Appendix 4
Bibliography

\mathbf{T}hese first two books are basic art resource books:

The Artist's Handbook of Materials and Techniques
Ralph Mayer
New York: The Viking Press, 1970

This detailed book is a valuable resource for artists. But even if you don't "need" this much information, you will probably enjoy reading about the history of various materials and methods. If you are a collector, read the chapter titled "Conservation of Pictures."

ARTIST BEWARE: The Hazards and Precautions in Working with Art and Craft Materials
Dr. Michael McCann
New York: Watson-Guptill Publications, 1979

Did you know that you can absorb toxins not only by swallowing them but also by inhalation or by skin contact? Did you know that "use adequate ventilation" doesn't just mean "open the window and hold your breath?" Did you know that children and sometimes even teenagers are at higher risk from exposure to toxic materials than adults are?

Protect yourself with knowledge! This book may scare you a little, but it contains constructive information. It is of value to everyone who uses any art, craft, or photographic material.

The next three books relate specifically to the Fairytale Diorama project (page 199), but I think you will find them all rewarding reading even apart from the project:

THE COMPLETE FAIRYTALES OF THE BROTHERS GRIMM
Translated and with an introduction by Jack Zipes
New York: Bantam Books, 1987

(Jack Zipes has written some other books you might enjoy reading. Two of them are: **THE BROTHERS GRIMM: From Enchanted Forests to the Modern World: Routledge, Chapman and Hall, Inc.,** 1988 and the introduction to a collection of contemporary fairytales; the collection is called **Don't Bet on the Prince: Routledge, Chapman and Hall, Inc.,** 1986).

The Uses of Enchantment: The Meaning and Importance of Fairy Tales
Bruno Bettelheim
New York: Alfred A. Knopf, Inc., 1975

". . . Fairy tales, like all true works of art, possess a multifarious richness and depth. . . . If the reader is stimulated to go beyond the surface in his own way, he will extract ever more varied personal meaning from these stories. . . ." (page 19)

Don't Tell the Grown-ups: Subversive Children's Literature
Alison Lurie
Boston: Little, Brown & Co., 1990

"Too often, as we leave the tribal culture of childhood—and its sometimes subversive tales and rhymes—behind, we lose contact with instinctive joy in self-expression. . . . Staying in touch with children's literature and folklore as an adult is . . . a way of understanding and renewing our own childhood." (p. 204)

And in that spirit, here are two final books—"children's books." They're for fun!

NO GOOD IN ART
Story by Miriam Cohen
Pictures by Lillian Hoban
New York: Greenwillow Books, 1980

Bad art memories? This is the book for you.

TENREC'S TWIGS
Bert Kitchen
Philomel Books, 1989

This beautifully drawn animal picture book is said to be about "the importance of tenacity and vision" (from the jacket copy). I think it's about art. If you look to the people around you for a response to your art, and then feel disappointed when they either say the wrong thing or can't say anything at all, this book will make you feel better.

Index